The Illuminated Landscape

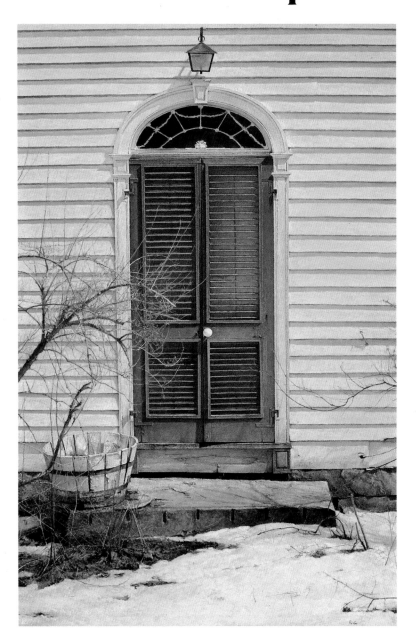

The Paintings of Peter Poskas

The Illuminated Landscape

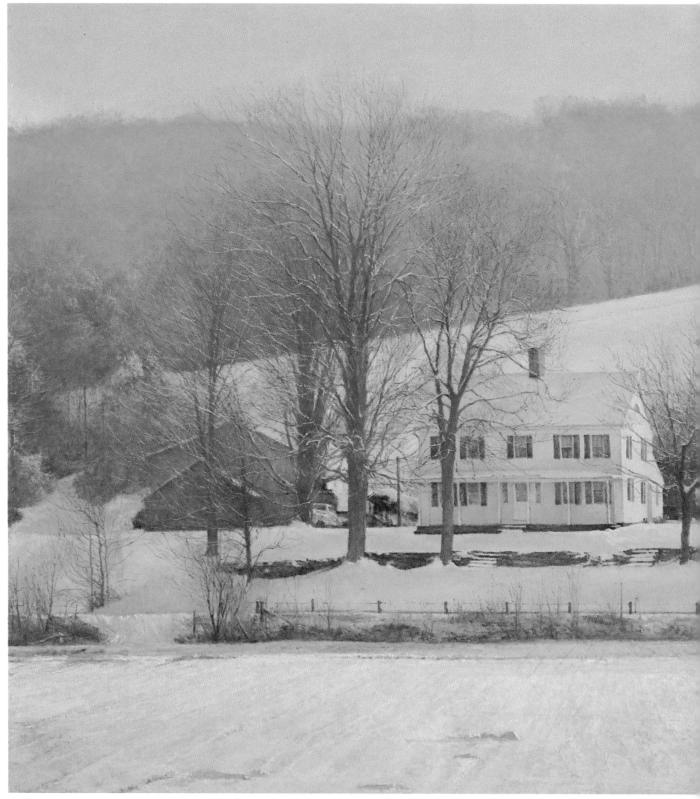

Watson-Guptill Publications/New York

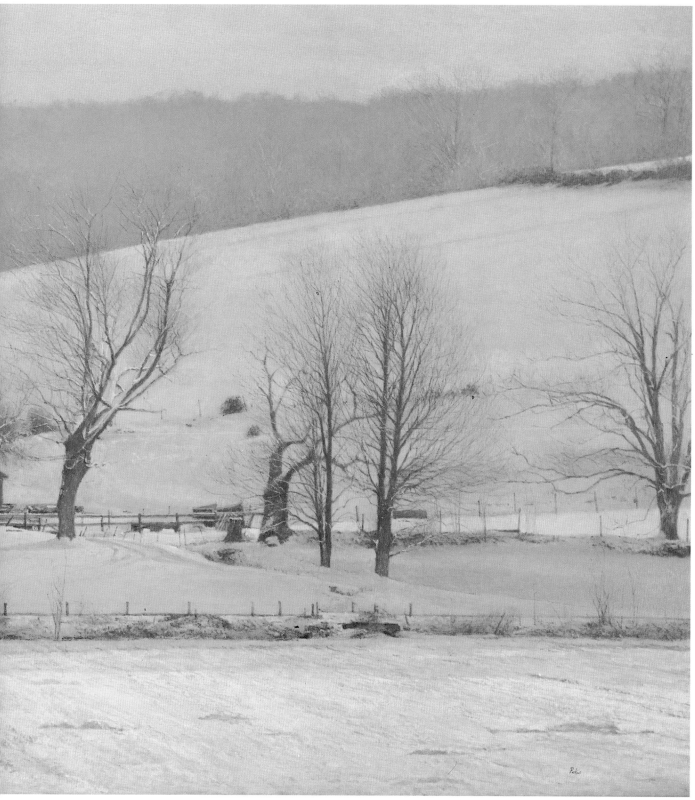

PETER POSKAS AND J. J. SMITH

I wish to thank J. J. Smith for his text, understanding, and friendship; Mary Suffudy for her patience, help, and kindness; Candace Raney for her sensitive picture editing; and Jay Anning for his thoughtful, attractive design work. A special thanks to Sherry French and the staff of the Sherry French Gallery, New York City, for their efforts in collecting and photographing the works in this book, and my sincere appreciation to those patrons and friends who are now sharing their paintings through this publication.

This book is dedicated to my family: my mother, who always believed in me; my father, who showed me an affinity toward nature; my uncle, who taught me to work with my hands; my wife, who gave me her love and support; and my son, who understands me.

It is further dedicated to all those who love work and respect the land, especially Albert Laukaitis, the Lizauskas farm, the memory of Alphonse and Eva Bauch, the memory of Emily Uranus, Ralph and Thalia Scoville, Frank Andrus and Frank Johnson.

Peter Poskas

751.45
P

Copyright © 1987 by Peter Poskas and J.J. Smith

First published 1987 in New York by Watson-Guptill Publications, a division of Billboard Publications, Inc., 1515 Broadway, New York, N.Y. 10036

Library of Congress Cataloging-in-Publication Data
Poskas, Peter.
 The illuminated landscape.
 Includes index.
 1. Landscape painting—Technique. I. Smith, J. J.
II. Title.
ND1342.P67 1987 751.45'436 87-21602
ISBN 0-8230-2533-0

Distributed in the United Kingdom by Phaidon Press, Ltd., Littlegate House, St. Ebbe's St. Oxford

Manufactured in Japan

1 2 3 4 5 6 7 8 9 10 / 92 91 90 89 88 87

Painting on page 1:
TRACERIES, EDGE OF SPRING, *oil on canvas, 48" × 30" (121.9 × 76.2 cm), Courtesy of Sherry French Gallery.*

Painting on pages 2-3:
FRESH SNOW, EARLY MORNING JOHNSON FARM, *oil on canvas, 33" × 60" (83.8 × 152.4 cm), Private collection.*

Edited by Candace Raney
Designed by Jay Anning
Graphic production by Hector Campbell

Contents

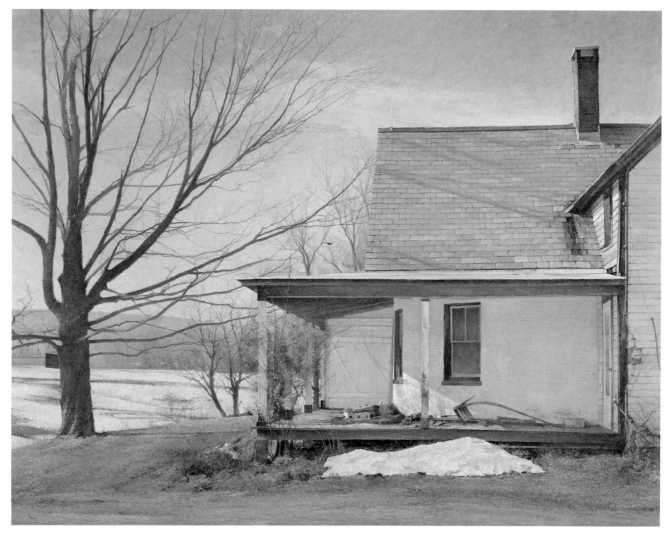

ROUND BRICK SCHOOLHOUSE
oil on canvas. 44½" × 56" (113 × 142.2 cm). Courtesy of Sherry French Gallery.

Preface

From early childhood I can remember two very strong feelings: a bond between myself and the land and the desire to in some way work with my hands. These have never left me and have become inextricably bound together. Although I had drawn and painted since the age of eight or nine, I hadn't really considered painting as a career. I spent three years in college as a botany-forestry major before I ever entertained the idea of art school.

Once I began to study art, I found that the prevailing dogma of abstract expressionism was not suited to my needs and point of view. Going against the grain, however, made me thick-skinned and even more determined to follow my own course.

There were only two living realists who in those days were popular enough not to be pushed into the closet. They were Wyeth and Hopper, and of course they became my heroes. The two of them gave me hope, and I tried to learn from them. People tend to classify realists superficially, according to subject matter, so when I painted the landscape I was "like" Wyeth, and when I painted urban scenes, I was "like" Hopper. I didn't really paint like either of them; the lesson of toughness and dedication, begun in art school, continued. Their influences can in fact be seen in my early work—Wyeth's pull in my watercolors and Hopper's influence in my early Waterbury paintings—but I was trying to develop my skills and a personal point of view.

When I painted Emily's farm, I totally committed myself to the subject, to exploring it intimately, to dissecting it and finding out what made it tick. I found out what made me tick as well. It was here I discovered my fascination with the flat facade and reflective surfaces, and it was here I got to know light in one place—day to day, hour to hour, month to month, season to season.

Between Waterbury and Emily's, I grew up as a painter and found my personal vocabulary of light-color-tone and paint. I worked out a method that is suggestive rather than explicit, echoing the nature of my subject and the infinitely variable and eloquently descriptive force of light.

In Dawns and Dusks, I focused primarily on light and color in a freer association that was not tied to architectural forms. This sharpened my understanding of paint quality and broke color away from the overriding tonal aspects of form.

At the Scoville farm in North Cornwall, my concept for interweaving architectural and natural forms matured. This is continued in the paintings of the Johnson and Andrus farms in Woodbury and Washington.

For me, painting has always been an evolutionary process—assimilating, building, stretching—not revolutionary, but growing; each painting builds on the lessons of the previous one. In the end, I work on the things that I believe in and that interest me. I don't place particular value on being stridently different. I am what I am, a manifestation of my own personal history and involvements; I will continue to grow with them and never deny them or their direction for any tide of fashion.

PETER POSKAS
Washington, Connecticut, 1987

Introduction

This book is about the subjects of Peter Poskas's paintings, about how they are composed, and about how they are created. All of these considerations are complex topics that overlay and interact with each other but upon close inspection turn out to be rational and simple, very much like the paintings themselves.

Landscape paintings have always been about a great deal more than the depiction of nature, although their beauty and accessibility have often masked their role beyond that of decoration. They were first accepted as an art form in America in the second quarter of the last century. The first members of the Hudson River School, early American landscape painters, sought to express religious, moral, and philosophical ideas and values in their romantic depictions of nature, for they saw in nature a reflection of the workings of God in the universe. The later generation of Hudson River painters, who concentrated more on precise renderings of exotic locations and natural wonders, had a scientific interest in weather, light, and natural phenomena. They were followed by artists who were more interested in expressing mood and feelings in their painterly depictions of dawn and dusk in gray and brown autumnal scenes.

Shortly before the turn of the century, when landscape was the dominant subject matter of painting, many artists were attempting to capture the effects of bright sunlight. The impressionists sought to portray the effects of sunlight through color and the effects of the paint itself. These artists increasing preoccupation with the materials and methods of art would eventually lead to the exclusion of all or most recognizable subject matter. The realist landscape did not vanish with the advent of modernism, although its role was considerably reduced. It continued to express the attitudes of contemporary culture in a radically changing world of machines and social unrest until the late forties, when abstract art seemed to make all but a handful of landscape painters irrelevant.

The sudden contemporary rebirth of interest in realist landscape painting is an interesting phenomenon. Unlike in earlier periods, there is a multiplicity of ideas, attitudes, styles, and directions. Since these new landscape artists were born or studied after the realist landscape had ceased to be a subject of serious art, there were no examples to follow, no schools to teach technique, no philosophies to discuss. Each artist had to find his or her own way independently. And they have. Suddenly, artists and critics everywhere are reassessing nature.

The common thread in contemporary landscape painting is a certain way of seeing, for few new works could have been produced or could be mistaken for works produced one hundred or fifty or even twenty-five years ago. The contemporary realist landscape may sometimes allude to the past, but it is very much informed by the present.

This way of seeing has essentially been molded by the photographic image. The photograph had been used in landscape painting since its invention, often in a very direct way, by such European masters as Corot, Degas, and Cézanne to twentieth-century American artists, Demuth, Sheeler, and Shahn. But the photograph did not have the same influence on these artists as it does on today's painters, who are conditioned by the camera to see in a whole new way. Regardless of whether they actually use photographs in their work, they have received much of their information and perceptions from television, slides, magazine layouts, and photojournalism.

From the photographic image has emerged the tight, energized composition, emphasizing structure and busy edges, that is the essence of magazine layout and print advertising. Serial images, as well as high-key, unnatural hues, alter the television generation's perceptions of nature. The coolness and detachment with which they have learned to greet the bombardment of even shocking images lends a sense of detachment to their art. The photographic eye, which tends to flatten deep space, sharpen contours, provide an overall pattern, and heighten perceptions of texture, has altered our way of seeing.

The subject matter of Peter's work, like that of most contemporary realists, is anti-picturesque, although the paintings are autobiographical and filled

with personal symbolism. He has chosen to paint the small rural farms in the countryside that surrounds him and the nearby industrial city where he grew up, even though such subject matter may seem at first glance nostalgic or narrative. On closer inspection, his is a dispassionate view filled with a hard reality that serves a practical purpose in his art.

He seeks the few remaining modest farms because their meager income means the houses haven't been painted or remodeled. Whatever improvements or repairs were made were both necessary and makeshift, and the fingerprints of their owners and their way of life are clearly marked on the house and the land. The texture of white weathered clapboards, the peculiar angles of odd additions, the stray detritus of farm life, all provide the structure for what Peter sees as the real subject of his paintings—the play of light in a landscape.

He is interested in how light varies as it illuminates a structure or surface and reflects and refracts from different textures; how it bounces into shadows and reveals or conceals form; and how the white farmhouse mirrors the colors of the sky and earth.

The gradations of light and sharply defined shadows are then tempered and interpreted in terms of weather and atmosphere and aerial perspective, concerns that seem to hark back to the phenomenological preoccupations of the Hudson River School.

One of the clearly contemporary aspects of Peter's art is his use of taut, complex designs that incorporate, particularly in close-up and middle-distance views, an interplay of rectangles; echoing twin shapes and lines; and a tightly cropped, energetic image that reflects both photographically informed ways of seeing and a constructivist sensibility. These designs tend to have a pattern of finely balanced lights and darks and an overall textural weight that diffuse and negate a central focus, leading the viewer to scan the whole surface. There is always an assertion of the plane of the canvas, even with respect to deep space. This is most evident in his close-up planar views that toy with the issue of flat-

ness. None of these operations is blatant or even obvious, for this is a finely tuned, carefully wrought balancing act so sophisticated as to be almost imperceptible.

Peter's method and materials echo the operation of his subject and composition in his layered and balanced, and ultimately self-effacing, approach and his contemporary way of seeing. Rich, vibrant colors are built up in thin, transparent layers that are wiped off to leave just a suggestion to modify and enliven the next veil of color. The eventual result is not unlike the disparate dots of a twelve-color photographic printing process, where a multitude of rich hues are translated by the eye into the appropriate color. This way of painting produces a magnificent sense of reality from a distance; when viewed up close, it reveals little except a few dry tones on the surface.

In his most recent work, the artist has combined this reductive process with lively, thin impastos whose perfection of color and tone read as objects that themselves read, upon close inspection, as no more than dry gobbets. Such balance and control are truly remarkable, relating to the past century in their deftness and precision but very much to the present in their conception.

Finally, the scale and shape of Peter's canvases refer both back to the past, in his newest panoramic shapes derived from the vistas of the Hudson River School, and forward to the present, in their large scale. Both size and scale seem, however, to retain a sense of freshness and invention as they present a vision of nature larger than the eye can take in, projecting the observer into the canvas while denying that possibility.

Peter's vision of nature, though unique, contains the rationale that underlies all contemporary realism—that all our latent and universal fears of a world threatened with nuclear obliteration or contamination, an environment threatened with pollution or extinction, a social order threatened with crime and overpopulation, can find surcease in a reexamination of nature.

J. J. SMITH
Bethany, Connecticut, 1987

Early Work

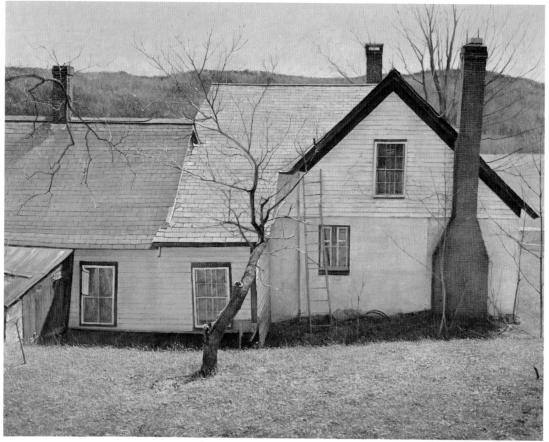

ORCHARD LIGHT, NO. 2
oil on canvas, 35½" × 44" (92.7 × 111.7 cm), Collection of Cluett, Peabody, and Company, Inc.

From watercolor to oils

P eter Poskas was born in 1939 in Waterbury, Connecticut, one of a string of small industrial cities and towns lining the banks of the Naugatuck River as it cuts through one of the most picturesque parts of the state.

Peter's earliest awareness of art came from magazine illustrations. From the age of five, he had liked to draw. When he was twelve, an amateur artist friend gave him encouragement and a set of oil paints; Peter used them to copy George Durrie's idyllic winter scenes from the annual Travelers Insurance calendars. In high school, his efforts at drawing houses drew praise and encouragement from his mechanical-drawing teacher.

When Peter entered the University of Connecticut, the first in his family to attend college, it was as a science major, with an eye on forestry and wildlife management. In the course of the next three years, however, his ambitions and interests changed and he decided to become an artist. His parents, being eminently practical, suggested he enroll at Paier Art School and pursue commercial art as a way to make a living. After a year of paste-ups, mechanicals, and lettering, Peter was sure this was not what he had in mind; his interest in painting had been piqued by Rudy Zallinger, the natural-history muralist, and Perry Wilson, a diorama painter at Yale's Peabody Museum of Natural History and New York's Museum of Natural History. Transferring to the Hartford Art School, Peter followed their conservative course of study to completion.

Upon graduation, newly married, Peter tried teaching as a way to pay his bills and still have time to paint. He then enrolled in the MFA program at the University of Massachussetts. Abstract expressionism was the prevailing style at the time, and Peter still recalls with frustration the faculty's denigration of his own realist enthusiasm. The only professor he remembers encouraging him was Chuck Close, who was then painting in an abstract expressionist style.

At this time, Peter's interest centered on drawings and watercolors, which he showed at Kennedy Galleries in New York City. While they provided an occasional sale, it was not an auspicious time to be a realist painter, particularly in what was regarded as an ephemeral medium. This precipitated his change to acrylic on canvas and later to oils.

The content, style, and structure of Peter's work evolved slowly over a number of years as he explored different formats, materials, and methods. Central to this process of discovery has been his interest in the small rural farm—its reflection of the rhythms of nature and of the individualism of those who work the land. During this early period, he produced volumes of drawings and small watercolor studies of nearby farms; these formed the basis of his early works.

Arbor (page 12), one of these early watercolor studies, foreshadows many of Peter's later concerns with the interplay of rectangles, a tight compositional organization, and subtle gradations of light. Another early watercolor, *April 1* (page 13), suggests the close-up views of windows and walls that Peter would later explore in several series at Emily Uranus's farm.

There is in these watercolors and early acrylics an emphasis on line and tone that reveals these works to be extensions of the concerns of drawing rather than full expressions of the possibilities of the mediums themselves. The essence of the

details portrayed is conveyed by their outlines, while modeling and transitions are essentially achieved through tonal gradations.

Frustrated by the inherent difficulties in applying his painstaking transparent techniques to the fast-drying medium of acrylic, Peter turned to oils. His use of a burnt sienna ground to unite the thin color in his compositions tends to give these works a warm glow. These early oils also exhibit a variety of approaches in the handling of the medium. *Black Birch* (page 19) and *Bethany Dam* (page 14) both show a fluid, painterly approach with large, flat areas of opaque paint. Works such as *Indian Summer, Valley Farm* (pages 20-21) combine large, descriptive foreground areas, rendered with an almost impressionist touch of opaque paint, with a contrasting middle ground and far distance built up in thin, transparent layers.

Peter summed up the experience of his early work and his effort to learn his craft as "a process of isolating elements of painting and working on them in a single-minded kind of way. I'm still working that way, concentrating in a series of works on specific problems and approaches."

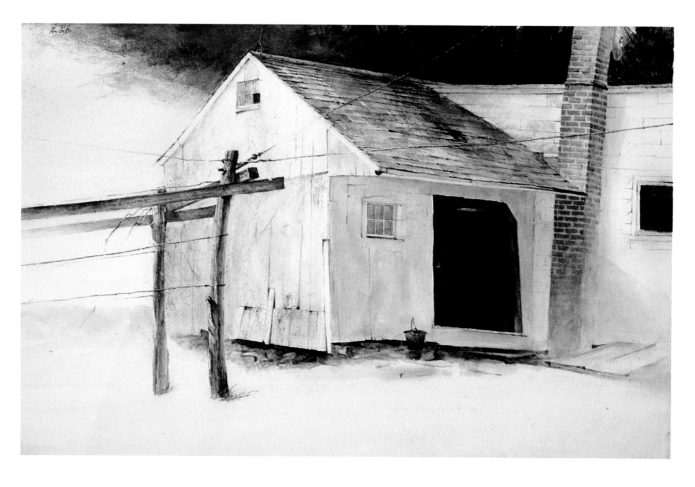

ARBOR

Watercolor on paper. 13" × 19½" (33 cm × 49.5 cm). Collection of Mrs. Kate C. Thurrott.

My earliest paintings were watercolors, all of them executed from start to finish on their actual locations. Because I was no stranger to drawing, having worked intensively in both the charcoal and graphite mediums, there is an emphasis on draftsmanship in my work. When I use time-consuming drybrush applications to capture fleeting moments of light, a well thought-out drawing enables me to focus more on paint, color, texture, and light quality rather than on proportions, shape, and placement—elements which are better resolved beforehand. As you can see, the underlying linear structure of *Arbor* is quite apparent.

I was fascinated at this point with bleeding out images and isolating or vignetting forms to manipulate the composition by focusing attention on certain elements. For example, the fading out of the background trees and the merest suggestion of a foreground throws an emphasis onto the arbor and the woodshed. This focus is created through the interplay of painting and drawing; by the juxtaposition of loosely and tightly handled areas; and by the suggested contrast of massed architectural forms with the more linear forms of the arbor.

The concern here with composition, focus, texture, and volume is not meant to play down the sense of place or the drama of light, but it is on these more formal considerations that the structure of form and the dynamics of light are built.

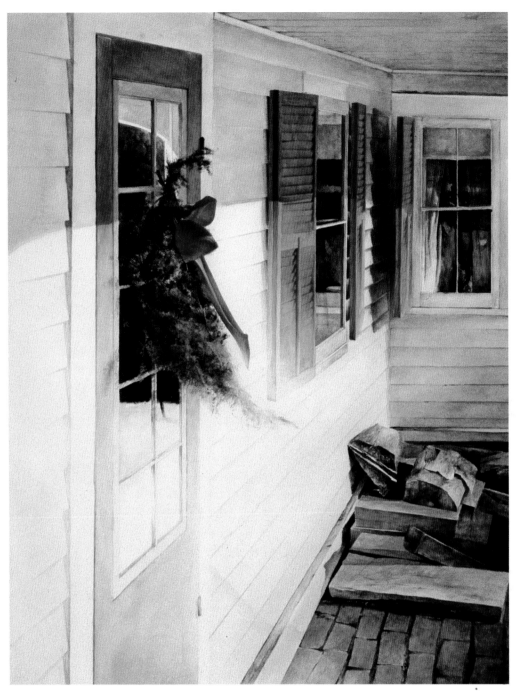

APRIL I

Watercolor on paper. 28" × 21" (71.1 cm × 53.3 cm). Collection of Mr. and Mrs. David Jepen.

In general, the concerns of formality and architecture, space and light are at the center of my work. These themes are evident in an early painting, such as *April I*, and will continue to be for years to come.

April I looks out onto the front porch of a house in Conway, Massachusetts. Near the end of a long hard winter, the remnant slabs of the woodpile give further geometric cohesion to the rectangular theme of windows, shutters, doorways, and porch walls. The newly exposed bricks pick up on this geometry and repeat the red color of painted trim and Christmas bow, further unifying the composition.

There is more completeness to the rendering of form and place in this painting, as opposed to the bleed-out quality of *Arbor*; however, some trace of this technique can still be seen in the fading forms of the door and the shutters and in the porch bricks on the left. These more diffused areas allow the eye to penetrate the space rather than stop at defined shapes and forms, as is the case in the upper areas of the picture.

The reflections found in the window areas are treated rather flatly and heavily. They are more singly oriented for design than to the spatial complexities that will be found in the series of window paintings done at Emily's.

BETHANY DAM

Acrylic on canvas. 23½" × 29½" (59.7 cm × 74.9 cm). Collection of Mr. Orton P. Camp, Jr.

Bethany Dam was one of my first acrylics and shows the paint applied more directly than it was in my watercolors. At this time, acrylic was a new medium to me, and although it is water-based, like watercolor, I had yet to synthesize it into my own personal language. *Bethany Dam* is an unusually dark picture for me; perhaps that was due to my lack of confidence in handling the intricacies and transitions of color needed for painting light. It is, however, consistent with the tonal approach I used in most of my early work—I just didn't push or modulate the dark areas as I would in some of my watercolors and many of the acrylics to come. Along with my insecurity in a new medium, the overcast nature of the day *Bethany Dam* was painted also contributed to the low-keyed color.

VALLEY FARM, BAUCH'S

Acrylic on Masonite. 38" × 44" (96.5 cm × 111.8 cm). Private collection.

After working almost exclusively in watercolor for a number of years, I felt the need to paint in a more flexible medium and on a larger and more compelling scale. Since my earliest attempts to create the effects I desired with oil paint had resulted in muddy colors, my first choice was acrylics, because of their quick drying time as well as the medium's ability to be handled both transparently and opaquely. These properties meant I didn't have to totally abandon my former work habits but could change things and paint over them. Acrylics gave me the flexibility of an opaque medium.

Valley Farm, Bauch's was my first attempt at a large-scale acrylic, and there are several differences between it and the earlier *Bethany Dam*. Besides being painted on the gessoed surface of untempered Masonite instead of stretched canvas, this painting also makes fuller use of transparent washes as a foundation or underlayer for opaque color. The result is a more light-oriented, higher-keyed, atmospheric painting than I had done before. However, new problems revolved around how to focus, push, pull, define, or subdue objects and forms in a medium that was inherently more opaque and didn't lend itself so completely to the bleeds and vignettes of watercolor.

SPRING HOUSE, VALLEY FARM

Acrylic on illustration board. 13½" × 17" (34.3 cm × 43.2 cm). Collection of Mrs. Kate C. Thurrott.

My desire to deal more fully with light and further explore form through detail and texture led me to try various surfaces as well as different techniques. This acrylic was done on the even surface of illustration board, as opposed to the more textured canvas used for *Bethany Dam*. This painting is quite small in scale and was executed entirely with watercolor brushes, so the board itself had little effect on texture and detail. There is also a melding of three techniques here: an underpainting wash of acrylics thinned to the consistency of watercolor; drybrushed texture and detail applied with heavier paint; and finally, the "pushing" of the highlights with opaque color.

The actual mixing of white into a color was the most difficult problem for me. Because I was primarily a watercolorist, and had the option of creating white areas by scratching back or leaving bare the white of the paper, I had little experience with this new technique. In watercolor, the lights were a remnant or remainder to be painted around, not added onto—watercolor painting is a process of subtracting light. With acrylics, my first attempts looked too obviously white, lacked warmth, and were almost foreign to the surface. To remedy this, I would add, blot, and scrape darker and warmer washes over the highlight areas

or drybrush a texture over the washes to amalgamate them into the existing surface. I would then add a few opaque spots to create highlights without covering the entire area with opaque paint. To me, it was important to make these marks a part of the surface plane or form and not to fragment or float them. In effect, I was glazing the surface, but this process was more like weaving than glazing. This idea of not fragmenting surfaces is critical to the sense of the whole; it is the interrelationship of an entire spatial envelope that conveys an integrated image. In the detailing and texturing process, it is easy to lose the sense of unity.

In *Spring House, Valley Farm*, so much of the space depends on the consistent, yet varied, green of the fields as they recede in space—from the more textured interplay of viridians and ochres in the foreground to the flatter, warmer greens directly behind the house, and on to the lighter, cooler greens of the distance. These color bands receding layer by layer into the picture plane are as important as perspective in suggesting a sense of space. They are also linked with an understanding of how each field, as a plane in space, reacts differently to light and its respective illumination, absorption, and reflection.

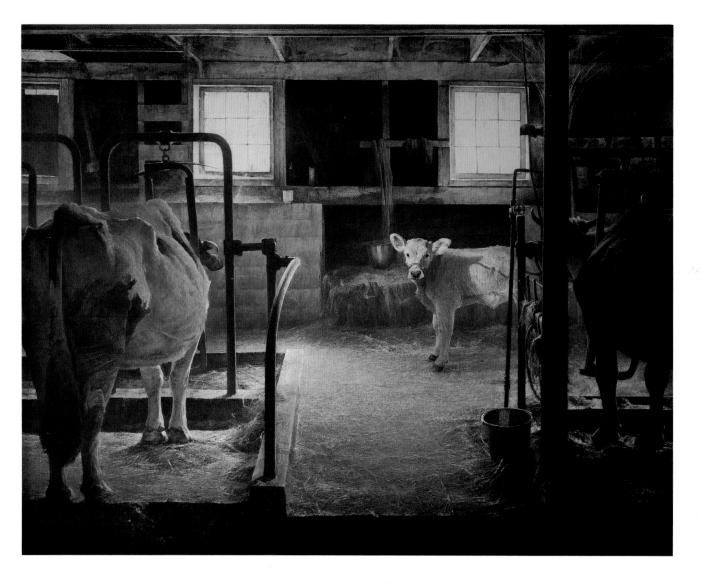

MORNING LIGHT, ALBERT'S

Acrylic on Masonite. 48″ × 60″ (121.9 cm × 152.4 cm). Private collection.

Morning Light, Albert's was the largest and the last of the acrylic paintings I did. Along with *Barn Interior* (opposite), it was the most compositionally ambitious. The two paintings are an interesting study in contrasts and similarities. In these early works, I was trying to formulate my approach to pictorial design while wrestling with the question of how much to change or play with the integrity of my subjects. In *Barn Interior*, I was really pushing the latter, making drastic changes: adding windows to gable walls, putting stanchions at oblique angles to the building, including animals where they wouldn't ordinarily be, using props such as the stainless steel milkpail at my whim. This all made for a balanced, related, rhythmical composition. But was it really what I was after, or, more to the point, did the painting retain its sense of place? I realize that this is an unimportant consideration for some painters, but it's critical for me. Even at this juncture, my tendency was more toward depicting a specific

site, the smell of a particular place, or a subject's integrity.

Morning Light, Albert's is very true with regard to site, except for two things: the position of the young bull and the boarded-up window on the left. Its major reorganization is one of textural and tonal orchestration as it affects light and space, attained by eliminating or muting some areas and adding contrast and drama to others. This is evidenced by the quality and density of atmosphere contained between the back wall of the barn and the viewer, which is as real an element in this painting as the architecture itself. In composition the picture is quite formal though natural; objects parallel the architectural form reinforcing the sense of frontality and order.

Painted on gessoed Masonite, *Morning Light, Albert's* has a noticeable looseness of texture in the washes, whereas the textures of *Barn Interior* are tighter, more highly rendered, the grain of the canvas having naturally asserted itself.

BARN INTERIOR

Acrylic on canvas. 48¾" × 47¼" (123.8 cm × 120 cm). Collection of Orton P. Camp, Jr.

This is probably one of my most inventive works, in both composition and light. Windows were added, doorways enlarged, stanchions rearranged (notice how they are oblique to the gable wall and not perpendicular to it, as they would appear on site), young heifers were usually tethered to the walls and not found in passageways. Objects are consciously paired: windows, poles, livestock, pails, curves of metal and twine. How important the dangling loop of baling twine hanging on the door is, not only for its spatial accent, but also for its reiteration of vertical motifs. The light here is all natural, but there are two separate sources: the light of afternoon coming in the barn's southern door and the morning's east light illuminating Albert and the animals.

Although, as in most early works, this painting is tonal in essence, the sense of color and warmth found here is unusual when compared to the color tonalities of *Morning Light, Albert's* (opposite), which has a single source of illumination.

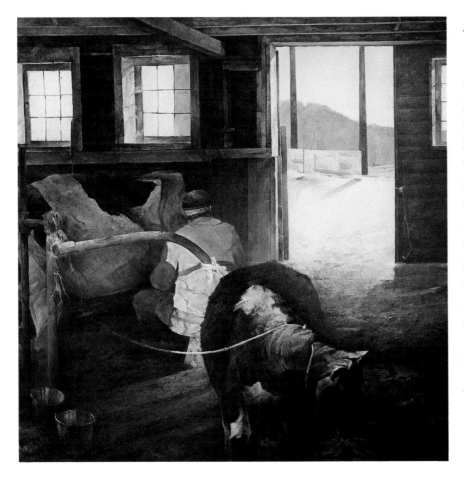

PENCIL STUDY, YOUNG BULL

Pencil on paper. 8" × 11" (20.3 cm × 27.9 cm). Collection of Manya and Kenneth Gries.

This study of a young bull was one of a number of drawings that I used to compose *Morning Light, Albert's*. Since my approach to painting at this point was more often concerned with value than with color, the logical step was to use preparatory drawings done in the field, sometimes augmented by a small watercolor or watercolor-like acrylic, as the basis for larger work done in the studio. Since I only painted at nearby locations, a trip to the subject for further reference was easily accomplished.

Studies such as this were also reflective of a modification of work habits as I turned from watercolors, which were relatively small in scale, to acrylics, which were often much larger. The main problem was the bulky equipment needed for the larger work: a sturdy easel, as opposed to a drawing board sitting on my lap, and a large paintbox, palette, and assorted junk, instead of my little knapsack of watercolor material. I did work on several mid-sized acrylics in the field but found it just too frustrating.

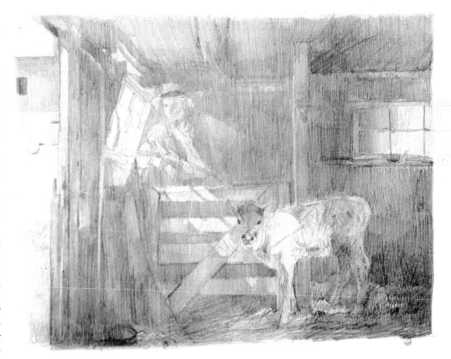

EARLY SPRING, FOOTHILLS

Oil on canvas. 6½" × 9¾" (16.5 cm × 24.8 cm). Collection of Hedda Windisch von Goeben.

The change to oil paint was fostered by my growing interest in light/color relationships as well as by my desire to paint in more open-air settings. Central to this new interest was the need for more direct color notations at the actual sites. And so the process of using thumbnail oil sketches began: I would take my watercolor board, to which I had pinned a piece of white canvas, and a wooden box of oil paints, on which I had cemented a piece of glass to serve as a convenient and easy-to-clean palette—and I was off.

In this study, you can still see a pencil line running along the top of the treeline. Its inclusion suggests the flexible nature of oil paint as well as its covering capacity. When painting in oil, there is little need for a careful drawing. At this point, I didn't use a ground color for the studies. They were painted directly and loosely on the white of the canvas. My general procedure was to paint in a layer of a thinned, transparent middle-tone color, which was accented by more intense darks and followed by lighter, opaque colors. The higher-keyed color was then rubbed or brushed into the underlying color and topped off by accents of thicker, opaque paint for highlights.

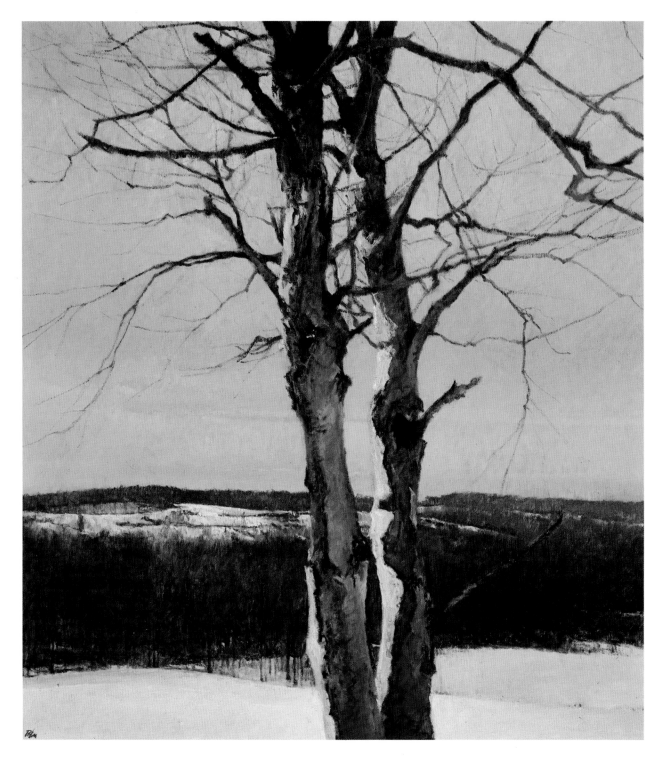

BLACK BIRCH

Oil on canvas. 34" × 29¼" (86.4 cm × 74.3 cm).
Collection of Mr. and Mrs. H. Dickson McKenna.

In its own way, *Black Birch* parallels the struggles I was facing with acrylics in *Bethany Dam* (page 14). It is a very early oil painting, and although at the time I was no stranger to opaque mediums, the added dimension of using a ground color proved challenging. In *Black Birch*, the handling of the ground color is inconsistent; it has little effect in the sky but is more obvious in the wooded hillside and the twin trunks of the tree. Nonetheless, this early oil conveys the atmosphere and feeling peculiar to this kind of winter day.

INDIAN SUMMER, VALLEY FARM

Oil on canvas. 48" × 54" (121.9 cm × 137.2 cm). Private collection.

Indian Summer, Valley Farm is an atmospheric and panoramic approach to the subject of the Bauch Farm. The entire building complex occupies just a small portion of the canvas.

In this composition, the picture plane is broken down into a series of lateral shapes, the most obvious being the division between sky and land. These two major areas are divided further: The sky has its subtle lateral banding of clouds; the land has its woodlot hills, the line of flat fields bordering the road, the brown strip of plowed earth; even the hayfield in the foreground broken by the lateral alignment of grazing cattle. The interlocking of these horizontal bands with vertical forms is subtle here, accomplished by the tops of trees jutting into the sky, buildings connecting hillsides and valley fields, the cows connecting green and brown strips of earth. There is also a series of paired groupings meandering through the middle distance of the composition: the two fir trees, the stacking of paired buildings; even the grazing cows are most often positioned in twos.

A more intentional use of ground color is prevalent in this painting, and a burnt sienna underpainting gives a very warm cast to the entire surface. It can be seen coming through, not only in such obvious places as the textured earth and tawny hillsides, but also, more subtly, in the blue of the sky and the green of the grass.

To prepare a colored ground, I thin burnt sienna to a desirable tone and consistency with straight turpentine and apply it with a soft two-inch house-trim brush. I apply the ground color to an upright canvas, starting at the top, making complete edge-to-edge horizontal passes with a fully laden brush, renewing the supply after each pass. Gravity will do the final blending if you overlap each stroke slightly with the following one. The wash running down the canvas will thin and pale in the upper areas, becoming heavier near the bottom; then the canvas is laid flat, to stop the downward flow of the wash, and allowed to dry. This natural gradient will then be consistent with the general tonalities of landscape painting; lighter toward the top (sky) and darker toward the bottom (land masses).

The freshly toned canvas is left to dry in the sun for several days. This drying process not only prevents too much ground from being picked up but also locks in the graphite preparatory drawing I had done before applying the wash.

I use the toned ground color as one might a gray charcoal paper: to provide middle tones and a warm underpinning for the color and atmosphere to come. It also allows me to go light and dark, not just progressively darker as I would need to if I had just used the white ground of the canvas itself.

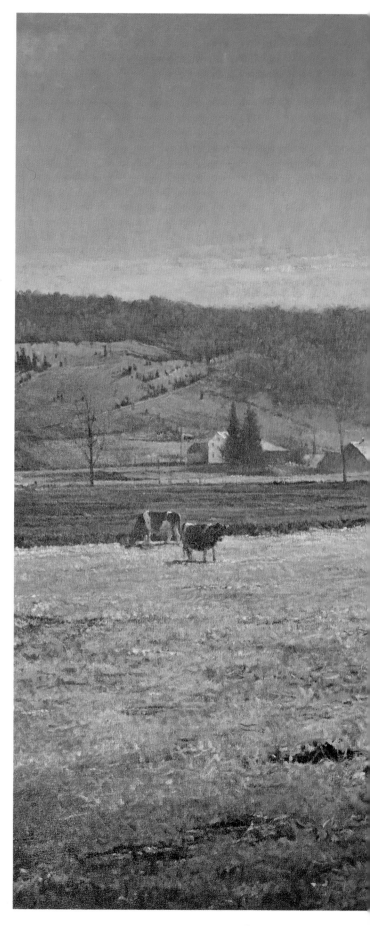

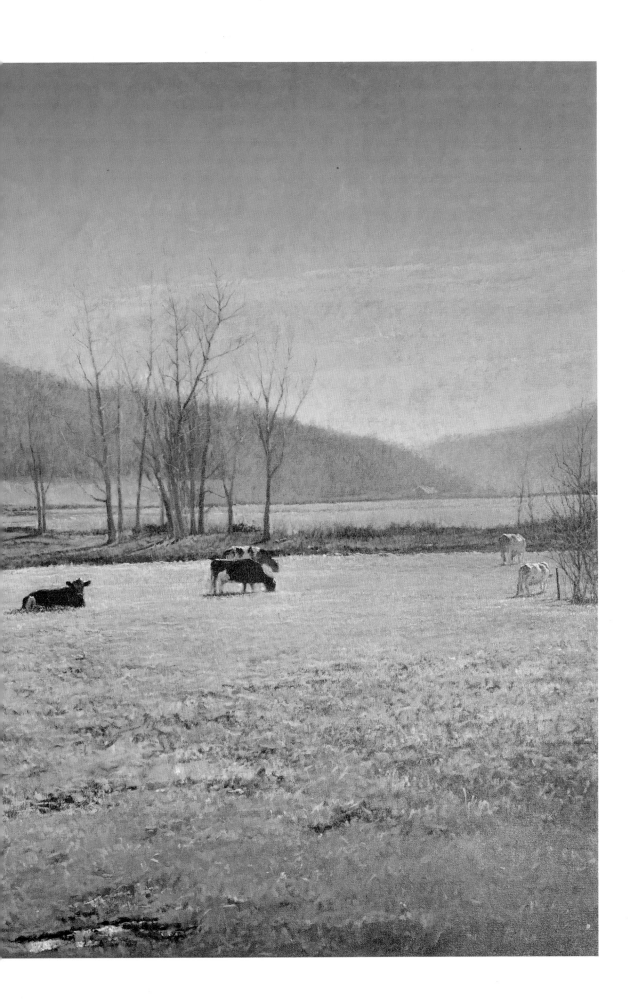

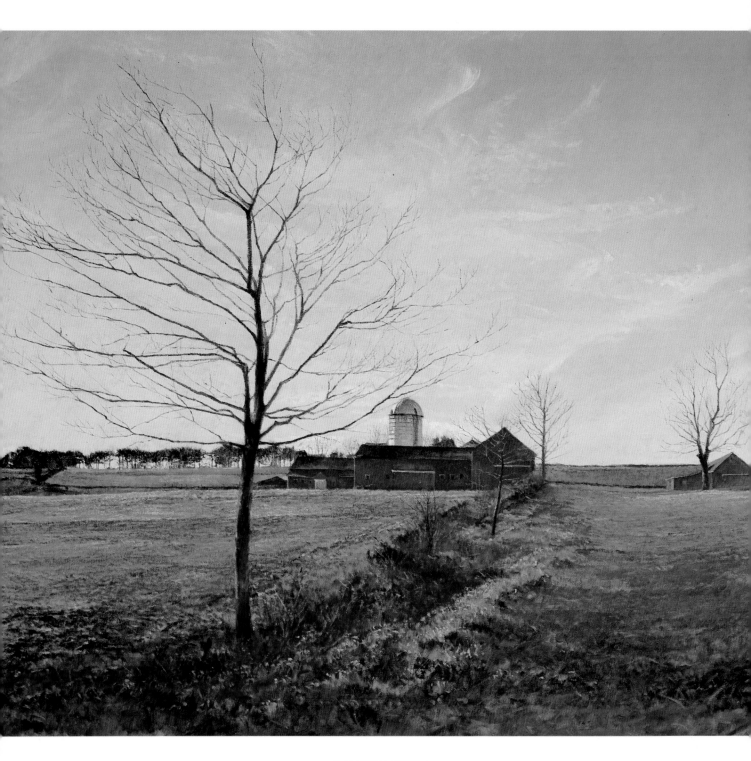

HILLTOP FARM

Oil on canvas. 28" × 40" (71.1 cm × 101.6 cm). Collection of Mr. and Mrs. Hubert T. Mandeville.

As the name implies, this farm sits up in the hills to the north of the Weekeepeemee Valley and the Bauch place. It is therefore quite natural to see the high open space as a panorama, as opposed to the more atmospheric, intimate viewpoint of the valley farms.

This painting is involved with the backlighting effects observed of a late afternoon in autumn, not with the cool spring morning light of *Winter Rye* (opposite page). However, once you get beyond the seasonal as well as spatial differences, the paint application is similar in both paintings.

It is difficult to unify compositions in panoramic scenes, and I

have done so here in perhaps obvious ways. The most apparent device was to use the near tree to invade the space of the sky and to echo the soft patterns of "horsetail" cirrus clouds with the tree's curved branches. This intrusion is repeated by the pines of the far hill, by the barns and their neighboring trees, and especially by the volume of the silo. Another problem I encountered in this painting was how to handle the road that separated the two barn groupings. I wrestled with this dilemma for quite a while before deciding to paint the road over with hay. At this point, I still hadn't made a firm decision on the question of subject integrity.

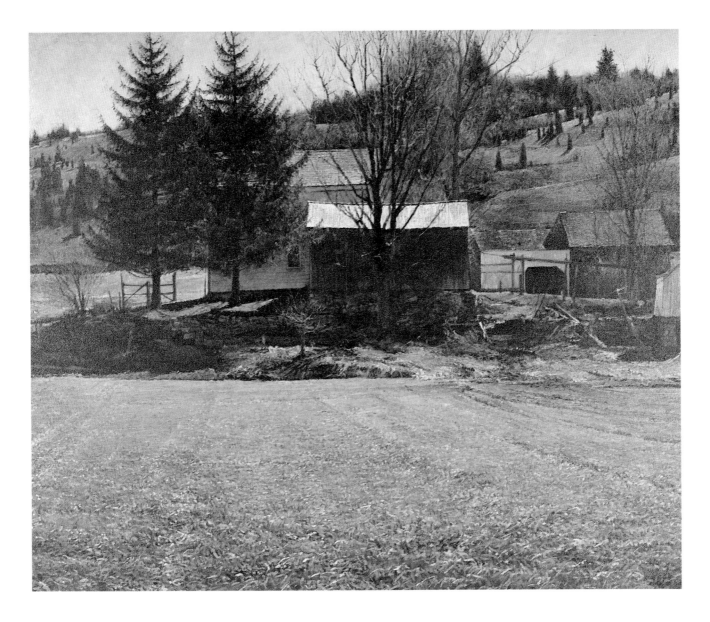

WINTER RYE

Oil on canvas. 26″ × 36″ (66.0 cm × 91.4 cm). Collection of Dr. and Mrs. Martin Wand.

This is the backside of the Bauch Farm as seen from the cornfields. It is very early spring, and the only real greens are those of the closely cropped grass near the house and the winter rye that will be plowed under before this year's corn is planted. To the right of the dark woodshed behind the house, you can see the wooden frame of *The Arbor* (page 10).

The backlighting is quite strong on this clear morning; in particular, it can be seen on the tin roof of the woodshed and in the translucency of the greens in the field. Backlighting effects are very dramatic for architectural subjects because their shapes are mostly in shadow except for their rooftops. In many areas of the connected and adjacent buildings, you can also see the intensity of reflected light, such as in the bottom clapboards of the main house and in the little white shed that is lit by the

strong light that bounces off the south wall of the main house.

The tendency toward formality is more evident here than in paintings like *Hilltop Farm* (opposite), because the structural impact of the rectangular forms increases when the view is in closer. *Winter Rye's* straight-on view has little sense of perspective and focuses instead on paralleling the picture plane, as do the paired shapes of the two large trees. The only reference to strong perspective can be found in the converging furrowed lines of the field of rye and in the more three-dimensional white shed huddled on the right edge of the painting.

The paint quality in this picture is fairly heavy, particularly in the obvious brushwork found in the foreground. In fact, the textural quality of the grass starts to counter the structure of what is essentially a flat plane in space.

Waterbury

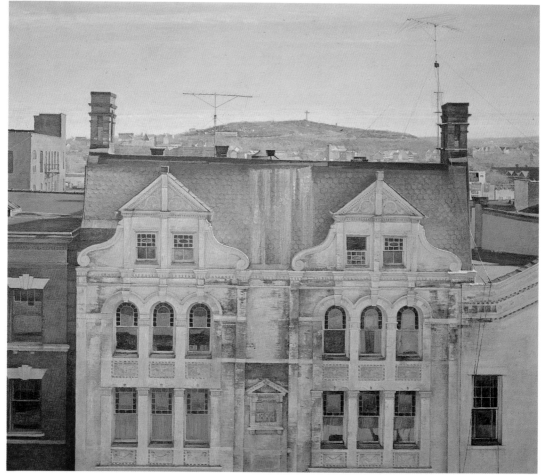

A.D. 1884
oil on canvas, 44" × 48" (111.7 × 121.9 cm), Collection of Mary Helen and Jack Levine.

The urban landscape

Peter found little of interest in the countryside during the summer, when "everything is green, the shadows are dark, the hillsides are softened, and most especially, the light is absorbed by the grass and foliage instead of being reflected into the shadows." When the rural areas came into full foliage, he turned back to Waterbury and began painting urban scenes.

The early urban works are mainly romantic vistas that seek to capture the topography of the city as it sprawls over the hilly landscape. There is a feeling of sadness in these paintings, a sense of distance and anonymity. Forms are rendered as solid concrete masses bathed in the harsh light of the late afternoon sun and set against dense, airless skies. The overall warmth of color, classical composition, opacity of paint surface, solidity of shadows, and Claudian skies suggest a city on the Arno rather than the Naugatuck.

A typical early urban view, *Morning, Washington Avenue* (pages 26-27), uses simplified mass and tone in a contemporary version of a classical composition. The eye is led from a foreground framing device down through a series of receding planes to the central point of interest, which is in full illumination in the center of the middle distance. Yet there is a contradiction here: Everything in the painting is described with the same sharp focus; there is no blurring of the near or the far, so the scene seems to lack a strong focal point. This consistency of focus also works against the sense of deep space imparted by the Renaissance perspective. The drama of the dark shadows and high wall to the right, the histrionic ray of light across the empty street, and the impenetrable, sulfurous sky suggest the surreal theatricality of a De Chirico.

The later Waterbury paintings still approach their subjects with sympathy and appreciation, but there is a more thoughtful, studied consideration of the overall composition. These works are antiromantic in their cooler, richer, more precise transparent rendering and tight, planar, abstract organization of positive and negative shapes and space. The harsh summer light now rakes and illuminates facades, the glare bouncing into shadows and burning a multitude of half-lights and half-darks.

A comparison of the two views of Borelli's restaurant illustrates the shift in Peter's approach to design. The earlier work (page 32) is a traditional composition, a soft, dreamy, evocative portrait of a building. The slow vertical march of the elements of the building is emphasized by the balance of the open negative space of the sky and the static, stable nature of the square canvas. The later version (page 33) was painted at the same time Peter was exploring the close-up, frontal views of Emily's windows. Here, the building is no longer an object depicted in space but has become fully integrated into the picture plane. The subject of the painting is not a building bathed in light but the effect of the light on the building. The sky is no longer used as a perspective device to locate the building in space; its importance now is as shape and color, an element of design.

Another change in Peter's perception occurred when he glimpsed the city from the top of a parking garage. He was struck both by the beauty and diversity of the tops of the buildings and by the complexity of angle from a point above the street. This shift in viewpoint, as well as his antiromantic sensibility, a lighter, more transparent palette, and a more intense perception of the effect of light, distinguishes the later Waterbury works.

MORNING, WASHINGTON AVENUE

Oil on canvas. 28″ × 24″ (71.1 cm × 61.0 cm).
Collection of Mr. and Mrs. Hubert T. Mandeville.

This view of the city is seen from the street opposite my parents' house in Waterbury, Connecticut. It is an early morning in July; the buildings on the eastern hill are veiled in mist; only St. Anne's Church is truly discernible as it straddles the chimney of a house in the middle distance. This is not the inner city, although the neighborhood has changed dramatically toward the urban since my grandparents first moved here. As a child, I remember helping pick corn, apples, and peaches that grew in nearby fields. My first studio was in the loft of a small horse barn at the back corner of our property. Today this view is somewhat the same: a few trees are gone; the house at the lower corner of the street is re-sided with the modern equivalent of asphalt shingles; the red tile roof on the Italianate house in the far distance has been replaced, leaving the scene a little more sterile and anemic.

I visit Waterbury frequently, not only because of the natural attachment to the place I grew up, but also because my parents still live there. There were also, however, two very practical reasons for my returning there to paint. One is the numerous architectural forms in the city—their definite planes and strong color were easier to understand and interpret in the new medium of oil paint than the softer, more amorphous look of the countryside. The other is that Waterbury's urban landscape provided me a new experience to learn from, so I painted the city at various times of day and under various lighting conditions for the same reason I would paint a series of panoramas or dawns to vary the theme of rural architecture.

This early painting parallels the first rural landscapes that I did in oils. In general, the paint is handled quite thickly, with little sign of the ground color in the sky, although it makes itself known in areas of the shadowed street, wall, and some of the houses.

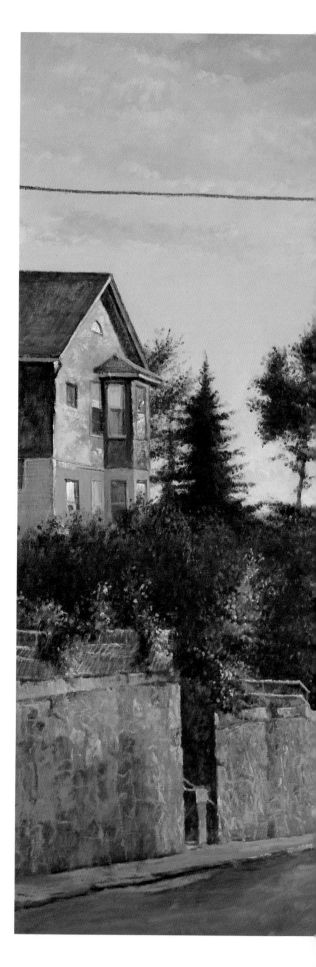

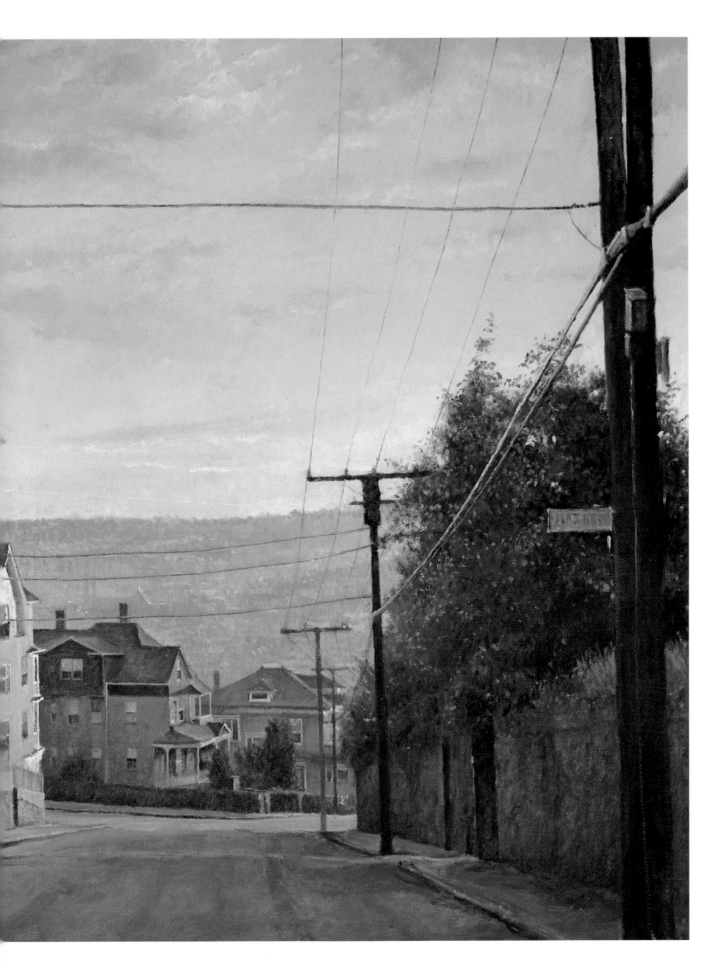

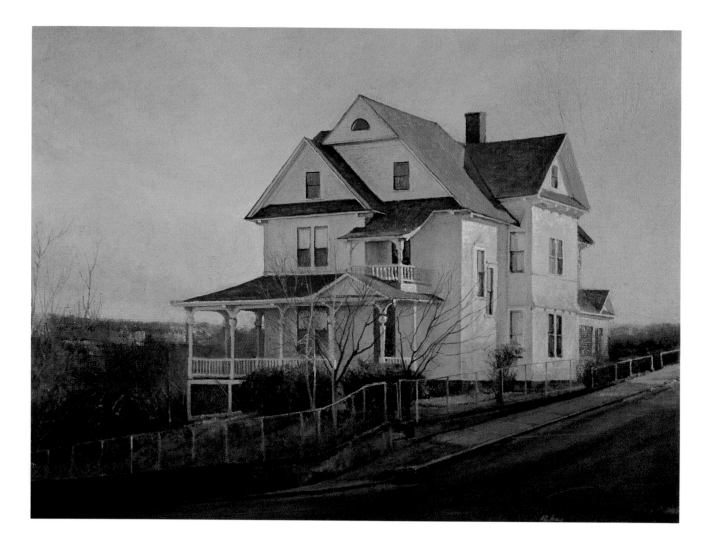

WINTER AFTERNOON

Oil on canvas. 15½" × 20" (39.4 cm × 50.8 cm). Private collection.

This is part of the neighborhood on Waterbury's west side where I grew up and, as a child, walked to school each day. It is a late afternoon in early March; even though there is no sign of snow, the winds are quite brisk, the air still severe.

My approach to such early works was to distill the image of the city into a romantic ideal. I did this by isolating architectural elements, simplifying compositions, and eliminating details. The weeding out of adjacent architectural subjects was my biggest problem in painting the city's streets. In this particular situation, my solution was to eliminate structures close to the white house, but not before I had tried to work out alternatives that included incorporating the adjacent buildings. However, it just seemed that these echoes of the white house's rectangular form were more confusing than unifying; even when I cast them into deep shadow, they still seemed to lack substance and authenticity. During the painting process, I eliminated one large house on the left and two overlapping buildings on the right. The end result is dramatically lit; attention is focused on the complex patterning of the roof planes. I also played down the light and detail of the sidewalk and road, which gave a subtle yet pronounced importance to the rectangular elements of the house itself and their echoes in the porch posts and window shapes. Even in the far hills there is the suggestion of a strong architectural element in the city. The emphasis here is on the contrast of the light and dark areas of the house combined with the interplay of its richly colored roof planes.

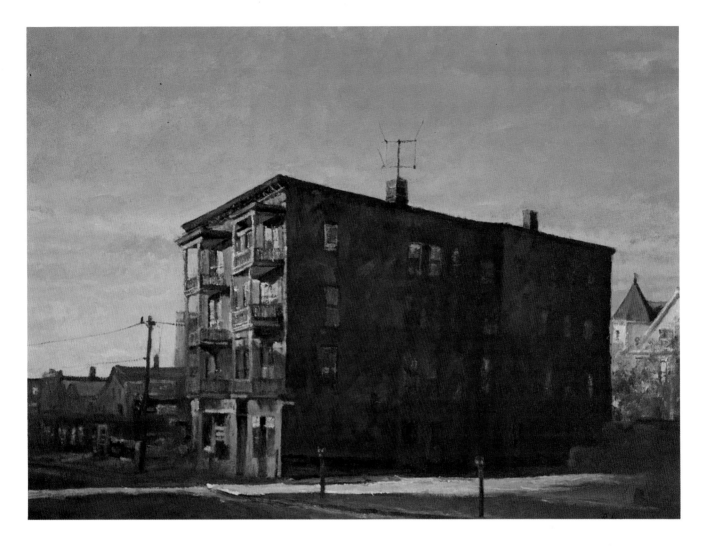

EAST MAIN STREET AND WELTON

Oil on canvas. 15" × 20½" (38.1 cm × 52.1 cm). Collection of Dr. and Mrs. Kristaps J. Keggi.

This building is one of my favorite sites in Waterbury. It was painted around the same time as *Winter Afternoon* (opposite page), in a similar light, about the same time of day, and with a similar sensibility. As in *Winter Afternoon*, there is a single structure jutting into the sky; in this case, it is a more massive building with a darkened side solidifying into a form that intrudes into the sky.

In *Winter Afternoon*, the painting process had to do with eliminating various compositional elements in the picture. In this case, the process is more one of distillation and simplification of what is actually there. Adjacent architectural forms are generalized, grouped, and subdued into a larger whole. A massed shadow with a few nonobtrusive, telling details, such as a window with its dim neon sign, hints at more complex forms; we hardly see these forms as individual buildings. The well-lit, more detailed yellow house to the right of the red building illustrates a variation on this theme. Its form, with its high-keyed color, tends to merge with the lighter tonalities of the sky, and the soft foliage of a tree further diffuses its impact, accentuating the darkened edge of the tenement. Within the shadowed mass of the main building, windows and their respective reflections are played down, reinforcing the sense of mass. Because of the dense quality of the tenement and its shadowed foreground, the shaft of strong light raking across the street into the parking lot is necessary to break the darkness, not only for compositional purposes but to establish a sense of space in the foreground.

HOUSE BY THE OVERPASS

Oil on canvas. 12½" × 27½" (31.75 cm × 69.9 cm).
Private collection.

House by the Overpass is much more of a statement in light and form than is *Lower Baldwin Street* (below). The paint quality is still quite heavy and textured overall, but relative differences are now asserting themselves: a quieter, less textured, slightly more atmospheric sky and the use of softer and harder edges. The space, although seen more directly front-on, is deeper, and the sky is broken into more assertively and plays a more distinct part in the overall design. The house, although essentially still a facade, has more density and sense of place than do the buildings of *Lower Baldwin Street*.

Originally, this painting was a square that included a curve of highway, guardrails, and painted lines rushing under the overpass, my thought being to use a linear element to counterpoint the vertical and horizontal rigors above. What actually happened was confusion and a lessening of the impact of the architectural element, which was the reason for this painting in the first place.

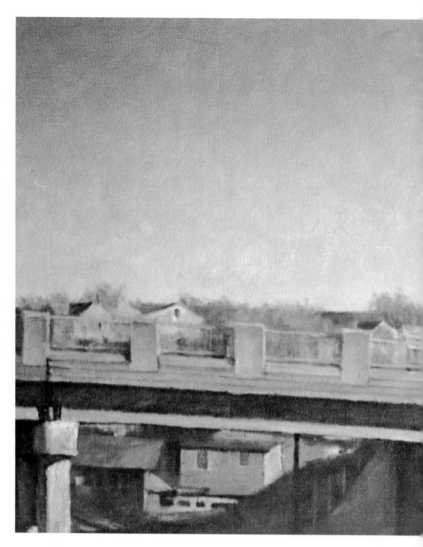

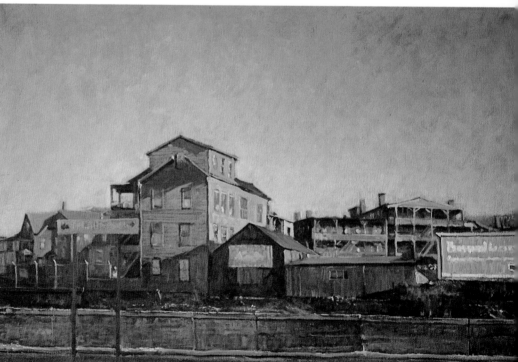

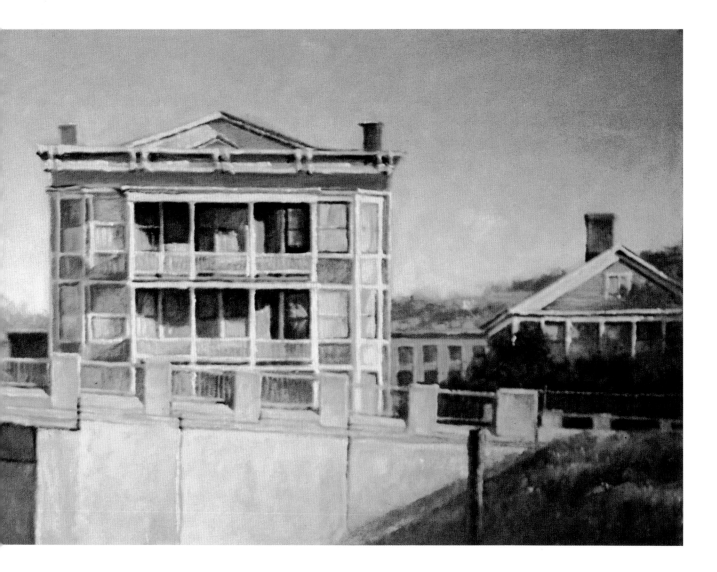

LOWER BALDWIN STREET

Oil on canvas. 20" × 29½" (50.8 cm × 74.9 cm).
Private collection.

A massing of individual structures into a city facade characterizes this view of the inner city. The lighting here is that of late fall, although this painting isn't as time- or weather-specific as some of my city themes. A more intimate back view is used here, but the painting exists primarily as an abstract cadence of forms and not as a statement of particular structures. Signs and billboards are also seen abstractly, as shapes or pieces of light and color; their message isn't clear, nor does it matter. Even the foreground road sign has an indistinct directional arrow, let alone an accompanying statement of location. There is an overall textured quality to the paint here, with a pronounced edge, as the strokes in the sky indicate; *Lower Baldwin Street* is an attempt at surface organization rather than an identification of a particular setting or place.

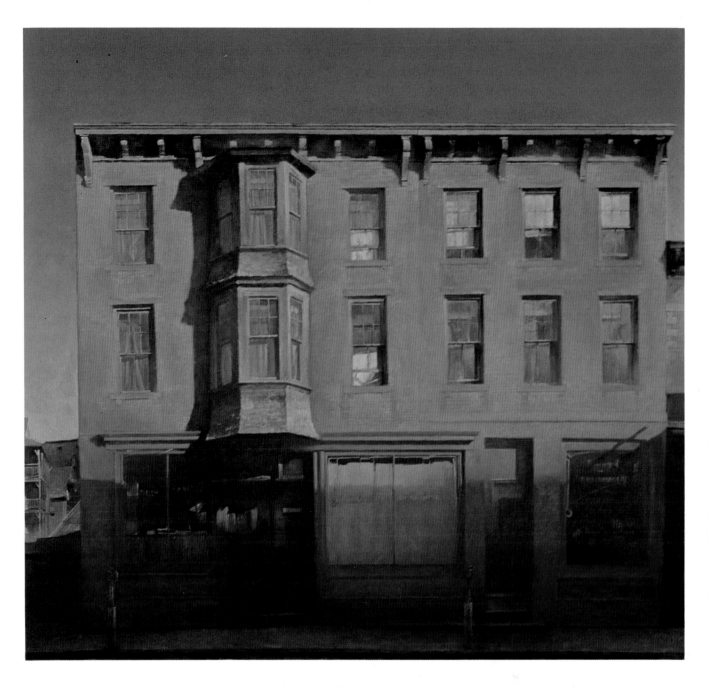

BORRELLI'S RESTAURANT

Oil on canvas. 30" × 34" (76.2 cm × 86.4 cm). Collection of Mr. and Mrs. Kenneth Hammitt.

Borrelli's Restaurant is seen here in the strong mid-morning light of October. The building is temporarily obscured by a nearby factory's shadow, which is gradually giving up its hold to a climbing sun. I can remember being absolutely stunned by the impact of light hitting the red painted bricks, and with this romantic vision etched in my mind, I went on to paint it. In keeping with this idea, I decided to heighten the red even further while exaggerating the blue of the sky and the darks of the shadows to force the radiant of glow light even more.

Like most of my compositions, *Borrelli's Restaurant* is based on the interplay and relationship of various rectangles, from the obvious regimentation of the upper-story windows to the variation in size and content of those in the storefronts to the window-like hollows found in the back porches of the tenement on the left. Because of the central focus on the building, I felt the need to throw things off a bit more than the green bay windows did on their own, so I added more sky to the left side of the painting. This created a sectioning of vertical shapes consisting of the bay, the corner of bricks and windows to the balcony's left, and the shaft of blue sky to balance the building's weight and volume.

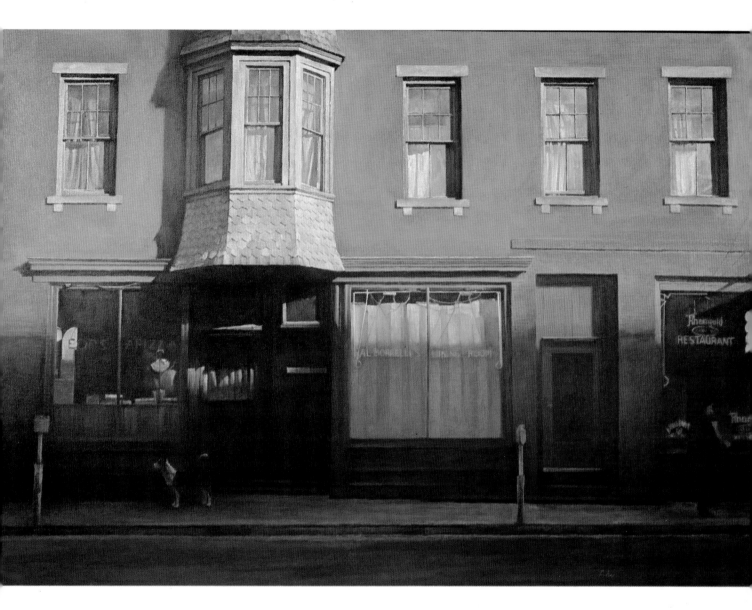

BORRELLI'S

Oil on canvas. 30" × 44" (76.2 cm × 111.8 cm). Private collection.

This work, although of the same building in similar light, was painted years later; it illustrates some of the changes that have occurred in my paintings. One difference is that the shadows reveal more of the specifics within them, which provides more of a balance between lit and non-lit areas. The overall quality of the light, now more penetrating, is cooler and seems harsher with the romantic veil of softness diminished. Things are more identifiable but less personal. The additions of a person and an animal only serve to reinforce this, as both look sideways in opposing directions, making no contact with the observer. Design is more measured now, and rectangles are seen as more abstract, not just as architectural elements of the building's structure. Notice the distinct relationship here between the lower part of the bay and the curtained window of the storefront, and how they relate in shape and tonal range compared to their more subdued architectural relationship in *Borrelli's Restaurant* (opposite page).

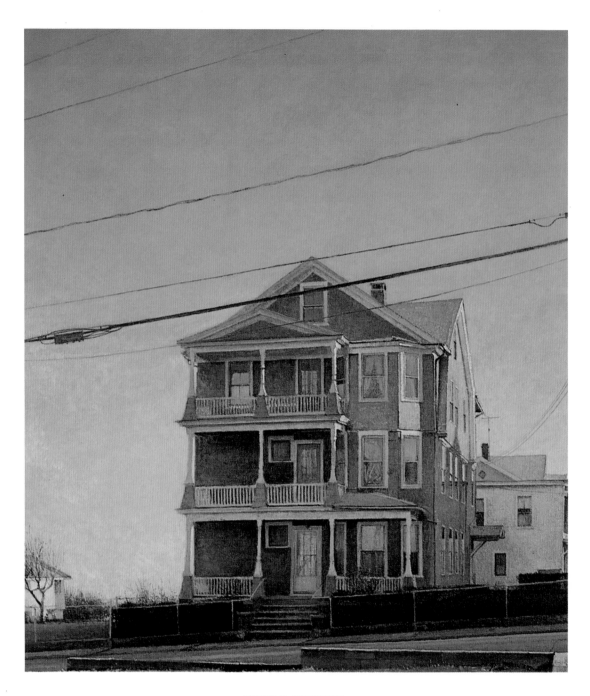

TRIPLE DECKER

Oil on canvas. 24″ × 20½″ (61.0 cm × 52.1 cm). Courtesy Sherry French Gallery.

This house, located on a nearby street, could be glimpsed while looking out the back second-story windows of my parents' house. What piqued my curiosity was the late afternoon sun hitting the turquoise bases of the porch posts. What I found after a short walk was this house, with all its rectangular variations—windows, bays, porches—clothed in a somewhat drab color made wonderful in the clear March light.

The theme of an architectural form encroaching on the sky is a familiar one for me; it is apparent in such paintings as *Winter Afternoon* (page 28), *House by the Overpass* (pages 30–31), and *East Main Street and Welton* (page 29). I was taken by how this house seems to grow, one step at a time, from porch roof to porch roof until it is topped by twin pediments. The repetition of the window shapes and their varied surfaces also appealed to me and gives a rhythm and unity to the overall design. There is also a wonderful variation of lateral accents found here, growing upward from the wall in the foreground to the road, steps, and porch floors and ending with the power lines themselves stretched across the sky.

The paint quality and light are not those of the earlier romantic works, even though they were painted in the same area; *Triple Decker* has the clearer, cooler, more descriptive look of the later paintings.

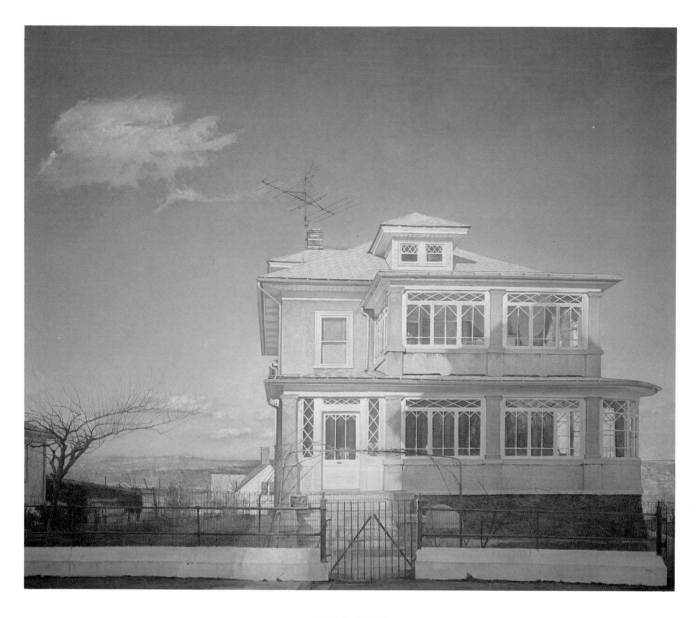

THE BOWER

Oil on canvas. 44" × 48" (111.8 cm × 121.9 cm). Private collection.

There were two Italianate stucco houses in my immediate neighborhood; this one has the eastern hills of the city strung out behind it. I had been walking this area of my old neighborhood for several months, observing the changing season and variable light, when this subject presented itself to me one late March afternoon. Since the skies of the earlier winter season had either been cloudless or choked with gray in the afternoons, I waited until the scudding puffs you see here appeared, around the onset of early spring.

The Bower is a variation on the compositional theme of sky pierced by an architectural form, and it was the last single house that I painted in Waterbury. This house, which is shown almost completely front-on, is set to one side of the composition, and is balanced by the vast expanse of sky, the all-important puff of cloud, and the portion of garage and the tree behind it on the left edge of the canvas.

The paint quality and light concerns here place this picture among my later Waterbury works, which focus on the clarity of atmosphere as well as the way the light penetrates and illuminates the shadow areas. Objects transcend from light into dark without losing their identity to a generalized, more romanticized shadow. The same applies to the peaked shadow of the house cast from across the street as it falls on, but does not obscure, the architectural details of the main subject. I was also interested here in the reflective surfaces found on these wonderful glassed-in porches; those on the first floor are seen into and through, while those on the upper story reflect the sky and the rooftops of the house across the street.

A comparison with the earlier *Winter Afternoon* (page 28), which depicts a house that sits just two doors away from this one, clearly illustrates the difference in thinking and approach between the early and late works done in Waterbury.

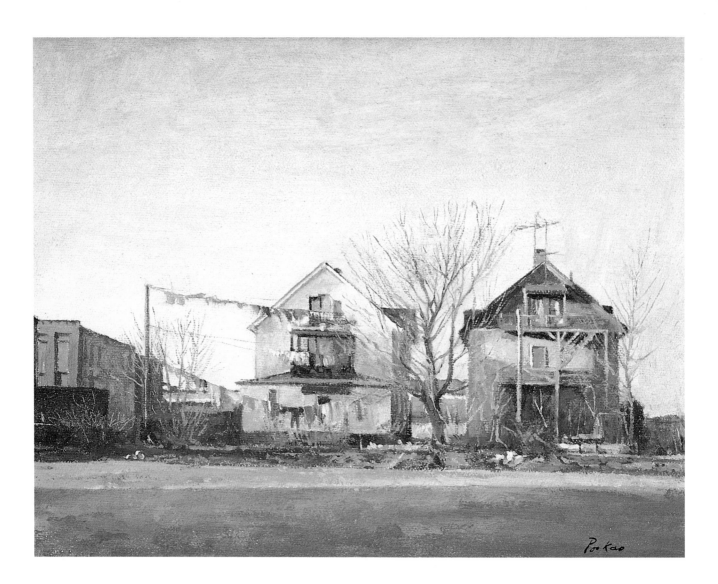

MONDAY IN MARCH

Oil on canvas. 8″ × 10½″ (20.3 cm × 26.7 cm). Collection of Hedda Windisch von Goeben.

This study, of sister houses found at the back edge of a parking lot in downtown Waterbury, shows the looser, sketchy approach I use for smaller works on which my larger paintings are based. As these are done directly on white canvas with no colored ground, there is a higher-keyed, cooler coloration to them. While there is no real attempt at blending or modulating transitions, color distinctions are nonetheless apparent, as seen in the warmer tones of the tree branches as they advance upward into the sun. Details such as branches are done just by scratching out color with a correspondingly sized finish nail (using the point for fine branches, the head for larger trunks).

In the studies, color is applied in a more general way. The patch of rubble on the edge of the asphalt, for example, has been rubbed out with the stub of an old bristle brush, leaving residues of more transparent, brighter color; these are further accented by opaque dabs of paint or nail scratches. Larger gradients of color and light are intently noted, if not carefully executed: The relatively dark, cool blue of the upper sky becomes lighter and yellower near the left horizon and pinker toward the right; the shaft of light in the foreground area is darker and cooler on the left, with touches of rusty red in the middle and a lighter, opaque, pinkish tone on the right.

Although these studies are sketchier and generally worked more loosely, they are the road map of color/light transitions that I follow when painting the larger works. In the larger paintings, the detailing of forms—whether house, tree, or stretches of pavement—can always be enhanced, but the studies must be there to serve as their foundation.

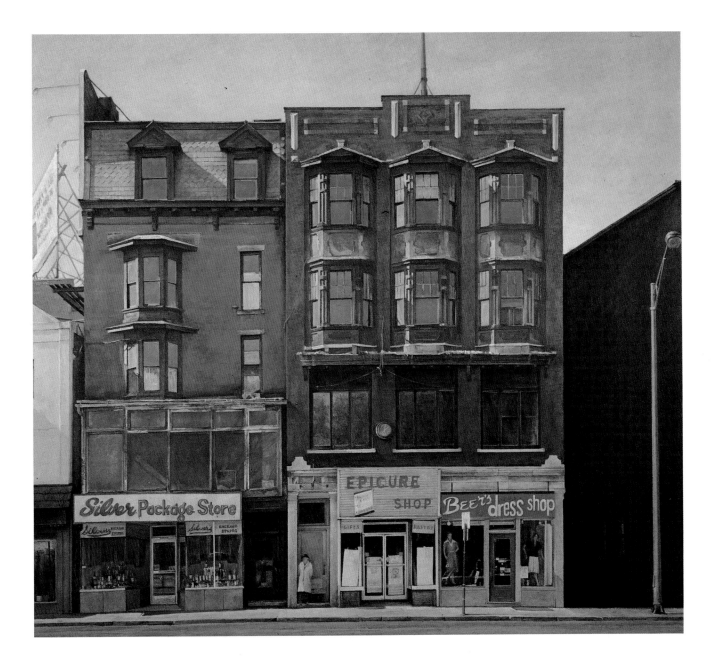

BUS STOP

Oil on canvas. 50" × 48" (127.0 cm × 121.92 cm). Collection of Mr. and Mrs. R.P. Hewitt.

Bus Stop was one of my first Waterbury paintings after *Borrelli's* (page 33). It continues the theme of a facade, but here the focus is more on an integrated design and an even more penetrating light. The sky, caught between angles of different buildings, is now broken into more varied shapes and further integrated into the composition by the superstructure of billboards and flagpole. In keeping with the overall design, the sky remains flat, with little emphasis on gradations of color. The deeply shadowed, relatively uneventful side of a building to the right provides relief from the busy repetition of rectangular window forms. I also repositioned a nearby streetlight to reassert the frontal plane of the picture.

At the time of this painting, I was just finishing my window series at Emily's (see pages 56–65), as my attention to the reflec-tive nature of much of the glass suggests. In this case, I also decided to be very explicit about the contents of the lower storefront windows; these areas serve as a counterpoint to the blankness of the upper stories and are in keeping with my new approach of seeing into shadows. The signs here are also more specific and readable, as opposed to the ones found in the earlier *Lower Baldwin Street* (page 30).

This new emphasis on overall surface didn't mean an indiscriminate or slavish approach to detail; if anything, the complexity of objects in this painting makes editorial judgements as to tone and color all the more critical for keeping spatial clarity and atmospheric presence. To incorporate all of these specifics and have them read as part of the larger forms existing in space and light is no easy task.

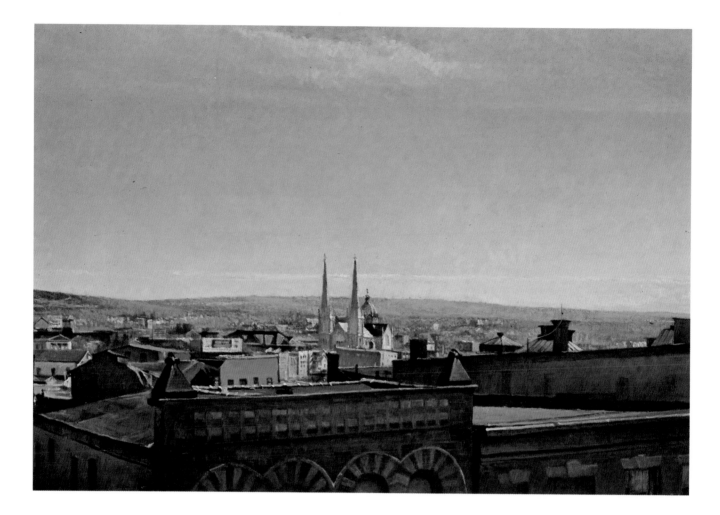

SOUTH WATERBURY

Oil on canvas. 25" × 35" (63.5 cm × 88.9 cm). Collection of Dr. and Mrs. Kristaps J. Keggi.

The ramp garage in downtown Waterbury provided me with a convenient location to work from and made a panoramic view of the inner city easily accessible. This later Waterbury painting, which is more ambitious in scale than the earlier works, uses light to throw buildings into deep relief and thus varies considerably from the condensed panorama of *Lower Baldwin Street* (page 30). In *South Waterbury*, although individual buildings are easily made out and strongly lit, they are essentially surfaces of light and color existing in space rather than specific entities (with the exception of St. Anne's Church's spires breaking above the horizon line). The facades of the foreground, while suggestive of specific buildings, are placed there as dark elements to lend scale, depth, and contrast for the light of the sky and the middle distance. For example, the shaft of sunlit rust color on a foreground rooftop is important to the picture's balance and depth.

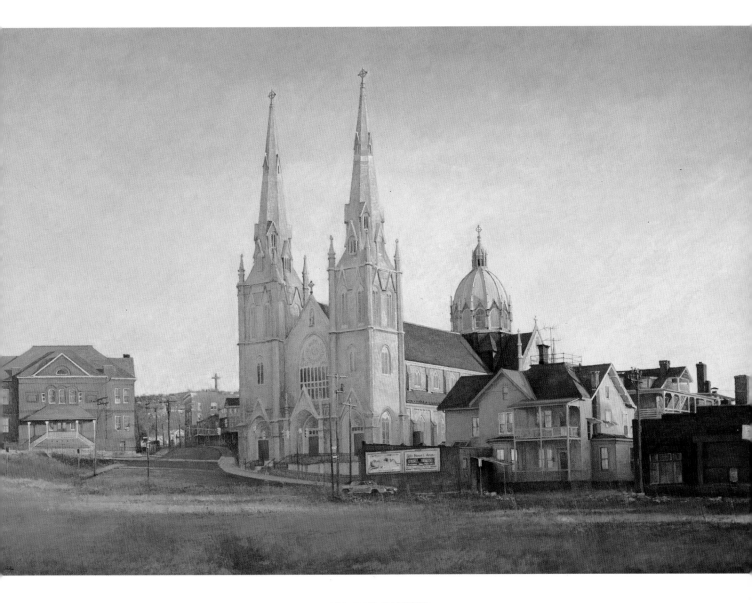

VANISHING PARISH

Oil on canvas. 35½" × 52" (90.2 cm × 132.1 cm). Collection of Dr. and Mrs. W. Scott Peterson.

Most of the views of the city that include St. Anne's Church were done from higher vantage points, but when a nearby city block was cleared to make way for new housing, I was able to work from street level. This picture, the last of the most recent paintings of Waterbury, takes the concerns of the earlier paintings and pushes them further. Here I am involved with an overall surface and presence, shadows that reveal their depths, and objects that retain their identity even in non-lighted areas. There is also an all-pervasive atmosphere of light. The paint handling reflects the consideration given to object identity and color and their transitions from light into dark.

The composition here is an unusual one for me: The tangential curve of the road, with its buildings all in perspective, is balanced by the smaller, concentrated form of the school on the left. There are also a number of subtle color relationships happening here: the variation and stretching of grassy yellows in the foreground; the bright spots of yellow in the middle ground, from the traffic lights to the yellow billboard to the sunlit section of the mustard-colored house; the inclusion of the white overhead sign on the right side of the canvas that leads the eye into the ascending cadence of chimneys, dome, and twin spires of the church; and the three maroon doors of St. Anne's that, along with the play of traffic lights, penetrate the vertically gesturing mass of the church and lead into the farther distance.

Though the painting is site-specific and has so many things to look at, it doesn't have the intimacy of the earlier, more personal romantic works.

CORNER LIGHT

*Oil on canvas. 31¼" × 47" (79.4 cm × 119.4 cm).
Collection of Mr. and Mrs. William McTiernan.*

Corner Light is an expansion and a clarification of the space, light, and atmosphere found in the earlier *Borrelli's* (page 33). Both are facades and are spatially organized in much the same way, but the suggestion of a tangible atmosphere is much more believable in *Corner Light*. This effect hinges on the interaction of many pieces making an overall statement rather than the more generalized, looser character of the earlier Waterbury works.

The composition of *Corner Light* is relatively simple, something like the letter "L" laid on its back. Superimposed on this design is the theme of punctuated space found in the variations of windows, curtained and clear, some seen into and some not, either reflecting the sky or impenetrably dark as they parade across the facade. I am particularly fond of the large vertical rectangle of sky, like a window itself caught and framed into smaller windows between porch posts and brick in the building on the left. There is also a curious juxtaposition of flatness and perspective in this painting, a reversal of the elements and scale found in *Vanishing Parish* (page 39); here, the frontal plane is dominant, the dimensional sense more like a sub theme or an accent in the overall design.

For all the detailed look of this painting, my approach here is more to imply yet at the same time very specifically suggest matter; for example, I painted the texture and color of the bricks but did not delineate each one. Central to this idea is to get the general color, tone, and texture correct, so that it conveys the surface and space, then authenticate it with a few well-placed, telling details. Of course, the degree of specificity depends on how much I want to play down or emphasize certain areas. This is a long, sometimes arduous process that requires stepping back a fair distance to better assess how newly painted passages can be assimilated into the whole. For example, I was very concerned about how far to push the reflective effects of the aluminum storefronts without confusing their spatial placement. A painting involves thousands of judgment calls such as this, all revolving around the needs of the specific object versus the framework of the design as it exists in light and space.

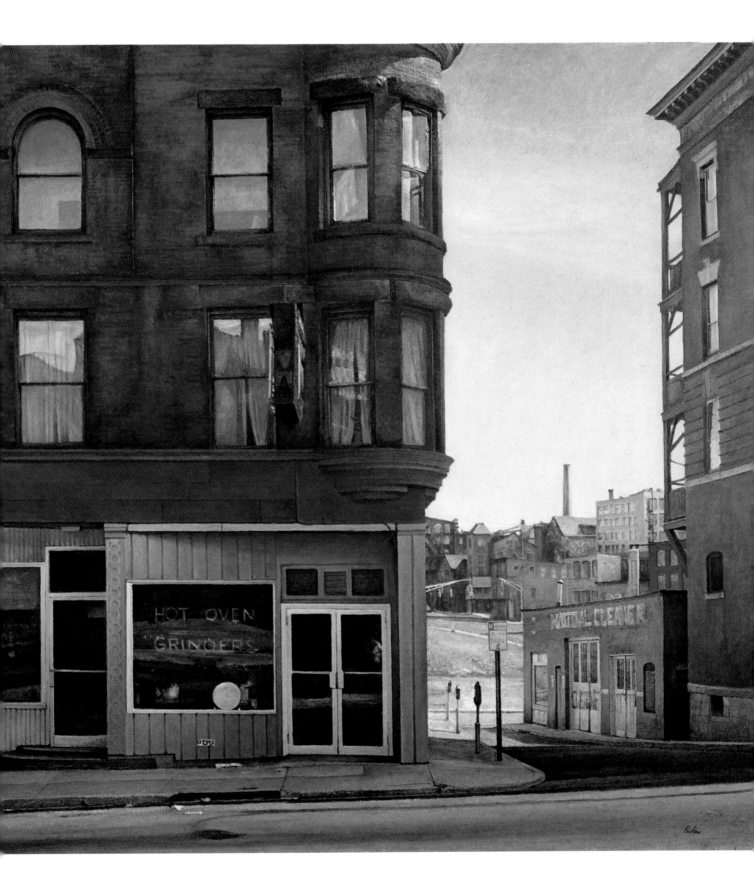

41

Emily's

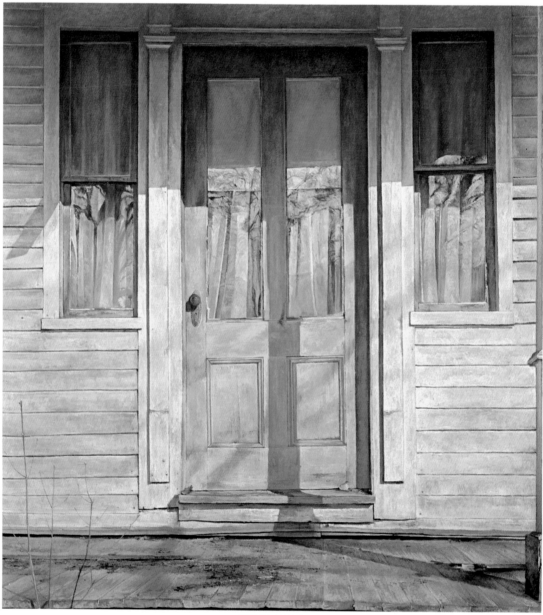

FRONT DOOR
oil on canvas, 52" × 46¼" (132 × 117.2 cm), Collection of Dr. and Mrs. Peter Pratt.

An intimate view of the landscape

In 1975, Peter began some sketches of a small farm at the end of his road that would serve as the subject of much of his work for the next seven years. The farm belonged to Emily Uranus, an elderly woman whom Peter came to know quite well in the few years before her death. Peter saw Emily as one of a vanishing species in Connecticut: a person who was self-reliant, who lived close to the land, and who knew and loved the rhythms and variety of nature.

Emily lived alone on the farm in much the same way her Lithuanian parents had when they bought it in the 1920s. There was no indoor plumbing or central heating. Emily got her water from a pump at the kitchen sink and bathed in a tin washtub. She heated the house and cooked on a big wood-burning stove, canning all her own fruits and vegetables and making her own butter and cheese. In the winter she hauled buckets from the springhouse to water the cows. Until recently, all the plowing and haying had been done with horses.

Gentle, shy, and modest, Emily was a warm-hearted and generous person. Peter remembers her as "the sort of person that if she had her last cracker, she'd give you half." Peter saw much of her persona reflected in her house and barns, in her small herd of cattle, and in her gardens.

The house was a stocky four-square structure; only the calm cadence of its un-adorned windows and the heavy cornice and return on its gables hinted at its original Greek Revival inspiration. Over the years, a variety of porches and en-closures, an ell, and a woodshed had been grafted onto this; through the forces of nature, each had developed a cant and character of its own. Neglect, coupled with a unique but practical sense of repairs, lent to the house a wealth of fascinating textures and details. In the side wall, where two clapboards had sprung loose, starlings had made a nest that Emily refused to disturb. The woodshed at the back of the ell, its doors long gone, looked like the black maw of some giant behemoth, devouring the hillside as it sagged into a parallelogram grin. Against this, the twisted posts and poles of a grape arbor clung and danced like some ghastly skeleton.

The house hadn't been painted in decades. Peter found the flaking, chalky surfaces of the clapboards to be the prefect foil for the reflection and refraction of light. To him, the clapboard sheathing—twisting, pulling, and splitting in response to the vagaries of each succeeding season—echoed Emily's heavy, cracked, and calloused hands, whose huge, blunt fingers seemed to trace the bail handles of all the buckets she had carried.

At Emily's, Peter explored five major types of subject matter in series, the vari-ations representing shifts in angle or changes in season, weather, or time of day. The first distant views of the north side were painted while Emily was alive. During the two years following her death, he painted the close-up frontal views of windows, views from inside the house, and frontal views of sections of the ell. Finally, after the house had been demolished, Peter returned to his countless sketches to produce middle-distance views of the woodshed and the rear of the house, as well as restate-ments of the early views of the north side.

Each series of paintings has a unique character in terms of style, composition, color, and light, reflecting the artist's maturing vision and evolving sensibilities and concerns. The changes that occurred can be clearly seen in a comparison of the early

Dawn, North Pasture (page 50) with *Sunburst, North Gates* (page 83), based on the same study but painted ten years later.

In *Dawn, North Pasture*, there is a greater concern for the particularities of detail, a sense of the didactic or narrative, which tends to undermine the cohesion of the painting. Like all the early works, this was painted on a rich sienna ground, which was allowed to show through to create tone. This tends to make the colors more intense, imparting an overall warmth to the painting. The paint was applied more loosely and opaquely than in the later work. The overall hot temperature, the equal weight given the color and tones, the empty sky, and the linear sense of detail all flatten the picture plane. This flatness, together with the weight and sharp focus of the fence in the foreground and its nearness to the bottom edge of the canvas, provides a sense of compression and unease.

In *Sunburst, North Gates*, Peter used a magenta ground under a more complex and transparent skein of colors whose sparkle and luminescence provide an almost tangible sense of the atmosphere and weather. He has also altered the composition by adding an empty area of snow to the foreground, extending the left-hand side of the painting slightly, and widening the distance between the fenceposts. Interestingly, although the fenceposts were made narrower, they are still the same height, thus adding to the sense of vastness and timelessness.

In the paintings of this period, Peter developed fully the design vocabulary that distinguishes his work. The most important themes are rectangles, echoing diagonals, and what he describes as "twinness," a pairing of similar objects.

Peter's art is one of mensuration, a progress of measurement, comparison, opposition, weight, solid and void, and positive and negative space. The rectangle plays a basic role in this operation, particularly in his middle-distance and close-up views. Against the steady rhythm of finely balanced rectangles are played echoing diagonals whose substance and angles are restated in different perspectives and voices across the canvas. Finally, twins—related pairs of usually vertical objects—invite comparison, provide a measured beat, and diffuse a single focus in the various roles they are made to play in the composition.

In *January Thaw, South Side* (page 59), twin tall windows accent the elegant cadence of similar shapes formed by the positive spaces of clapboards in between and adjacent to the edges. The window mullions echo the shapes, as do the electrical box and the shadows on the shades. The heavy horizontal shadow at the top anchors the window shapes and echoes the repeats of the clapboard wall.

The telephone wire that skitters across the clapboards provides a sense of relief as well as a suggestion of perspective; the long diagonal at the top is echoed in similar shadows across the clapboards, the wedge shape on the shade, and the positive and negative shapes of shadow versus snow at the bottom.

The twinness of the windows diffuses their centrality, inviting us to compare and contrast the similar elements within: the shades, the drapes, and the row of flowers. All these elements conspire to urge us to examine the whole surface of the canvas and appreciate the diversity of all its forms and textures as they are revealed by the raking light.

All of Peter's large works have one, and often two, versions that differ in scale, execution, and conception, for his art is one of evolution, of deliberation and refinement. While Peter refers to the smaller works as studies, almost all of them are complete and finished works that provide insight into the artist's creative process.

While he was working exclusively at Emily's, Peter would begin by making several finished and notational drawings and a one-hour plein-air oil sketch, usually about six inches in the largest dimension. Often weeks, or even years, would pass before he used this material for a large work. This accounts for some of the differences between the thumbnail sketches and the later renditions.

The thumbnails were painted on white canvas with no colored ground. The relative scale of the canvas weave, the speed and directness with which they were painted, and the thickness of the paint lend to these works a fluid, almost impressionist immediacy; the details are more implied than stated. These thumbnails were originally only intended for the artist's use in recording a scene and establishing the basic composition and color transitions.

The large study seldom closely resembles the final work, for radical changes often occur in composition, lighting, color transitions, and the addition or subtraction of detail. A comparison of the large study of *Kitchen Window* (page 58) and the final work reveals the radical changes that can occur within a set format to yield an entirely different painting.

The study is bright and cheerful, with sunlight raking the trim and clapboards, bouncing off the window still, and reflecting a warm glow into the shadows. The clapboard wall, sparkling in the full sunlight that is reflected in the window panes, enhances the effect of brilliant light while flattening the picture plane. The color and tone of the door and gutter negate the implied perspective of their diagonals to retain the flatness of the picture plane. Even the details of the hasp and lock serve this pur-

pose by subtly emphasizing the general horizontality of the elements.

In contrast, the final work (page 58, bottom) has evolved into one of mood and mystery suggested to Peter by a visit at a different time of day. The greater tonal contrasts and the change in the angle and intensity of the light imply deep space. To further this sensation, Peter has emphasized the diagonal elements, adding a small section of foreshortened clapboards to the right side of the composition. In doing so, he has made the window the central focus of the composition. By doing away with the hasp, substituting the empty void of the doorway for the door, subduing and softening the image reflected in the window panes, and softening the color and detail of the curtain, the artist has drawn us through the picture plane, piquing our curiosity about what lies behind.

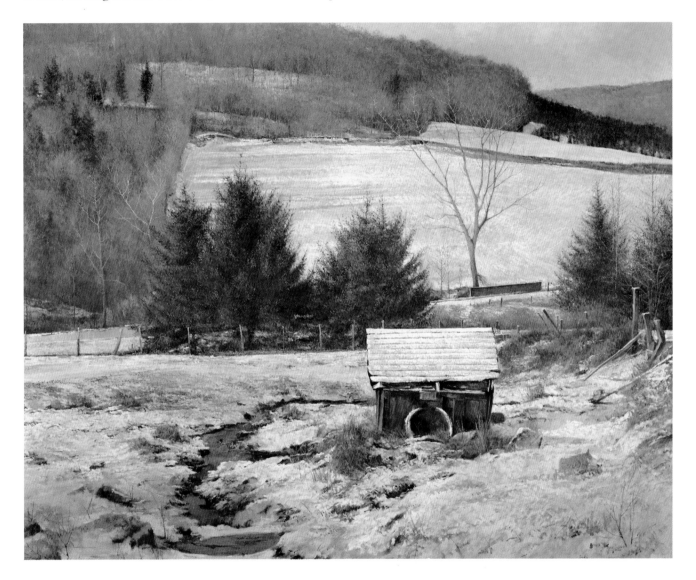

MORNING LIGHT, SPRING HOUSE

Oil on canvas. 38" × 44" (106.5 cm × 111.7 cm). Collection of Mr. and Mrs. Hubert T. Mandeville.

Emily Uranus's farm sits at the end of our road, and though I would pass by it almost every day after my family had moved to Washington, Connecticut, I still felt a reluctance to push my way into her life. It was a piece of good fortune that I was introduced to Emily at a neighbor's home; we instantly became friends. I was sketching at her farm the very next day.

This first large painting was done approximately six months later. As evidenced by the rich sienna ground and the agitated brushwork, it is a contemporary of some of the Waterbury paintings but not of the highly atmospheric, evenly handled later work.

With this new subject, I felt more comfortable working with the longer views of the pasture seen here in *Morning Light, Spring House*. In the ensuing series of Emily paintings, there would be a gradual journey inward, from the fields to the barns and finally an intimate look inside the house itself. Simultaneously, the architectural elements in these paintings would play an increasingly important role.

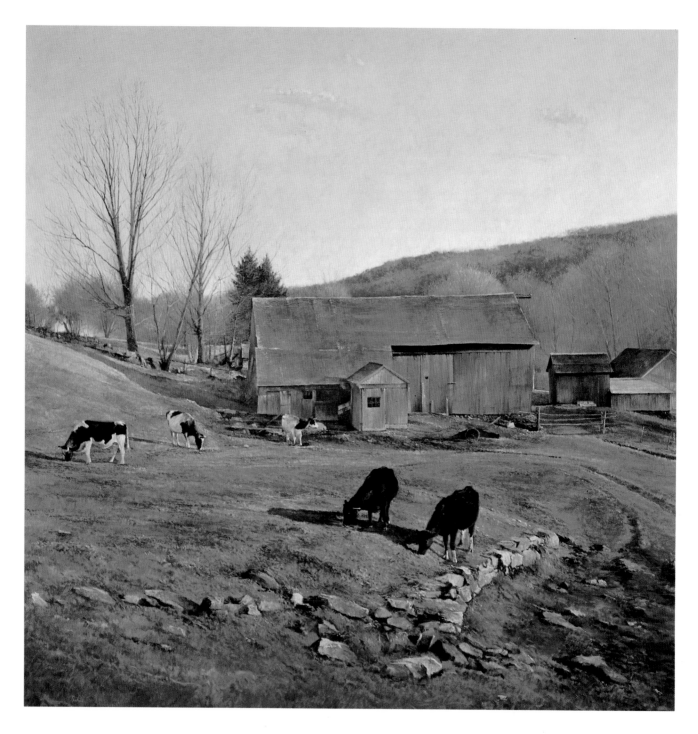

FIRST AIRING

Oil on canvas. 50" × 48" (127 cm × 121.9 cm). Collection of Orton P. Camp, Jr.

Emily has let the stock out for their afternoon drink at the springhouse. The grass in the moist lower pasture is beginning to green, so the animals are grazing on their way to the water. Although the house isn't visible in this particular view, the scene is still fairly encompassing: On the upper left is the apple orchard, which is directly above and behind the house; some of the smaller outbuildings at the orchard's edge can be glimpsed just behind the barn; the milk shed and the aged cow found in *Spring Sun* (page 48) are here, as well as the often painted north gate.

Here the foreground falls away abruptly because of the gully created by the freshets running down to the spring. I am sitting on the bank of the higher pasture overlooking the springhouse, which sits to the right and is out of view. The upper north pasture I am in is the location of *Spring, North Pasture* (opposite).

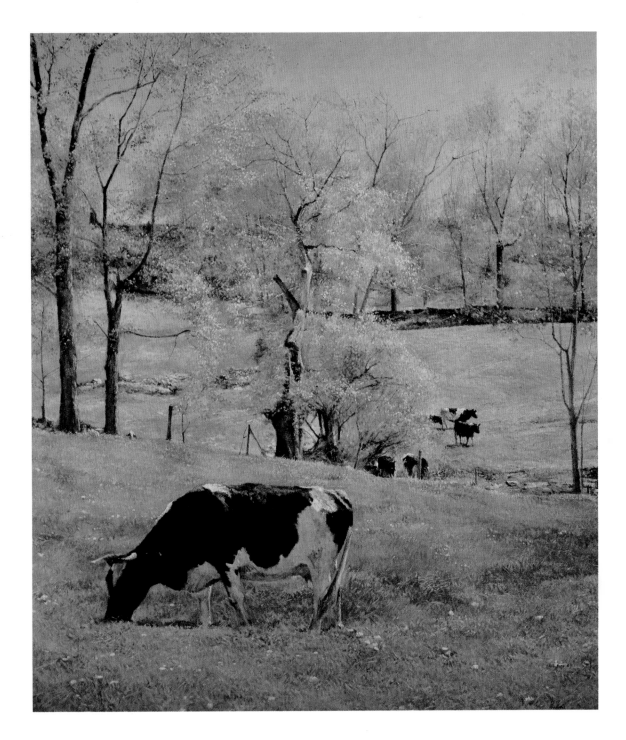

SPRING, NORTH PASTURE

Oil on canvas. 44″ × 34″ (111.7 cm × 86.3 cm). Private collection.

With the new fullness of the year's grass, Emily's small herd of cows was out for the season. They seemed to have rounds ranging from the upper pastures to the lower fields nearest the barns and were almost predictable in their wanderings. Here they are seen coming down the hillside, a few of them already stopping for a drink at one of the freshets that eventually runs to the spring house. The sun is quite high; it is late morning, and the new foliage almost glows with a tender translucency; a veteran apple tree, its gray deadwood glistening in the sun, still has its spare but wonderful bloom.

Spring, North Pasture is another very early painting done at Emily's; there are glimpses of the sienna ground color coming through the sky, in some of the tree trunks, and on areas of the animals' bodies. Most of it, however, has been covered by the abundance of brushwork simulating the textures of foliage and grass. It is revealing to see the progressive change in the handling of such textures in the later paintings, *Orchard's Edge* and *Early Morning, Old Orchard* (pages 52–53), where hay, grass, and leaves are a part of the surface plane and have a more unified spatial consistency.

One very important aspect in the development of the paintings at Emily's was an absorption in the life of the place. Hopefully, this state of mind is conveyed throughout my work as a key element in the precipitation of these paintings.

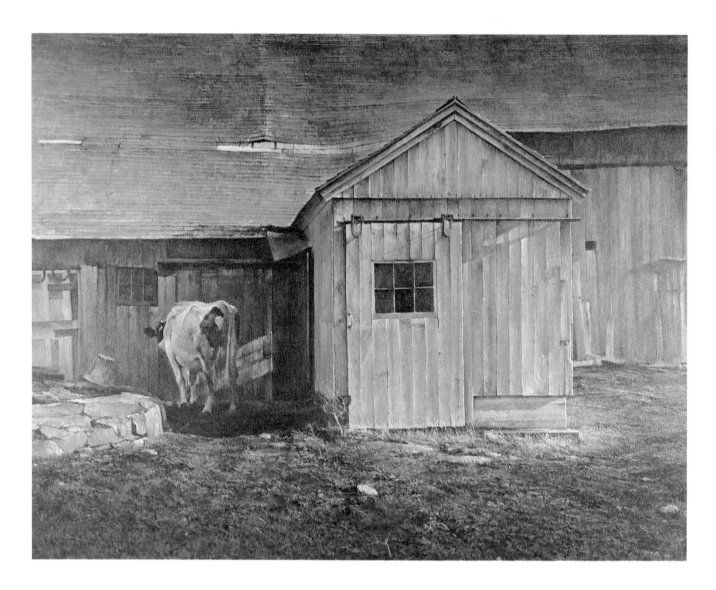

SPRING SUN

Oil on canvas. 40″ × 48″ (101.6 cm × 121.9 cm). Collection of Dr. and Mrs. Martin Wand.

Emily wasn't the most practical farmer; she grew attached to her animals, keeping them longer than was optimally productive. At most other farms, this aged cow waiting to be let into the barn to return to her newborn calf would have been culled long ago.

The transition to the more even, atmospheric light found in the later Waterbury paintings occurred as well in the Emily series. There was also a parallel development in the changing role of architecture, which began to be a major part of the overall design. The barn here is seen as a facade and emphasizes the importance of rectangular themes. The sense of light is very particular, created by a tactile, atmospheric sense of moisture-laden spring air and by the warm, higher-keyed reflected light of the brown and straw-colored paddock. The pinkish tones of the barn will be dramatically altered with the coming change of season and its light-absorbing predominance of green.

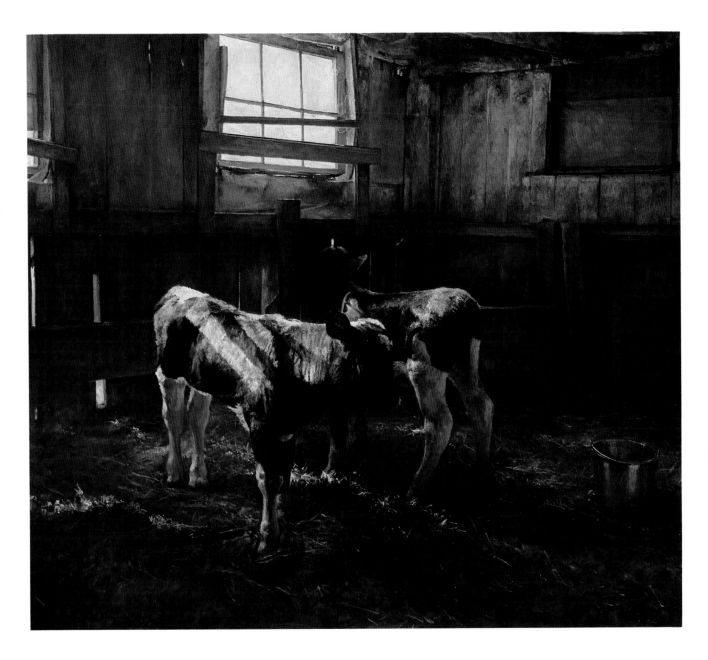

CALF PEN

Oil on canvas. 43" × 48" (109.2 cm × 121.9 cm). Collection of Dr. and Mrs. Peter Pratt.

It was such a treat, a contrast and a relief, to come into the barn on a late winter afternoon. I would immediately be aware of the change in temperature and instantly struck by the aroma and atmosphere of life. Emily would be there, feeding, milking, cleaning, surrounded by the heavy air and bathed in the day's late amber light. The place was full of sounds, too: chewing, clanging, bawling, the heavy breathing of large animals. Outside the door was white stillness.

While drawing the young bull, I became fascinated by his restless, fidgety nature and decided to do him twice, coming and going. Another calf was there also, but its patterning and demeanor didn't work; besides, there was something charged about the alertness and tension of the young bull's attitudes that shouldn't be diminished. Another reason for his double appearance is to diffuse interest across the canvas rather than make the animals a focal point; there is also an added spatial push generated by two overlapping forms.

A key question that I grappled with in this picture was how

inclusive to make the barn: How many windows should be put in? How much space and site detailing seemed right without lessening the impact of the animals? The rest was fine tuning and evolved as the painting went along; for example, the covered window on the left side had originally been a lighted slit going all the way to the top of the canvas. This proved too distracting an element, however, and called unwanted attention to that area. Painting in a burlap shade solved this problem; now focus moves down to the sunlit cracks between the boards leading to the calf. I also felt the stainless steel milk pail was necessary, as both a spatial reference and a muted focal point to the relatively vacant right side of the painting.

While the calf is important to this painting, the quality of light and air in the barn is equally important, if not more so. The hay gives a sense of textured density to the atmosphere of the barn. Later in the day, shafts of light streaking through the caked glass window and separated barn boards are enhanced by the magical mist of pollen and hay dust.

DAWN, NORTH PASTURE

Oil on canvas. 16½" × 20" (41.9 cm × 50.8 cm).
Private collection.

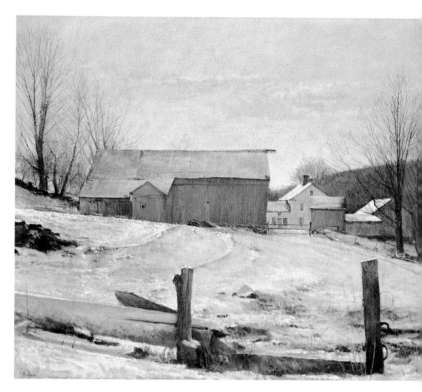

This view and variations on it occupied me through all the years of painting at Emily's. *Dawn, North Pasture* is one of the first paintings done at Emily's and takes a relatively low point of view, almost looking up at the farm buildings. The curving cattle paths made on endless trips to the spring for water are seen catching the early morning light. Old horseshoes, leftover from earlier ways of working now used to hold the slender bars of the gate, are nailed to the post on the right.

There is a pronounced warm cast to this painting, created most obviously by the sienna-colored ground but also by the quality of that particular day's light. The composition, although centered on the snow-covered field of the middle distance, still makes use of the rectilinear theme: The field creates a rectangle of negative space that echoes the positive shapes of the barns above it. There is also a repetition of parallel channels from the two fence posts in the foreground to the dual groupings of barns framing the house, ending with the large trees flanking either side of the canvas.

WINDFALL

Oil on canvas. 23" × 24" (58.4 cm × 61.0 cm). Collection of Mrs. Orton P. Camp.

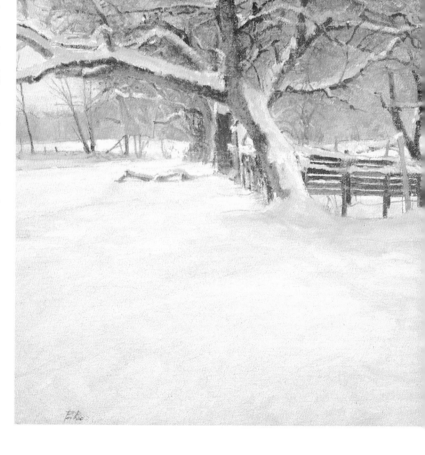

The apple trees in the northeast corner of Emily's orchard were the subject of a number of paintings. This one is of deep winter on a gray, pale morning with only a hint of warmth coming from a corner of the southern sky.

In time and style, *Windfall* is akin to the Waterbury paintings' *Morning in March* (page 36), as they are both site studies and are done directly on white canvas. The high positioning of the trees, their branches cut off by the edge of the picture plane, concentrates activity in the upper part of the canvas. Here, the angular shapes of darker, snow-capped trunks twist their way across a cloudlike bank of branches, the warmer-toned ones converging into the sprawling apple tree in the front corner of the orchard. This haphazard activity up top is contrasted with the relatively formal arrangement of the stock pen fence, which helps to define the snow-laden side of the tree trunk. The stepping back into deeper space is quietly asserted by the sequencing of the wind-felled limb, the tree line, a stone wall, a field of snow, and finally the far bank of trees at the horizon. The cool simplicity of the snow, with its muted shadows, contrasts and gives space to the subtle activity of the trees.

In muted paintings such as this, the more general and broader differences have to be kept uppermost in mind in order to retain spatial structure; the far masses are kept a textured gradient of cool violet gray against which the darker, cooler trees are played, reserving the modulated warm gray for the closest tree. The relative warmth of the yellowish sky becomes cooler as it comes forward.

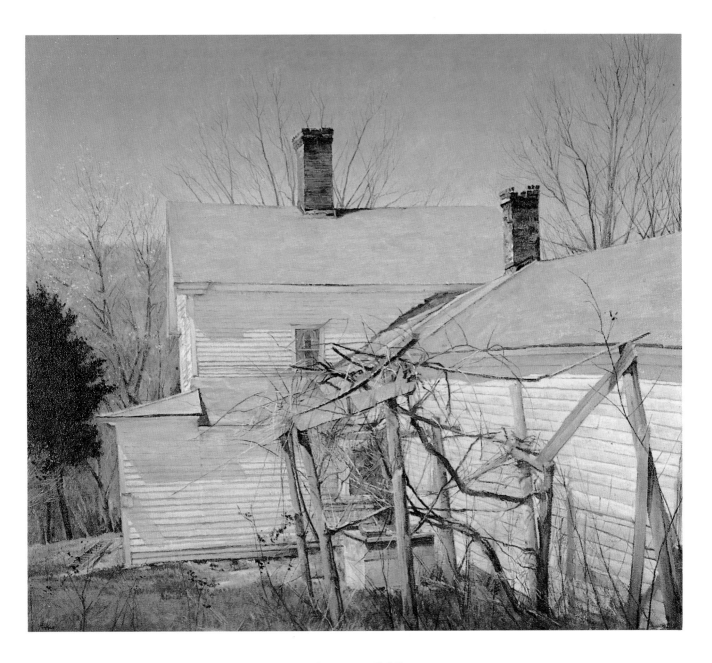

GRAPE ARBOR

Oil on canvas. 18" × 20" (45.7 cm × 50.8 cm). Collection of Mr. and Mrs. Joseph A. Goldstein.

Grape Arbor is a small early work that hints at the coming formal aspects of later, larger paintings and includes the seed of *Spring Patchwork* (page 67) and *East Light* (page 69).

Grape Arbor is keyed quite high for a relatively early picture, largely because it was painted directly on white canvas, but also because of the day's high, clear light. Although this painting has a sense of the penetrating light found in later works, there is more attention given to individual, specific details, which makes it lack the clear spatial impact and even surface of the more recent paintings.

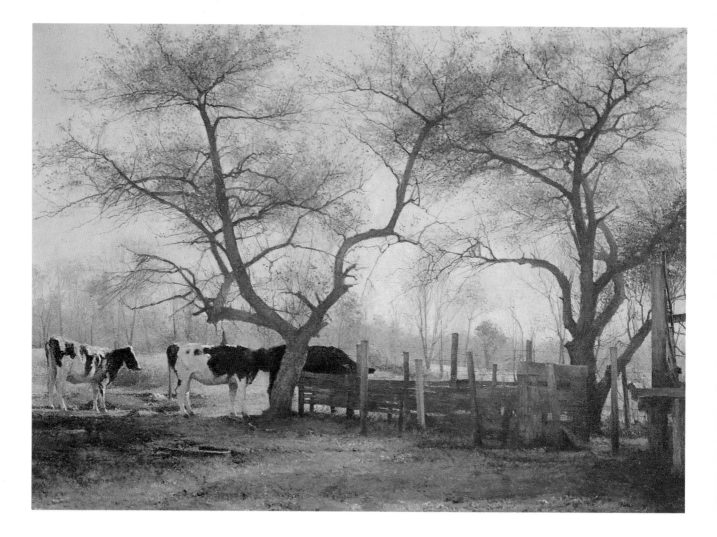

EARLY MORNING, OLD ORCHARD

Oil on canvas. 24¾" × 33" (62.9 cm × 83.8 cm). Collection of Vera and Gene Ehren.

The two apple trees function here as a spatial screen, a device that adds depth to a view united by atmosphere and mist. These trees are not a dense, dark silhouette but are more like a closer part of the air. Nor are they completely flat: their trunks turn and twist, catching cool reflected light from the sky, while a few take on a warmer glow, subtly suggesting their volume. They are united by their touching branches and by the similarly grayed boards of the stock pen below. The lateral direction of the pen is picked up by the cattle, ending on the left with a solo heifer. This lateral march of livestock and wood echoes the sloping edge of trees at the top of the far pastures.

At times, the particular light, feel, and atmosphere of a day are more the subject of the paintings than the objects portrayed. Here are several heifers foraging around the stock pens in Emily's orchard, but the painting is really more about an Indian summer morning: its stillness, moist softness, and distinct aroma of fall.

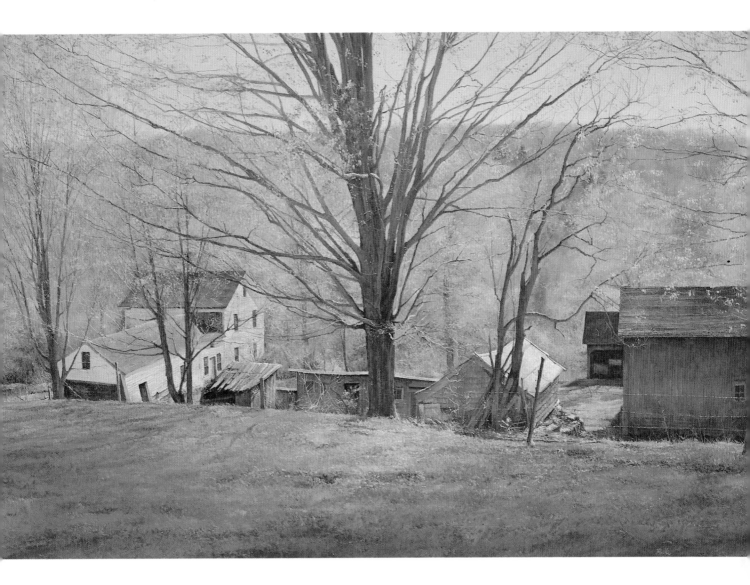

ORCHARD EDGE

Oil on canvas. 29" × 44" (73.7 cm × 111.8 cm). Collection of Mr. Patrick J. Waide, Jr.

There was a small, flat area of pasture situated on a little rise directly behind the house and barns where the apple orchard was planted. Most of the surviving trees were located in the southern end, to the left of the house and not in the line of sight of this point of view.

Although painted in the late afternoon, instead of late morning, *Orchard Edge* deals with the same theme of light and time of year that is found in *Spring, North Pasture*. In *Orchard Edge*, the overlapping architectural forms also serve as a relief from the pervasive green. In addition, there is the muted atmosphere of the far hill seen behind the screen of new foliage. Texture is certainly a strong element here, but it is less consuming and is more a part of overall structure, as is evidenced by the cohesiveness of surface in the grassy foreground. The focus of relative warmth in the large maple tree is key to the spatial dynamics in this painting as much as its linear overlapping of the far distance.

In comparison to *Spring, North Pasture* (page 47), this painting's foreground area is relatively restrained, more suggestive, and focuses texture in limited areas. However, I can recall going overboard with the brush here while finishing this painting, only to scrub the surface back to the underpainting with turpentine. Then, having left the ghost of the direction in which I wanted it to go, I came back in with paint much more selectively, wiping much back out as I went along, until arriving at this final distillation.

EMILY'S GARDEN

Oil on canvas. 38" × 44" (106.5 cm × 111.7 cm).
Collection of Mr. and Mrs. Carlos Canal.

Emily's gardens were casual, secluded happenings tucked away in pieces like this one near one of the barns. They were by no means neglected; all the plants were well cared for and in the best of health. Instead of shouting at you, these beds held a sense of discovery, a treasure unsuspectingly come upon. They truly reflected her hand and herself.

These are still the lighter, fresher greens of early summer, full of life and promise. As in *Orchard Edge* (page 53), I felt the need, not only for relief from green, but also for the more formal contrast of architecture, to give further emphasis to the wonderful unplanned look of the gardens. Texture certainly abounds here, but it is selective in variation and makes considerable use of the burnt sienna ground beneath it. I was intrigued by the contrast of the edgy, sunlit mown grass with the more random foliage of plants, a green counterpart of the defined form of the barn, and by the softening of things distant and things close that gives impact to the crisper flower shapes of irises and poppies. There was a lot of blotting, rubbing, accenting, and redefining going on in this painting; it became almost a selective happening, as were Emily's gardens themselves. I did several paintings of her gardens that year, but summer is not my time, and I found myself making a turn to the more utilitarian world of the solidly architectural.

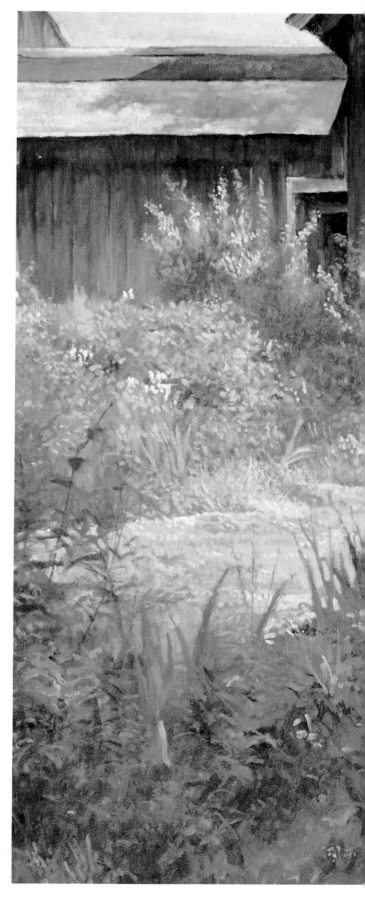

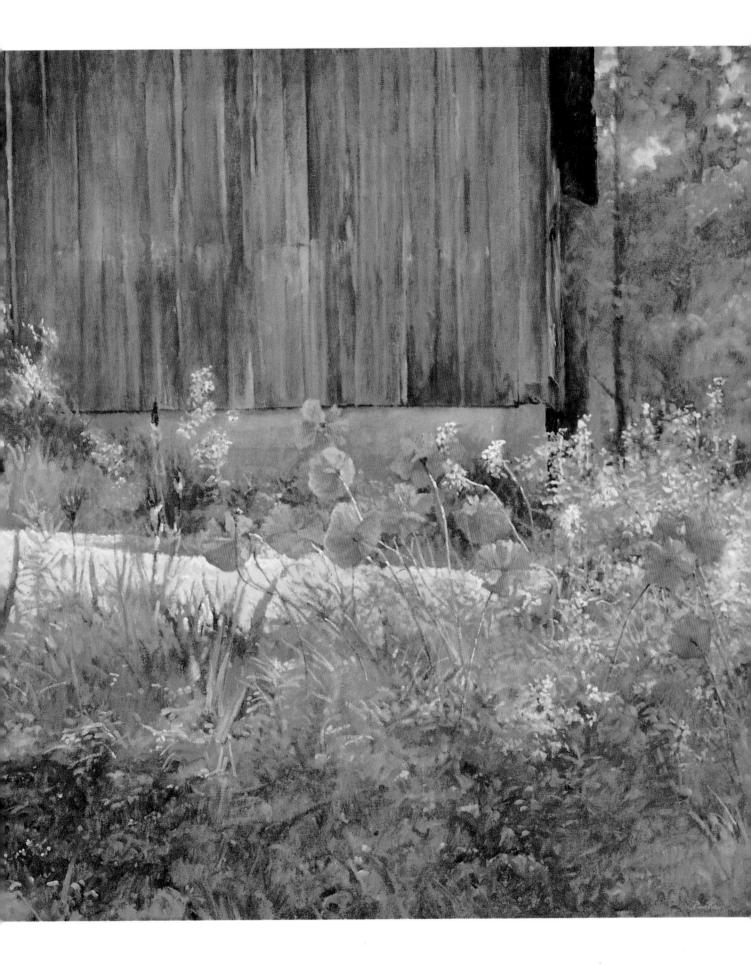

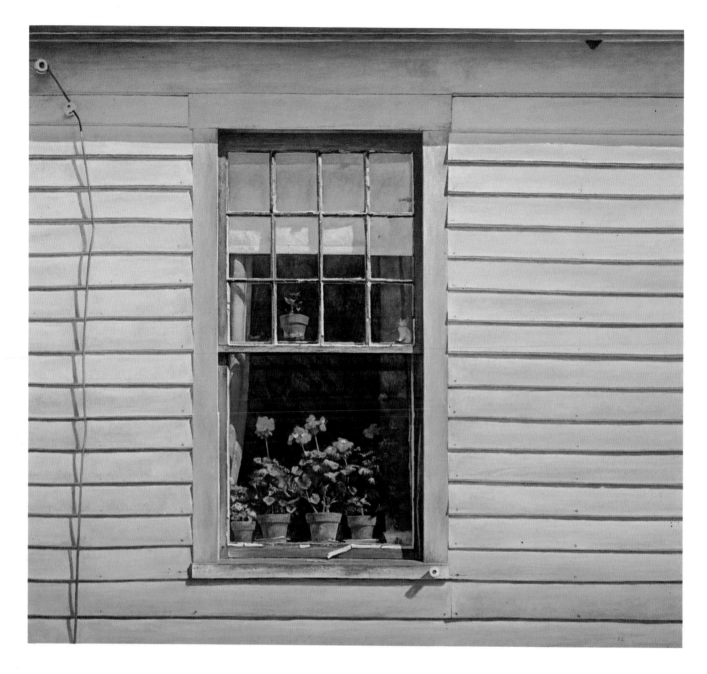

EASTER SUNDAY

Oil on canvas. 44" × 48" (111.7 cm × 121.9 cm). Collection of Mr. and Mrs. Elisha Dyer.

Emily's geraniums were almost a foot high, sprouting new green as well as the year's first crop of blooms. The south side of the kitchen was bathed in the high, clear light of early spring.

I wanted to keep the simplicity and strength of the vertical rectangle of the window, which is capped and integrated into the wall by the eave and its shadow. Set in the rhythmic facade of clapboards, the window is positioned slightly left of center; the telephone wire fractures the space on the left into two parts.

The burnt sienna ground is most evident in the light reflected on the dark windowpanes but is also seen coming through the faded green window frames and the curtains and, more subtly, in the shadows and lower edges of the clapboards.

This scene contains subtle, though very important, clues for showing form and space in flat facades. Because of the simplicity of the subject, I took great care to observe the variations

of light. The strong reflected light bouncing off last year's dry, dead grass makes the undersides of the clapboards lighter than their shadows. This variation in value is more apparent on the right side of the window than on the left side. I also paid careful attention to overall gradations of color and light. Reflecting the intensifying light, the clapboards become increasingly paler from bottom to top until the progression is broken by the eave's shadow. The highlights seen on the left side and bottom edges of the mullions and window frame indicate those areas where the warm, reflected light is hitting most directly.

In the final analysis, this painting, with its simple but rigorous definition of rectangles that parallel the picture plane, is more than an exercise in rhythms or rendering architectural surfaces. I was just as concerned here with place, light, weather, and time of year as I am when painting a "pure" landscape.

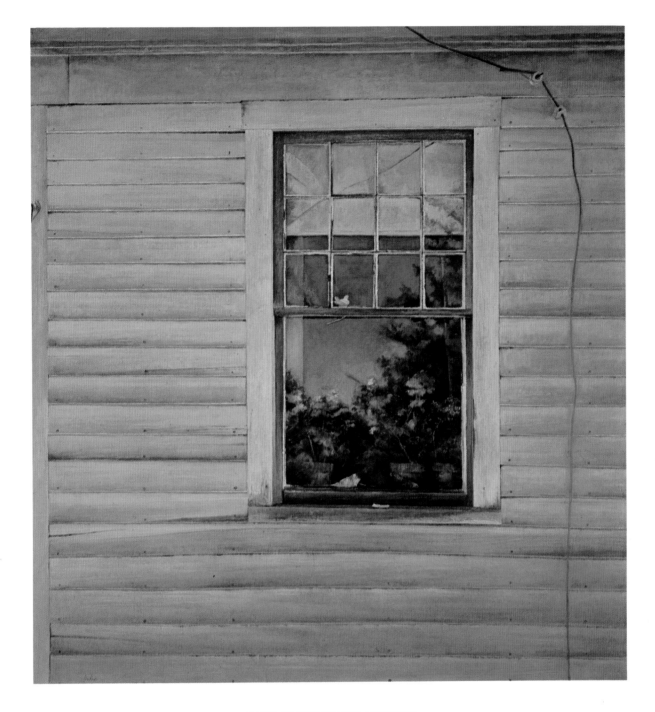

EMILY'S WINDOW, AUGUST

Oil on canvas. 40" × 36" (101.6 cm × 91.4 cm). Collection of Mr. and Mrs. H.H. Dickson McKenna.

This was the window adjacent to the one in *Easter Sunday*; the time was late summer. The geraniums had grown considerably since the spring; I suspect they might have been pinched back at least once.

There is a peculiar warmth in this painting. August was an exceptionally dry month, and the grass had turned from green to a high-keyed buff or straw color. This color, reflected from the ground onto the clapboards, produces a strange, ochre-sienna coloration. The effect was heightened further by the contrast of the blue summer sky reflected in the window, except for the direct sunlight striking the white material of my shirt and then reflected in the lower portion of the window. All reference to form is accomplished by the subtle variations in reflected light.

The wall reveals a gradation, not only of light to dark, but also of cool to warm. The coolness of the blue sky is present in the opaque color modulation of the higher clapboards, but it gives way to the warmer, deeper, transparent hues of the lower boards. This influence of contrasting color temperatures and values also appears on the upper and lower surfaces of the window mullions; cool, blue, opaque gray above (the sky influence) and warmer, transparent yellow gold below. The bottom edges of the clapboards fairly glow with this warm light.

I particularly like the two-dimensional reference to space in the contained sky-landscape reflected in the window—the idea of looking in and looking behind you at the same time; of reflection dissolving into plants, plants into sky—their overall liquid nature.

STUDY, KITCHEN WINDOW

Oil on canvas. 11¼" × 11" (28.6 cm × 27.9 cm).
Collection of Mrs. Peter Baumberger.

Study, Kitchen Window was painted earlier in the season and has a brighter, higher-keyed light than *Kitchen Window* (below). This study is about light and its diffusion taking precedence over form. Additionally, the fluid quality of paint affects this interpretation as much as the time of day and year. The window is now a part of a facade with little reference to depth through perspective. It also illustrates a change in my work at this time, a swing toward the penetration of light in shadowed areas. It is paralleled by a similar development found in the later paintings of Waterbury.

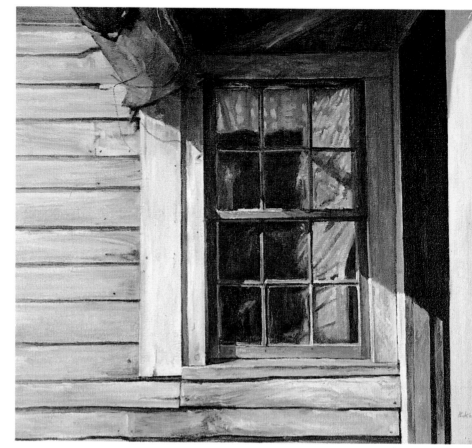

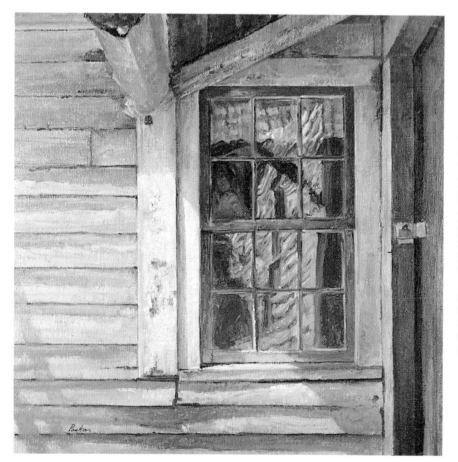

KITCHEN WINDOW

Oil on canvas. 16½" × 19" (41.9 cm × 48.3 cm).
Courtesy Sherry French Gallery.

The small kitchen window next to the south doorway is included in a number of larger works; in these, it is often a small, unnoticed detail, a part of a diverse composition. This window was the only source of light on the south side of the kitchen, but any direct sunlight was blocked by a tall screen of evergreens. Because of the lack of sunlight, I never painted this potentially wonderful interior, with its sink and brass-fitted hand pump; instead, I concentrated on the exterior versions.

The emphasis in this painting is on structure; the window is seen as part of the architectural element, as a stable and strong form. Even the element of light is seen as form, with its hard lines and abrupt transitions.

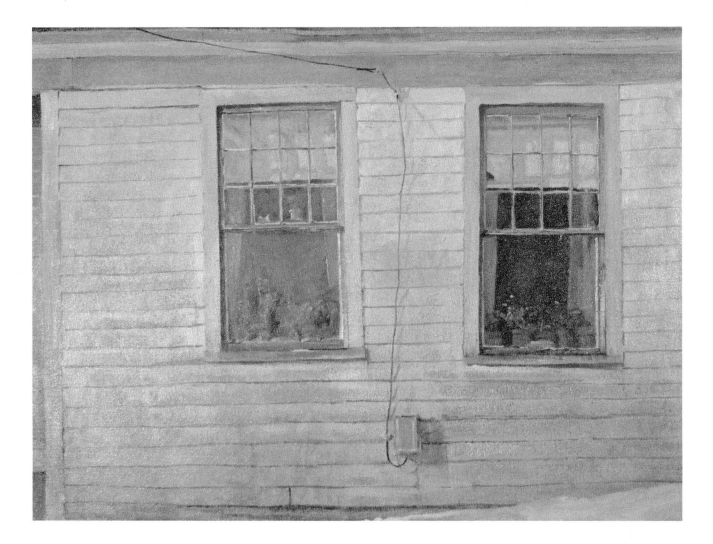

JANUARY THAW, SOUTH SIDE

Oil on canvas. 14" × 20" (35.5 cm × 50.8 cm). Collection of Mr. and Mrs. J.J. Smith.

After a time of getting acquainted with the farm, all the time moving closer and closer to the house, I became interested in the play of light on the south side. While working on a more general view of this southern exposure, I was struck by two things: the display of inward signs of life and the formal simplicity and strength suggested by the isolation of the window elements.

For all the formality of the window paintings at Emily's, they are also very site-specific. These are real places of real people, not just fabrications in pigment, but carefully distilled images that are meant to read, reach, and touch us through their profound sense of place.

THUMBNAIL SKETCH, WOODSHED PHLOX

Oil on canvas. 4" × 6" (10.1 cm × 15.2 cm).
Collection of the artist.

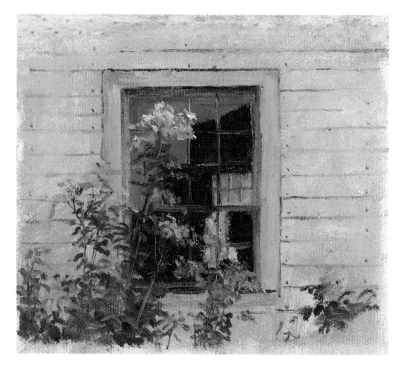

Summer is not my time for field work. I find the prevalent leafy textures much too light-absorbing, too overwhelmingly green. There are several exceptions to this, however: the paintings of Emily's gardens in earliest summer, with their fresher greens and frequent blooms, and the more architecturally focused images, such as this one. These phlox were located on the north side of the woodshed, so a much cooler palette than summer usually dictates prevails here; the only note of a true summer green is surrounded and framed by the darkness of the woodshed interior, which intensifies its impact and gives it a jewel-like quality.

Like many of the early sketches at Emily's, this one is quite small (4" × 6"), as the reference to scale provided by the push pin indicates. It was done on white canvas, and, as seen most obviously in the clapboard areas, the paint covering is incomplete and dragged along the surface. In the area to the left of the window, an ochrish light gray is partially covered with a warmer lavender, and a cooler, lighter blue gray has been brushed over the right. I do this in my sketches not only for color modulation but also as a shorthand note to indicate the surface/color/light transitions.

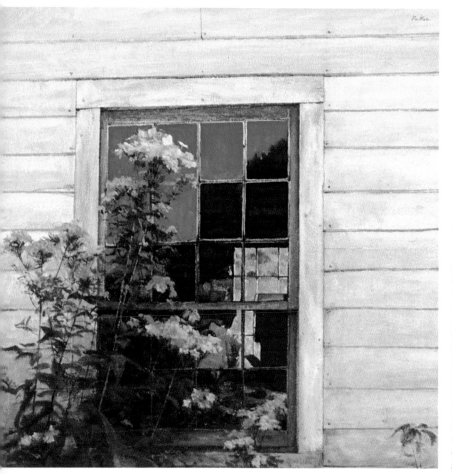

STUDY, WOODSHED PHLOX

Oil on canvas. 20" × 22" (50.8 cm × 55.8 cm). Collection of Mr. and Mrs. Carlos Canal.

Using the basic composition of the sketch above, I went on to clarify the various forms, the spatial sense, and the particulars of place. There is now a more refined gradation of light and shadow on each clapboard, but I have kept to the general description of lighter at the top, darker at the bottom. The clapboards are developed further by the variations of reflected light found at their lower edges, which are lighter and warmer at the top and darker and cooler as they near the ground. This general idea of the way in which light falls on the clapboard wall is much more important than any detailing of form; however, any detail work that incorporates this concept of space, light, and color will necessarily have a more meaningful impact. Of course, describing forms that are more irregular makes things more complicated and difficult, but the theory of where the light and shadow should fall still provides a more flexible and creative way to paint forms. For example, the flower heads of the phlox are a good illustration of this point: Some are in sunlight, some are in shadow, and the shadowed ones have varying degrees of reflected light. In general, however, the ones to the right are lighter and warmer, and those to the left, darker and cooler. A complicating factor is introduced by those shadowed areas created when the canopy of one phlox head blocks the light of a shorter neighbor.

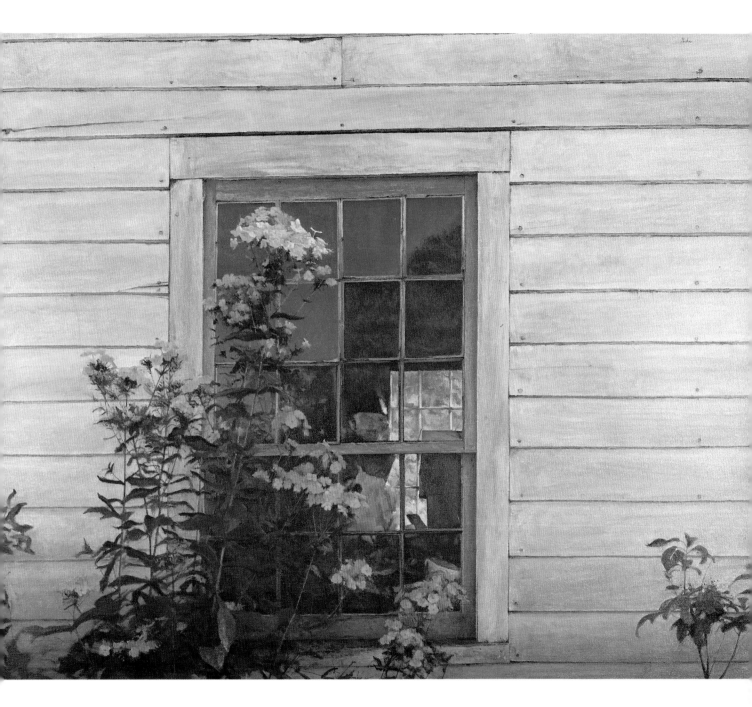

WOODSHED PHLOX

Oil on canvas. 38″ × 48″ (106.5 cm × 12.9 cm). Private collection.

In the final painting, I used a magenta wash to more effectively integrate the cooler temperature of the woodshed's north side with the vibrant tones of the phlox. I also opened up the painting by giving it a little more space horizontally. Here the window is a little off center; the weight of the flowers is balanced by extending the clapboards to the right. This change prompted me to include the sprig of laurel on the right, which compositionally provides extra weight to the vacant wall. The laurel also introduces an element of subdued light that ranges from warm ochre greens to very cool dark greens. Its drooping, rounded forms, in contrast to the relative flatness of the phlox leaves, repeats the rounded forms of the phlox heads.

When I first painted the phlox blooms in this larger scale, I felt the need to be more specific about their makeup, to show detailed parts of the whole. My first attempt was an agonizingly frozen, hard-edged portrayal of something whose nature was elusive, soft, and fragile, not porcelainized. I immediately wiped this version out and built up the phlox more slowly, being more considerate of how each individual surface contributed to the group form of the phlox head. In the end, the individual blossoms were left incomplete, suggested more at their edges, and accented by subtle color modulations. The highest contrasts and most intense color changes were reserved for the uppermost florets catching the daylight.

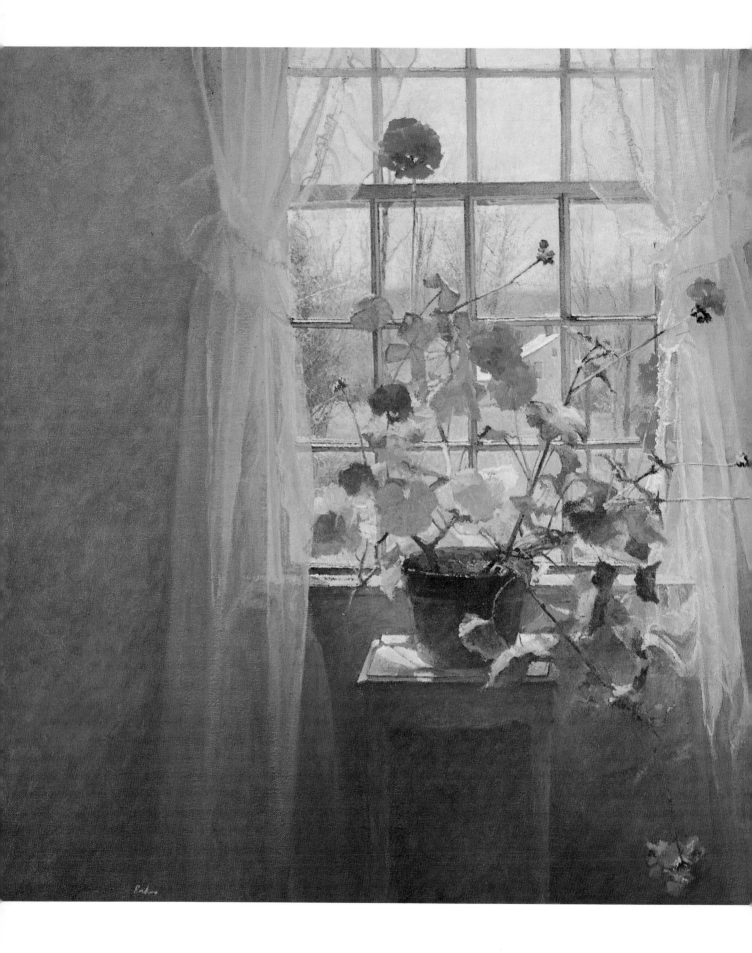

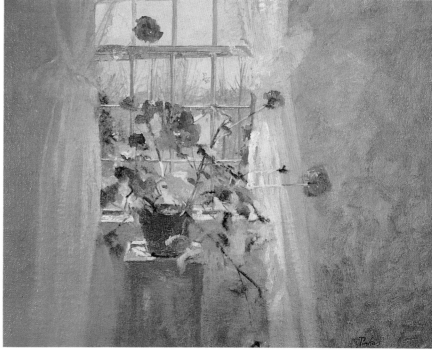

STUDY, RED GERANIUM

Oil on canvas. 9¾" × 12½" (24.8 cm × 31.8 cm). Collection of Dr. and Mrs. Joseph Rowan.

This study of the pink-gray southeast bedroom at Emily's clearly shows the quick shorthand approach I use to record the basic light-color transitions found in my preparatory work. It was done directly on white canvas and has an overall coolness when compared to the larger painting at right. The painting process is quite similar in both: first, a basic underpainting of mid-range color is put on; it is then modified toward the darker end of the scale and is later accented with opaque color. The sketch is basically a gesture that becomes refined and sometimes redefined in the larger work.

RED GERANIUM

Oil on canvas. 22½ × 30" (57.1 cm × 76.2 cm). Collection of Mr. and Mrs. Peter Zurles.

Red Geranium is not a painting of a flower, a plant, a window, or a landscape. It is a picture about the interactions of natural and interior light, the atmosphere this interplay creates, the presence of interior space through light.

The gauzelike curtains are key transitional elements integrating the outside and inside rather than having the sharp demarcational solidity of wood abruptly setting the boundaries between landscape and architecture. Instead, layers of translucent veils reinforce the atmospheric presence of interior space. This also allows the plant to assume its spatial ordinance yet maintain its subtlety and delicacy.

That the geranium is somewhat unkempt and spiky in nature is so symbolic of Emily. It is not the florist's sterile perfection, the almost plastic uniformity of contour and bloom. It is like her wonderful gardens, half hidden, to be discovered, nudging you on, never daring to shout at you. The neighbor's house glimpsed through the window is really a mate to Emily's own, built at a similar time and following a similar plan. It is like being in the house and seeing it from the outside at the same time.

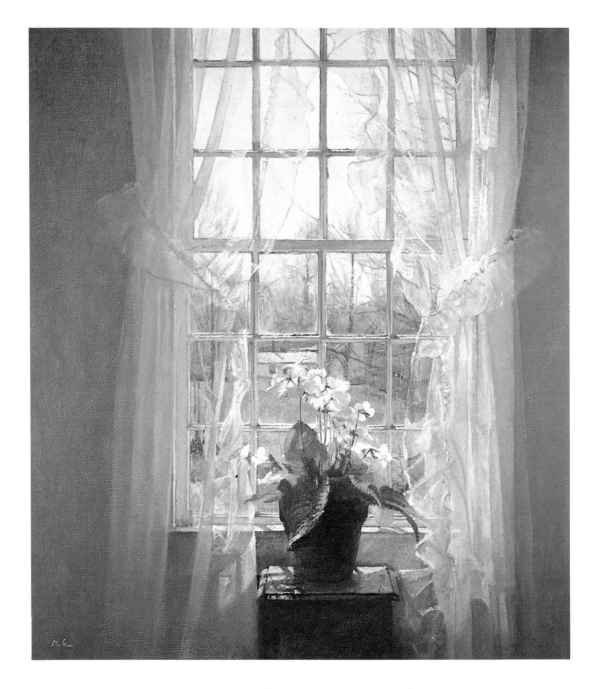

CAPE PRIMROSE

Oil on canvas. 20" × 17¼" (50.8 cm × 43.8 cm). Collection of Mr. and Mrs. Covington Hardee.

Cape Primrose depicts the blue gray south-facing bedroom upstairs at Emily's, awash with the light of the mid-morning sun. I was immediately fascinated by the possibilities I saw in the indoor-outdoor differences and transitions: the varying effects of sunlight and reflected light; color variations—spring green outside, leaf green inside; and the point at which the two worlds of the interior and the exterior meet.

When translating these differences into paint, a primary concern is to determine which areas are opaque and which are transparent; similarly, there will be areas described by direct light and others by reflected light. For example, the high-keyed blue in the clear sky and the lighter, cooler green of the grass have an opaque quality compared to the warm transparency of the interior walls and the cool, translucent yellow greens and rich darks of the primrose's leaves. There are transitional areas as well: The curtains have passages of opaque and transparent

paint, and the window mullions superimpose an opaque interior grid on sky and land. There is a similar transitional bridge on the outside found in the transparent violet gray handling of the band of trees stretching across the horizon. Patches of opaque light also find their way to the inside of the curtains, the windowsill, and the plant stand.

Although the backlit quality of the light used in this painting reduces the influence of direct light, it still has an impact. The effects of direct light are found here in the window mullions, where form has been simplified to an opaque highlight and a darker turning edge and accented by a warm, reflected light on the lower surfaces. A sense of the increasing effects of reflected light is found in the lower part of the window where the larger flat surfaces of sill and table, along with the warmer reddish glow imparted by the clay flowerpot, throw their light back into the window area.

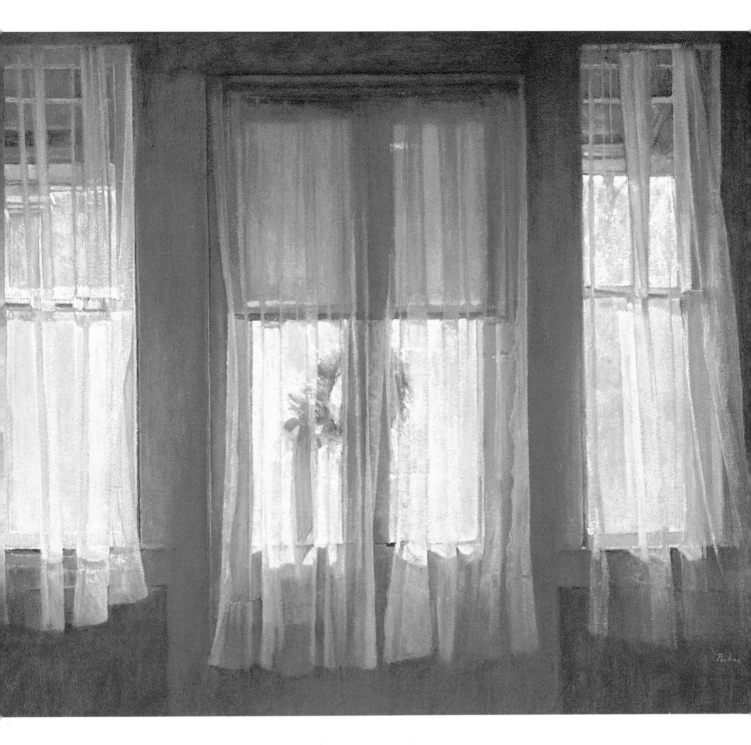

WINTER AFTERNOON

Oil on canvas, 17¼" × 19¾" (43.8 cm × 50.2 cm). Private collection.

The inside of Emily's front door—with its incantations of vertical shapes and horizontal lines and its aura of enclosed, dusty light that hinted at the outside world—was a new discovery. The contrast of warm interior light, a combination of translucency and reflection, with the suggestion of a cooler, opaque exterior was an intriguing one. The softened images seen through the gauzy curtains and the distorted reflections of the windows contributed even more to the interest this seemingly simple subject held for me.

The degree of light penetration is not only important to the sense of atmosphere but is a strong compositional element as well. This is especially true of the warm yellow window shade, not only because of its tonality, which aligns it with the darker interior areas, but also because it breaks up the repetition of vertical shapes.

EAST BEDROOM

Oil on canvas. 13½" × 14" (34.3 cm × 35.6 cm).
Private collection.

The large window series was executed while Emily was still alive. After her passing, and with the impending demolition of the homestead, I embarked on a fevered documentation of the house in all the aspects that interested me. At this time, windows became my priority, and I began to do small paintings of the second-story windows. The rooftops of nearby porches or sheds provided a handy, though sometimes too close, platform from which to work. At times, in order to gain a foot or so of space, I would paint standing on a ladder and use the roof itself as a taboret. Perhaps because of the relative inaccessibility of the second story, or perhaps because Emily was no longer there, I never did any large paintings of the second-story windows.

This painting of the east bedroom window (a six over six, the smallest of the second-story windows) was done in early spring; the snow was gone, and a faint reference to the orchard can be seen reflected in the glass along with my own image. No ground color has been used on this small canvas; the white of the canvas as a base conveys the high, clear light of an early spring morning.

SPRING PATCHWORK

Oil on canvas. 54" × 48" (147.1 cm × 121.9 cm). Private collection, England.

In this canvas, the south side of the woodshed is seen head-on, as opposed to the severely angled perspective of *East Light* (page 64). The light is that of late afternoon in late winter, and there is no hint of green anywhere.

Spring Patchwork is the logical transition between the relative simplicity of the window series and the intricate surfaces of *East Light*. It is an expanded facade and includes more of the building, sky, and foreground than do the window paintings. The windowpanes are still meant to be intriguing, but these dark shapes are not as deep, as rich, or as telling as those in the window series. Here, the windows are seen more as reflective surfaces keyed to the architecture of which they are an integral part than as single entities with lives of their own.

The area in shadow gives more drama to the light, which is isolated to the right yet integrated into the thick shadows of the clapboards. The patch of barn boards on the lower right echoes the reds of the chimney. The elements of sky and grassy foreground, although nonarchitectural, are nonetheless constricted to definite rectangles and integrated into the whole.

At this point, after drawing closer and closer to the house until I was literally peering in the windows, I found myself backing away. I did this, however, with changed sensibilities and perspectives, in order to reassess and rediscover things I might have overlooked or seen in different ways.

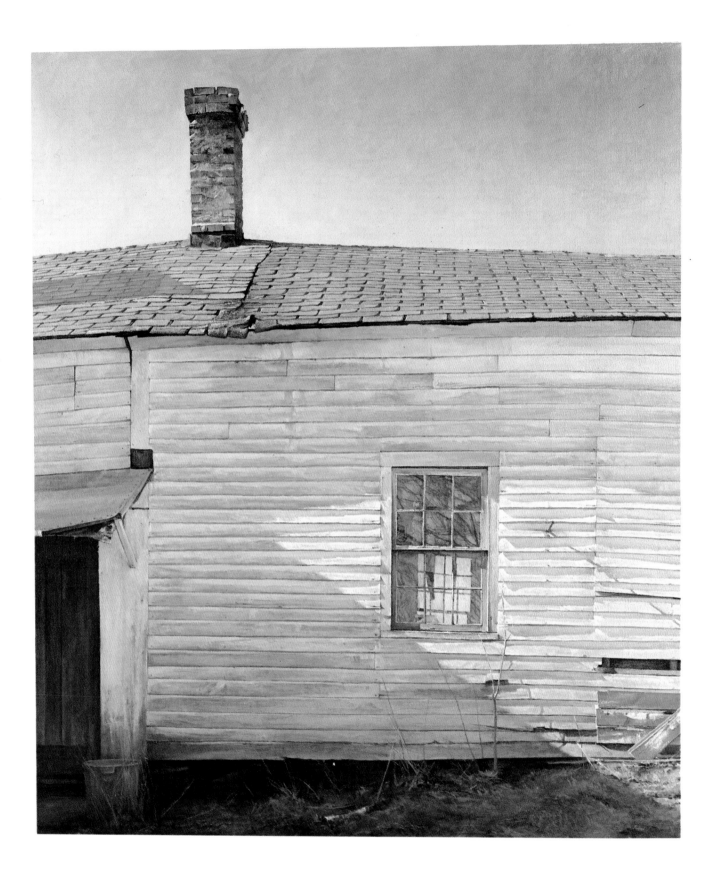

CLOTHESPIN BOX

*Oil on canvas. 10" × 11½" (25.4 cm × 29.2 cm).
Collection of Hedda Windisch von Goeben.*

Clothespin Box was painted, as were all my early studies, directly on a small piece of canvas tacked to a drawing board. Even so, I may have done a quick drawing a few days or minutes before. If I am attempting to capture a fleeting light condition such as that found late in the day, a preliminary drawing will allow me to focus totally on the color-light transitions of the painting. Later that evening—with the image fresh in my mind—I will go over, change, stress, and clarify things in the studio. Away from the subject, I find that I can deal with the needs of the painting without becoming overinvolved in detailing the object.

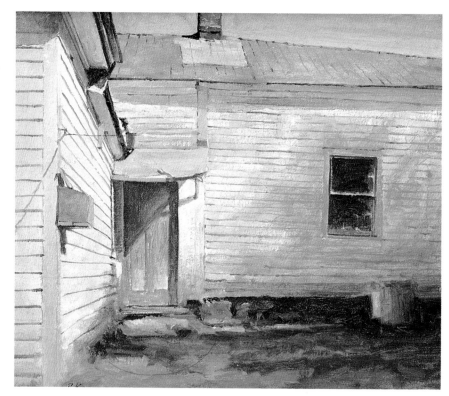

EAST LIGHT

Oil on canvas. 42½" × 47" (107.9 cm × 119.4 cm). Celanese Corporation Collection.

In this painting of a view into the kitchen and east bedroom windows, the high sun approaching midday casts a long shadow from the roof's overhang, and each thin clapboard shades the next in a seemingly disproportionate thickness. Though this subject is rooted in the dimensional and is not just a planar facade, the pervasive light works to negate and flatten the perspective. Form is more a result of the linear emphasis here; however, the sense of perspective is seen more as texture, pattern, and rhythm. Such telling details as the chimney, windows, and flowerpot are seen essentially head-on; their presence does not reinforce perspective but functions as pattern. The window and doorway of the woodshed on the right are positioned so obliquely that they read, not as objects, but rather as vertical linear accents. This linear theme does not entirely deny a sense of space; depth is manifested here through color variations, scale changes, and overlapping forms.

The composition in *East Light* is still quite formal; it is essentially rectilinear, with diagonal elements and accents. Within the larger framework of the house's walls, I have focused on the architectural features found in the lower and upper windows and the chimney. These three elements are linked together by their repetition of ascending vertical shapes. There is also a bond between the chimney and flowerpot, not only because of their similar shapes, but because of their similar colors. They help to tie together the upper and lower parts of the painting. The clay pot, however, has the additional function of providing a sort of "spatial punch": a near object overlapping a farther one, reinforcing its position with warm red color and rounded form.

There are also repetitions of vertical linear forms here: the corner board of the upper story; the almost vertical line of the woodshed's roof edge; the two saplings of the foreground stepping their way up to the second story. These are not only overlapping spatial clues but also help to unify and make sense of the divergent planes of the house.

Although I have stressed the formal considerations I took when composing this painting, they should not detract from but rather intensify my feeling for this place that I care so deeply about.

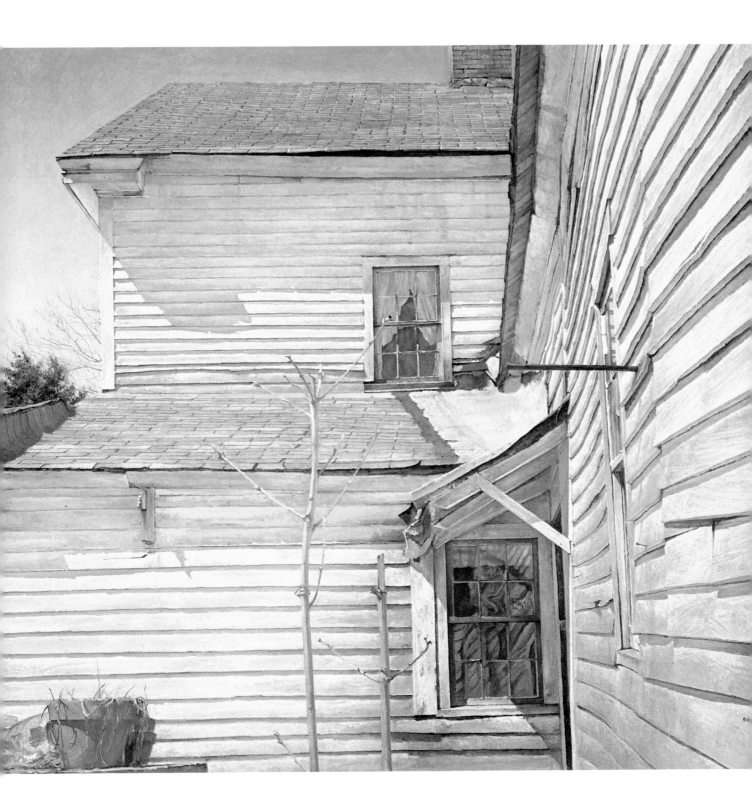

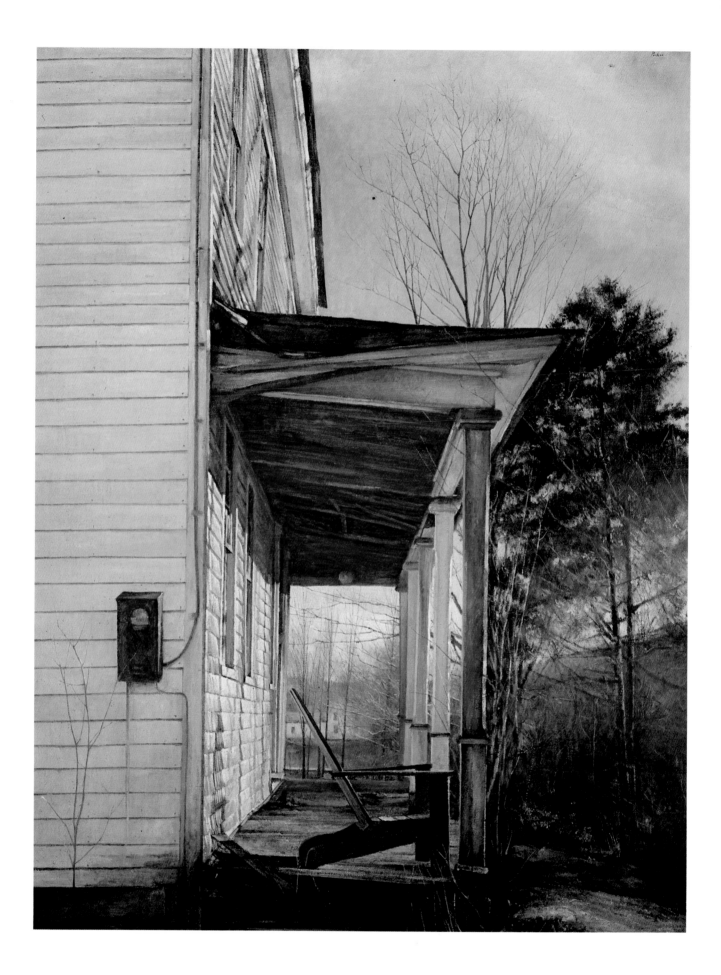

EMILY'S PORCH

Oil on canvas. 44" × 36" (111.7 cm × 91.4 cm).
Collection of Mr. and Mrs. Carlos Canal.

The sun approaching the top edge of the western hills gives its highly charged, warm yellow light to the house's front facade and its porch. A glimpse of a red Christmas bow can be seen just above the slanted back of a copper blue Adirondack chair. Porches are wonderful things, combining inside with outside. They are an architectural framing of the landscape, imposing their formal horizontal and vertical rigors on nature's casualness.

Emily's Porch was done after *Front Door* (page 42) and takes advantage of the expanded form and the expanded light relationships found there. These complexities of light are particularly evident in the many juxtapositions of direct and reflected light, from the more shadowed north side of the house next to the sunlit west side, aglow with its rich, deep reflected surfaces, to the interplay of reflected and direct light on the receding line of porch posts. The wonderful shape of the blue chair is also defined by the varying intensities of reflected light, with a few telling accents of warmly colored direct light.

The composition is based on a by now familiar theme—the vertical rectangle, which ranges from the larger shapes of house and porch to the negative spaces of sky. These primary shapes are reinforced by the linear repetitions of the vertical found in the corner boards, the tree trunks, and the slits of windows echoing porch posts and the negative spaces between them. The twin-trunked cedar tree serving as an extension of the porch posts into the natural landscape is particularly intriguing, as is the way the rectangle of negative space formed by the end of the porch echoes its smaller, darker counterpart, the rusted electric box. Although this theme of the vertical rectangle was rigorously explored at Emily's, it was not exhausted: it would be picked up in later years at the Scoville Farm in North Cornwall (pages 84–103).

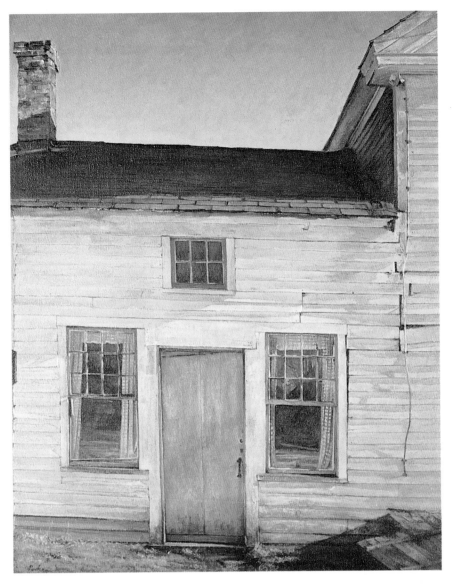

KITCHEN DOORWAY

Oil on canvas. 20" × 15½" (50.8 cm × 39.4 cm).
Collection of Maureen Maher.

This door was in essence the front door for Emily; it combined the practicality of leading directly into the kitchen with the most direct path to the barn from the house.

Since the sun only reaches this north side of the house for a very short time during the year, there is little room for variation. During the winter and earliest spring, the sun sets before it gets to this side. Later in the year, when the sun does come around, the leaves block the light and cast this side of the house into deep shadow.

I returned to this location with an expanded vocabulary after I had completed the window series. While this small painting relates very much to *Spring Patchwork* (page 67), the complex nature of window and door groupings and their close proximities demanded a different approach to the composition.

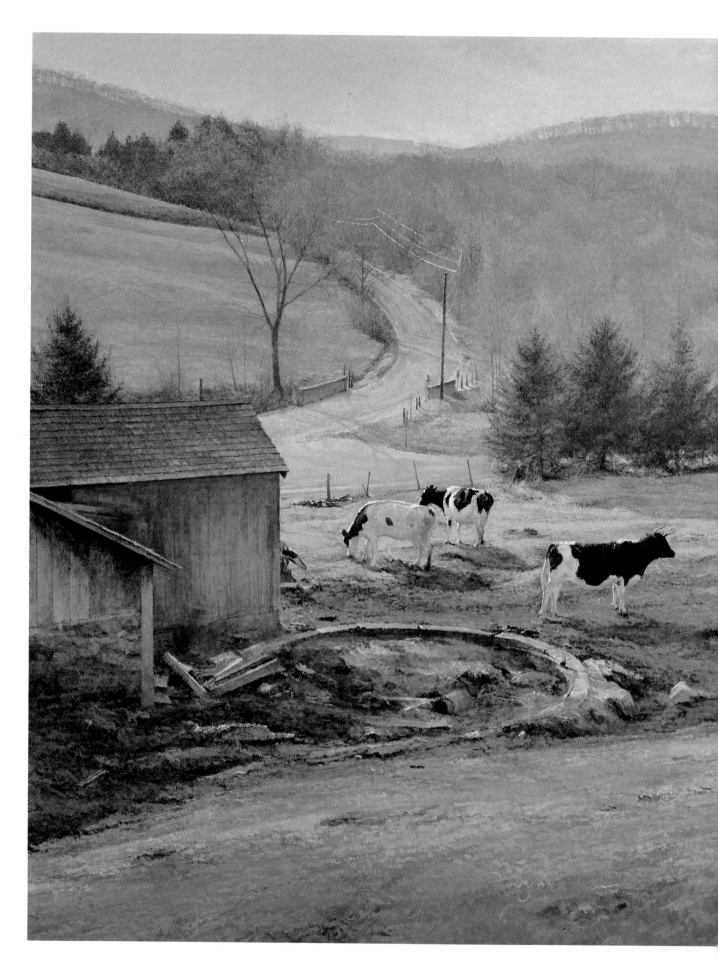

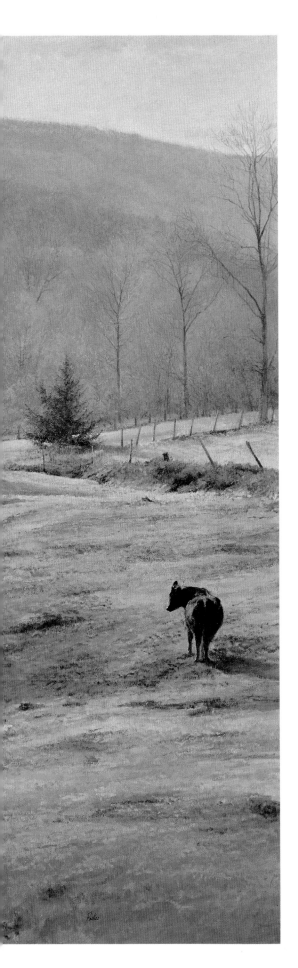

EARLY SPRING, BLOOM OF RED MAPLE

Oil on canvas. 42" × 48" (106.7 cm × 121.9 cm). Private collection of Mr. Louis F. Polk, Jr.

Most people would identify fall as the time frame of this painting. Early spring and late autumn have much in common visually: In all but the warmest, wettest places, new grass lies underneath last year's buff-colored stubble, and, except for the fiery springtime blooms of red maples, the trees are barren of leaves. The telltale difference in spring, however, is in the moisture of the air, at your feet and in your nostrils. The light is softer, denser, not the clear, acrid air of the late year.

On this late afternoon, the cows and heifers, let out for a drink at the spring, linger on the new, sweet grass before returning to the barn. I was always attracted to this particular view but had never painted it; this time, the cattle and their relative positions made the composition work for me. I particularly like the way the curved gesture of the lone Angus on the right is repeated in the stone underpinnings of a defunct silo and turns the eye back into the picture.

Key elements of the composition radiate from the broken circle of the silo foundation, the most obvious being the barns and heifers of the paddock area. The arching slope of the foreground gently pushes the eye into the broken edge of the foundation's stone circle, whose shape is picked up by the curved road with its sunlit power lines. The evergreens, dark colored accents found throughout the upper half of the painting, serve a compositional purpose by echoing the groupings of cattle and by breaking the straight line of the lower road and forcing attention back to its curved counterpart as it rhythmically penetrates the receding sweep of hills.

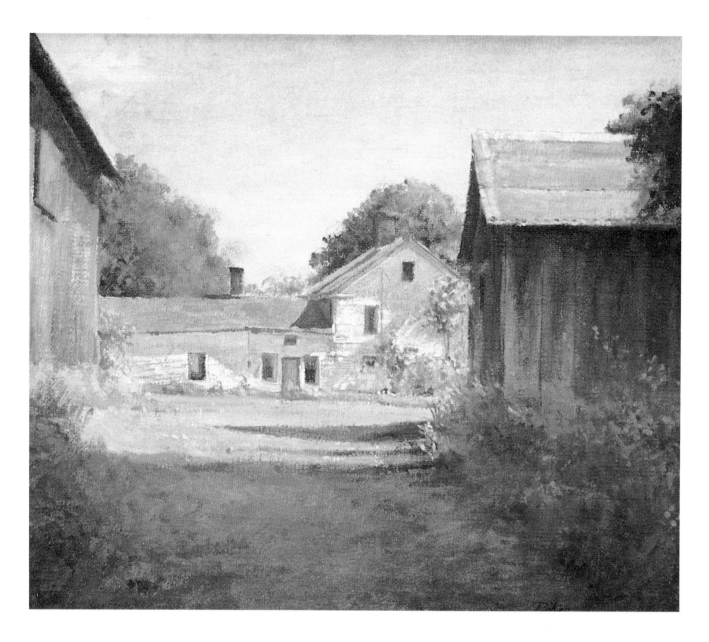

FROM NORTH GATE, JUNE

Oil on canvas, 8¼" × 9½" (21.0 cm × 24.1 cm).
Collection of Mr. and Mrs. William J. Ruane.

This study, done in early June, is very similar to the other North Gate
paintings (pages 78–82), in composition if not in season. While the pattern-
ing of light and shade is strong, as evidenced in the shadows on the house
and the closely cropped grass in the foreground, the overall impact of
color/light/space is muted by the light-absorbing green foliage. In the less
fecund seasons of fall, winter, and early spring, a fuller expression and
range of light-color interactions is made possible. Although this is clearly
where my preference lies, I am currently rethinking my tendency to avoid
painting the summer months. Perhaps the answer is to be more selective,
to choose places that are more open and less choked by green, or to find a
way to break up the green masses while remaining true to the particulars
of place.

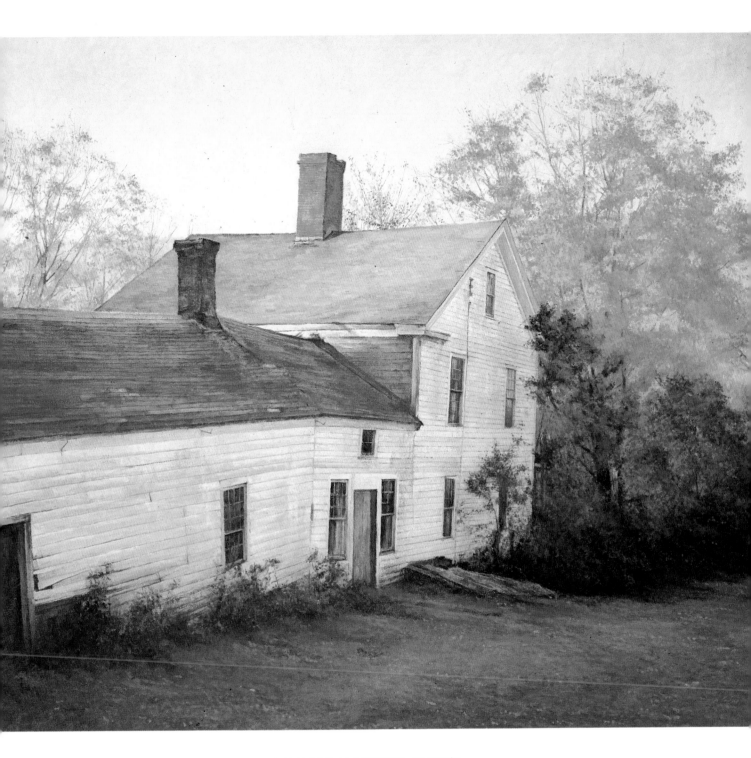

OCTOBER MORNING, EMILY'S

Oil on canvas. 26¾" × 31" (67.9 cm × 78.74 cm). Private collection.

This is the north side of Emily's house looking down the wood-shed to the main house. Except for one chimney and part of a roof, most of the house is blocked from the first of the sun's light by the hill to the east; and the hill to the west, which by this time is fully illuminated, is instead shrouded in heavy mist. The moisture-laden air drains the intensity from the normally brilliant October color, and the frost that lingers in the cold morning air reduces the strong contrast usually seen in fall.

Although interesting, the effects of frost and mist tend to flatten out objects with a surface of opaque grays. To suggest the structure beneath, I had to first overstate the color and contrast below the surface and then cover it selectively, leaving some high-contrast edges and textures to serve as clues to form. This type of handling can be seen in the grass in the foreground, where the warmer, transparent green of the underpainting shows through the denser areas of relatively opaque color.

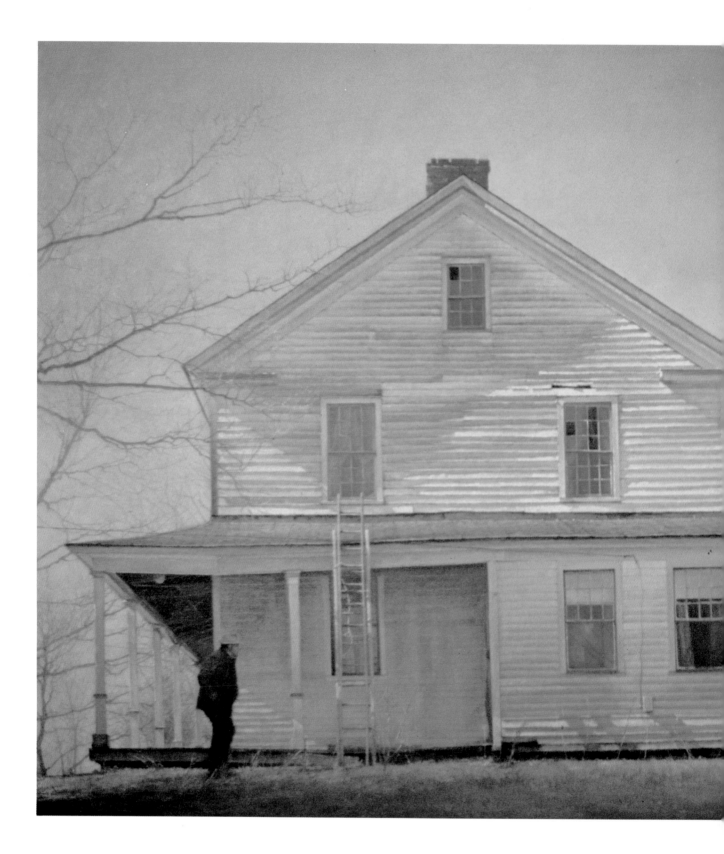

SPRING RISING

Oil on canvas. 37" × 47" (93.98 cm × 119.38 cm). Private collection.

The events of *Spring Rising* took place on one of the saddest days of my life. Emily Uranus had been gone for almost two years by then, and Emily's sister, Alice, and her niece, Millie, had kindly given me the run of the place for about as long. Knowing the house would soon be dismantled gave me the incentive to try to record as much of it as time would allow.

In the painting Alice's husband, Joe, just rounding the southwest corner of the house, is surprised to see my ladders, from which I had been doing my window studies, leaning against the porch roof. He has come from supervising his sons in the storage of Emily's belongings, which they took from the north side of the house and put in the nearby barns. Tomorrow the house will be torn down. Over in the far window on the left, the faint image of half a face can be seen through the reflections of the spring sky—it is Millie Uranus.

On its last day, the house resembles a ship being boarded, held fast by the lines of tree branches so as not to slip away. My sun-dappled ladder, very much needed for the composition of the painting, is like an instrument of intrusion rather than observation. Everything seems so fragile in this glancing spring light, and indeed it is.

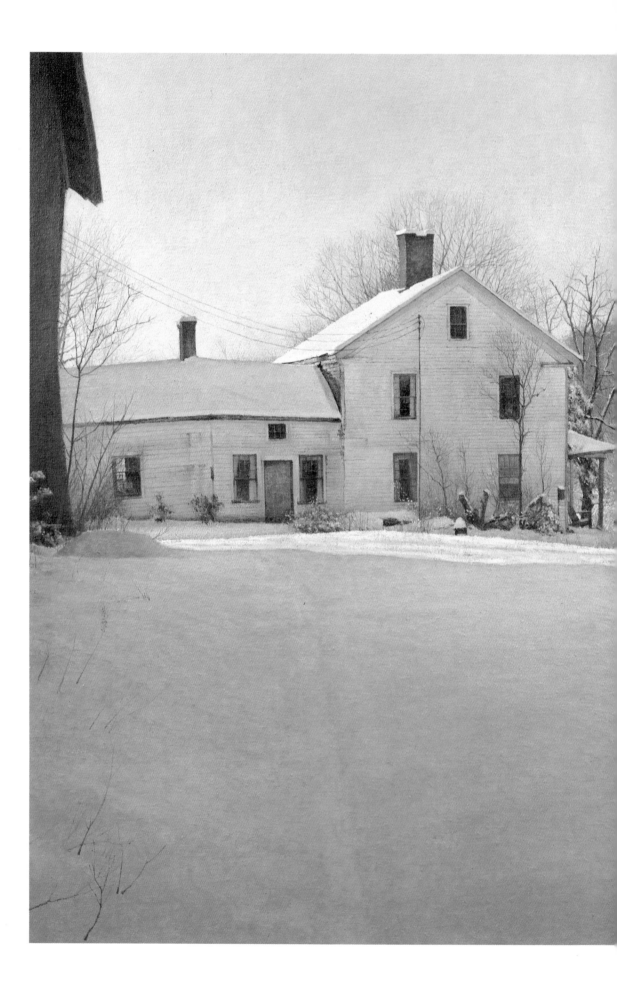

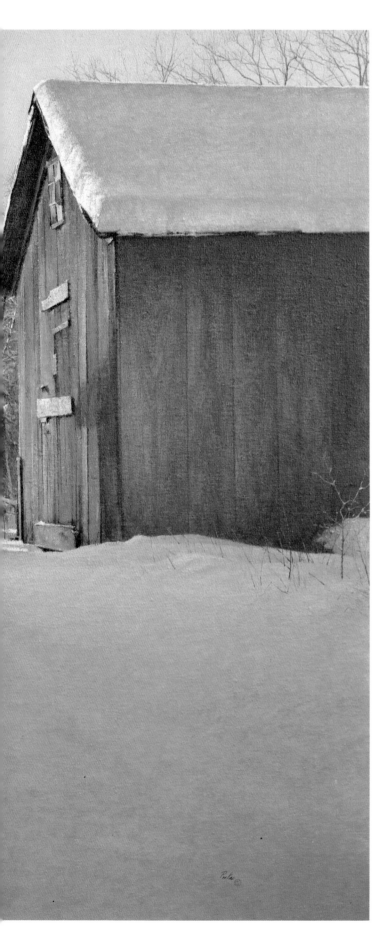

DAWN, EMILY'S FROM NORTH GATE I

Oil on canvas. 34½" × 40" (87.6 cm × 101.6 cm).
Collection of the Tanner Capital Corporation.

I always went down to Emily's after a night's snowfall, not only to observe the air and light changes in the morning sky, but also to find out what treasures of geometry were exposed, covered, or combined by the newly born blanket of white. In this case, a gently clearing storm had left behind a windless morning, and much of the snow still clung to roofs and tree branches. The viewpoint here is fairly close to the barns, just inside the north gate that leads to the pastures and the springhouse.

The morning's light—clarity combined with a touch of moisture—gives a weighted volume and atmosphere to the air. Here, space is defined by the relationship between the massed color-light areas of sky, the facades of house and barn, and the color and light gradations on the foreground snow. The yellowish blue of the sky and the overlapping pink-pearl gray of the house are linked by a common magenta-tinged ground. The lateral shaft of sunlight running between house and barns casts warm light on the house and on its snowy shadow. The warm tones of the shadow beneath the house help place its structure solidly in space.

Reflections of color from different parts of the sky help tie this painting together. A cool-toned blue picked up from the sky, for example, is superimposed on the warm-toned ground of the foreground field of shadowed snow. This mingling of warm and cool tones relates to other areas of the painting, such as the walls of the house and the mass of snow on the barn's roof.

The play of rectangular forms punctuates the facade of the house from window to door to chimney and is picked up again by the reversed darker shapes of the flanking barns. A unifying webbing of trees, branches, and twigs is scattered throughout the canvas to give texture, accent, and additional scale to the painting.

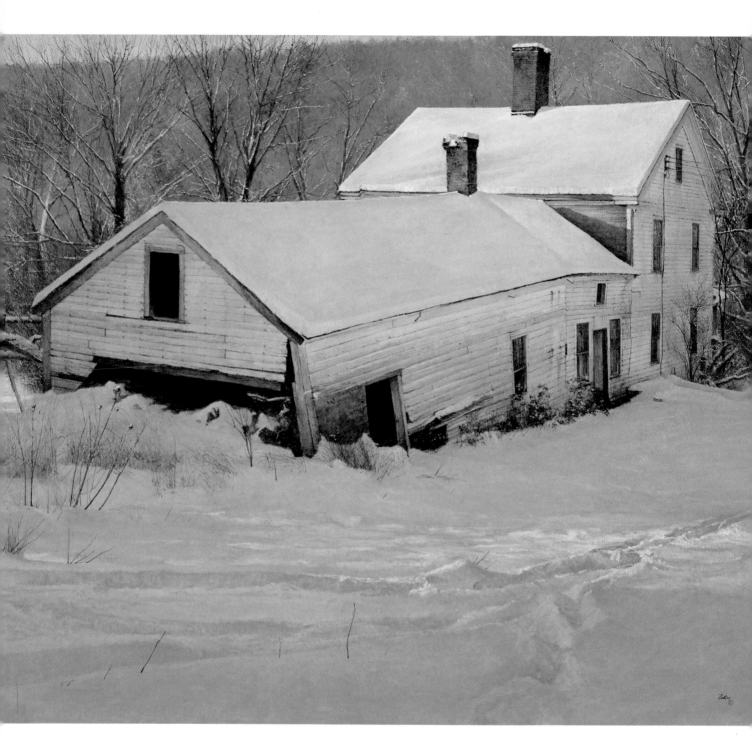

EMILY'S, NORTH GATE II

Oil on canvas. 34½" × 40" (87.6 cm × 101.6 cm). Collection of Mr. William Webber.

Morning light at Emily's always had a special appeal to me; I was particularly fascinated by the morning light of winter, with its broad planes of light and shadow. It's not just the sense of place or person that attracts me but a place's orientation to light. When I select a site for painting, I am concerned about whether the adjacent hills are in sunlight or shadow or whether they are warm or cool; I am looking at the way that light reflects off nearby buildings or surrounding planes of snow or grass; I notice which clapboards have a particularly raking light.

Here in *Emily's, North Gate II* is the clear yet somewhat moisture-laden air you find after a night's light snowfall. It is not the abrupt change brought about by the strong winds of a Canadian high, but a gentler clearing which further softens the early morning light. Looking down the north side of the woodshed and house, the first hints of moving air begin to fell some of the snow from tree branches.

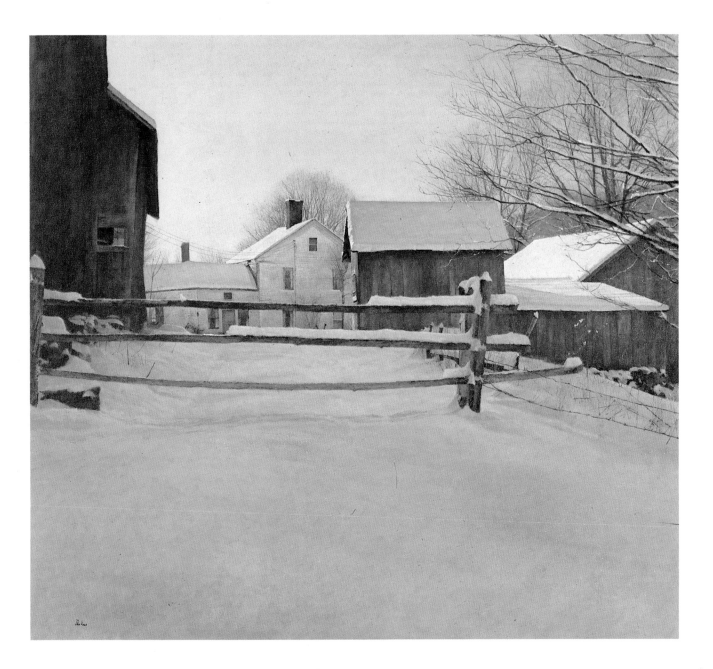

EARLY MORNING FROM NORTH GATE

Oil on canvas. 33½" × 36" (85.1 cm × 91.4 cm). Collection of Pierre-Alain Blum, Switzerland.

The approach to light and space used in *North Gate I* (pages 78–79) is also used here. Although this view pushes farther back into the picture plane, the sense of depth is subordinated by the strong horizontal of the bars of the gate connecting the flanking dark shapes of the barns. The frontal plane is further emphasized by the line of buildings that form an unbroken link across the picture plane. The placement of the buildings creates a sense of perspective, but their real function is to provide a geometric pattern of shapes across the composition.

There is a compositional emphasis on groupings of horizontal rectangles, from the long bars of the gate to the rooftops of the buildings. Strong horizontals are also picked up in the broken patterns of the snow caused by my recent crossing of the gate. And the not-too-obvious trio of electric wires stretched from house to barn parallels the triple rhythm of the gate, particularly the graceful curve of its lowest member.

A linear compositional theme can also be found here: the chimneys; the reddened side of the small barn to the right of the house; the vertical gateposts; and the massive, cold vertical of the barn on the left.

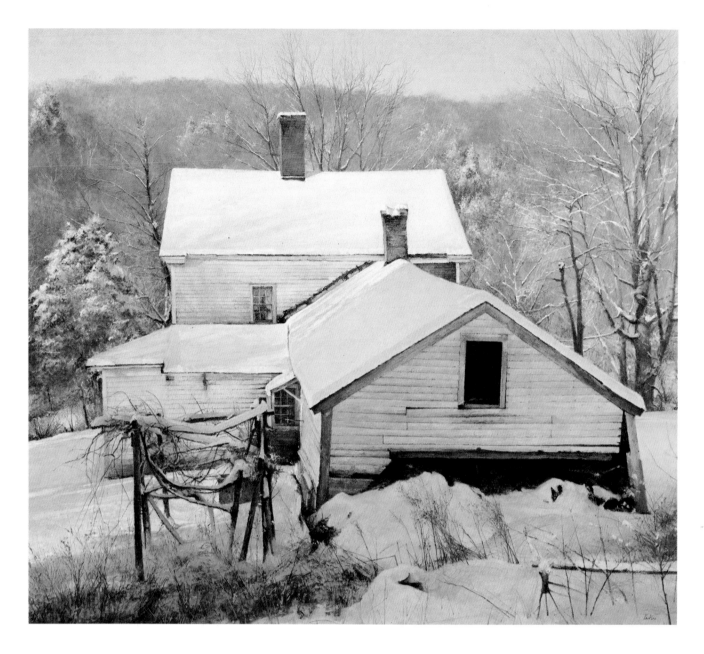

CLEAR MORNING, FRESH SNOW

Oil on canvas. 30½" × 33½" (77.5 cm × 85.1 cm). Private collection.

The back of Emily's home always fascinated me, especially the pronounced geometry of snowy planes coupled with the subtle shifts of winter light. Seeing the house from the orchard's edge, I always felt irresistibly drawn into it, a feeling of almost being propelled through the air toward its combination of deep space and rhythmic forms. From woodshed window to kitchen chimney to house chimney to grape arbor to shed roof to main roof, the effect is like being on an architectural toboggan run.

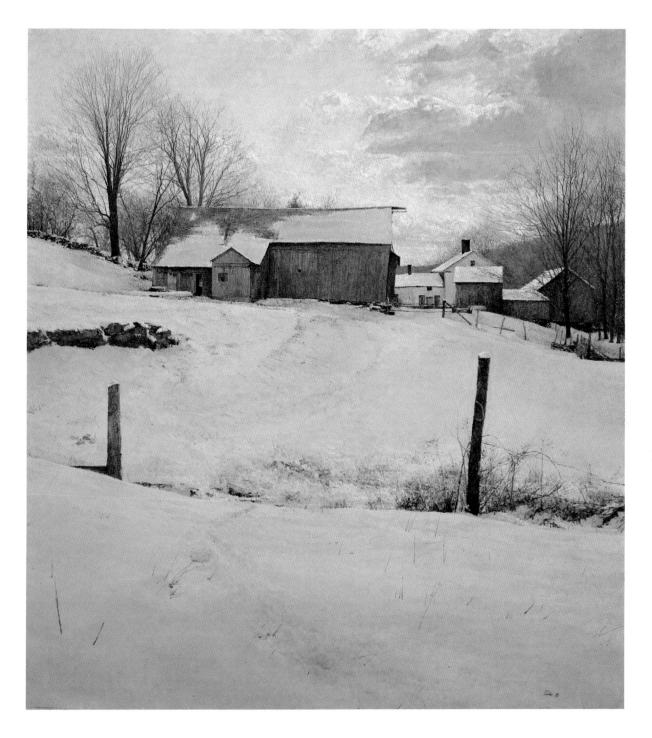

SUNBURST, NORTH GATES

Oil on canvas. 40" × 35½" (101.6 cm × 90.2 cm). Private collection.

With *Sunburst, North Gates*, the paintings at Emily's have come full circle to the panoramic viewpoint at which they began. There are important differences, however; although concerned with the same subject as the early *Dawn, North Pasture* (page 50), *Sunburst, North Gates* is quite a different painting. A slightly deeper viewpoint and a vertical format push the architectural elements into the distance and emphasize the foreground.

The light here also differs from the earlier work. Though it is close to midday, the light is subtle; a sunburst coming out from behind the clouds leaves the foreground in the suffused light of high-keyed shadows. In this respect, the magenta ground of the later paintings is an effective base for these kinds of light and color conditions.

This painting has a sense of quiet and measured tranquility; the equal horizontal bands of sky, middle ground, and foreground provide the compositional framework for this feeling. The sense of depth and space here depends on the interplay of subtle color variations, between the influence of the blue-aqua of the sky and that of the lavender gray in the foreground.

The painting, done after the start of my sky-oriented *Dawn and Dusk* series, uses cloud formations as a positive element in the composition rather than as negative space.

North Cornwall

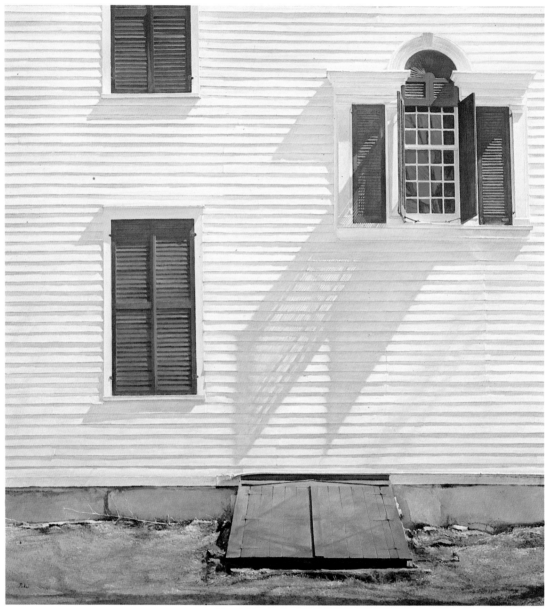

NORTHSIDE
oil on canvas, 48" × 43¼" (121.9 × 109.8 cm), Collection of Mr. and Mrs. William McTiernan.

Architectural forms and the landscape

After Emily's death and the destruction of her house, Peter began a three-month search along the back roads of Litchfield County, stopping to talk to farmers and occasionally making sketches or taking record photographs, hoping to find a new subject. But the face of rural farm life was rapidly changing because of increased mechanization and gentrification by city dwellers seeking a weekend retreat. It wasn't until Jonathan Scoville, a fellow artist, introduced Peter to his cousin Ralph, who owned a farm with forty dairy cows in the high hills of North Cornwall, that Peter found a subject to which he could commit himself.

The Scoville farm appealed to Peter because the house was white and it was a small family farm. Peter has generally chosen to paint white buildings because of the way they reflect light and mirror the colors of the landscape. Equally important to the artist was the modest scope of the farm operation; as Peter explained, "Anything that's done or maintained on small farms is almost always done by the people themselves. At Scoville's, the porches were enclosed and the little plant room constructed with old storm windows, probably salvaged from other people, other lives. So you have these 'fingerprints' of the people and how their homes and lives are shaped."

While Peter's work is concerned with the authentic, living quality of his subjects, his viewpoint is unromantic and dispassionate. While fingerprints are important as a personal biographical record of the shape and texture of a way of life, they are not meant to serve as narrative or commentary, but rather as compositional elements, providing a spot of color, a variation in shape, or an opposing line. Peter distills and structures his phenomenological observations, altering and emphasizing color and tone, and manipulating and orchestrating light and shadow.

The fingerprints are often overlooked at first glance, but on closer observation they sometimes ring a discordant note or provide a seemingly untranslatable passage that leaves the viewer with an unanswered question. One example of this phenomenon can be seen in *Farm Cats* (page 94). At the end of the storm-window porch enclosure hangs a bit of white cloth, beneath which lurks what appears to be a cage. Peter explained that since the storm windows didn't quite fill the space between the porch posts, the farmer just tacked up a piece of canvas and then used an old iron milk crate to hold down the bottom.

The richness and abundance of these fingerprints at the Scoville farm lent a quirky sensibility, a greater sense of surprise and metaphor, as well as more varied and colorful details to the paintings Peter produced over the next three years.

Another aspect of the Scoville farm that was to play an important part in the nature and viewpoint of the paintings from this period was the location of the farm itself. Emily's house had been located at the base of a hill in a narrow little valley. This meant that many of the vantage points were looking down from above. There was always a sense of enclosure, with little opportunity for long views. Scoville's, however, was a hilltop farm in high country, with an open feeling, longer vistas, and more intense light. Because the land pitched steeply from the house, which sat on high foundations, there is a heightened sense of drama in these paintings, particularly when the building looms at a greater angle in such works as *Afternoon Before the*

Frost (page 90). In that painting, the landscape viewed past the corner of the house implies a deeper space than did similar views at Emily's.

The more intense light at the Scoville farm also required a sharpening and strengthening of color. It was at this point that Peter discarded the burnt sienna ground color that he had used at Emily's to unite his color schemes in favor of a dilute magenta. The result was that the highlights have a greater snap and the shadows a fuller resonance. This adjustment was a further step away from the artist's earlier tonal approach to coloration.

In many of his Emily paintings, Peter had tended to leave much of the ground color to read prominently in his shadows, but the broader spectrum of color he found reflected in the shadows and half-lights at the Scoville farm led him to a more complex and colorful warm/cool adjustment in these areas. These adaptations all represent a significant shift from Peter's earlier tonal handling of color.

Although they were friendly enough, Peter never felt the same intimate relationship with the inhabitants of the Scoville farm that he had experienced at Emily's, where her life and his work had become inextricably bound. The Scoville farm was much busier; the farmer and his wife went off to work it every morning, leaving the house all but deserted during the day. The more anonymous sense Peter had about this place, coupled with the larger scale of the house and the fact that the porches surrounding the house prevented a close-up planar view, led to a shift in scale and angle in these works. To accommodate the larger, more complicated structure and still provide enough detail, he significantly enlarged the paintings. This in turn had some effect on his methods and materials.

For the last paintings at Emily's, where he had already begun to enlarge his format, Peter had changed from a fine-weave canvas to a coarse weave. Peter's method of painting by applying layers or "veils" of paint one by one and then wiping them off, leaving only the ghosts of the paint in the tooth of the canvas, produces a dry, matte, transparent finish to the surface. A coarser canvas, he discovered, provided the necessary scale to the surface of larger works, but tended to fill up and hold the paint to such a degree that the surfaces would lose their sense of transparency and luminosity and become shiny and opaque.

For the Scoville paintings, Peter began using a medium-coarse canvas, applying the paint with wider brushes and in a freer manner than before. While he continued to use his method of applying thin washes of paint diluted only with turpentine, each wiped and blotted out with a rag, color areas became more coarse and fragmented. Edges and planes became crisper, more spontaneous, and more self-assured than the carefully blended contours of the Emily series.

The first paintings Peter began at Scoville's were *Afternoon Fire* (pages 88-89) and *Farm Cats* (page 94). Close in color and tone, they are similar to compositions that Peter had explored at Emily's. Clearly, however, the real point of interest in both paintings is the long row of storm windows along the back ell.

The middle-distance view of *Afternoon Fire* suggests Peter's cautious approach to a new subject and contains many of his favorite elements: backlighting, raking light, and the reflected color in the shadows. But, Peter explains, "What really struck me was the spatial ambiguity of the row of storm windows that reflects the sky from another angle and plays a mirror trick image with the opposite porch."

Peter found that the row of windows gave "a greater sense of what's behind you" than had the windows at Emily's, and in *Farm Cats* he became intrigued with the possibilities of showing the opposite nature of these windows: the transparency in a reflection, a view opposite a view, a row of windows behind a row of windows. "I wished to give the effect of simultaneously looking through the fractured images reflected in all those panes, fading from brushy foliage to blue sky, while looking at the pattern of the windows and clapboards of the interior wall," Peter explains.

The hide-and-seek of these reflections, however, is only part of a rich, complex, abstract interplay of

rectangles that echo back and forth like a Mondrian, the rhythm and flatness of the space punctuated by the few well-chosen diagonals of fallen trim, gutter pipe, and clothesline.

Continuing his fascination with the imagery of reflection and transparency and with the view behind coupled with the view beyond, Peter turned his attention to the odd little bay on the opposing porch. He developed a series of more than half a dozen major works that seem to form a cycle of the seasons, a drama peopled with recurring objects and forms that express the nature of the weather, the light, and the cadence of farm life glimpsed in the reflections of the windows and the distant bits of vistas.

In the first of these works, *Reflections, Spring Skies and Silos* (page 91), a rather ominous image of the silo looms in the intense blue sky reflected in the window, looking like a bloated bomb or a ghastly balloon come to some unfortunate end amidst the strange tropical landscape that is the dimly perceived array of plants inside the house. While he agrees that these forms seem to lend themselves especially to metaphorical interpretation, what interested Peter most at the time was "the pitch and axis of each pane of glass that gave multiple rather than continuous images from pane to pane, like the staccato of split images that Sheeler made use of."

Aside from the quality of light, and perhaps the intensity of the blue sky, there is little in this painting to indicate the season except for the lush and rather odd-looking vine, which seems to take on a barometric role as the seasonal cycle evolves. "Summer is my least favorite time to paint," Peter says, "because when everything comes into full leaf, the light is not as dominant a factor, and I find green landscapes dull. The vine, I believe, is a form of bindweed or morning glory, although I've never seen it bloom, since I always head back to the studio in late spring and work on winter views until fall."

When Peter resumed his study of the little plant room the next fall in *Afternoon Before the Frost* (page 90), he began with a frontal format of ex-quisitely balanced rectangles, with the long, dark, horizontal shadow under the porch anchoring the long, slow horizontals of the bench, clapboards, and porch roof that give a sense of the quiet dullness of the deepening season. The thin reflections of the intense blue sky in the windows and the static nature of the plants inside suggest the stillness of this time of year, while the drooping, brown-tinged vine forecasts the killing frost that is to come. There is a sense of being pared down to the essential, telling details. While Peter sees much of his role as an artist as being a faithful recorder of visual information, he does not hesitate in judiciously editing or rearranging certain details to clarify or simplify his compositions. "I would certainly not go so far as to eliminate a window, for example, but I often move the position of trees or change the angle of a hill. I rarely introduce new elements to a painting, but I will eliminate or reduce in scale, size, or tone something that confuses or does not further the composition. In *Afternoon Before the Frost*, I pruned the trees on the left because they were matted and confused."

Porch Rockers (page 98) and *Spring Plowing* (page 99), nearly identical vertical views, offer interesting contrasts and an insight into Peter's working methods. In *Porch Rockers*, the artist set out to play up the sharpness and spareness of this winter view bathed in intense winter light. He did this by emphasizing the multiplicity of thin lines and bright, blank negative space. The thin, calligraphic traceries of the vine; the distant tree and wisp of bush; the wire screening on the porch and the receding diagonals of the porch rail; and the bench with its row of spindles—all contribute to this sense. In *Spring Plowing*, the artist reflects the fullness of spring, emphasizing the solidity of forms and filling in the deep negative space. To accomplish this, he eliminates the porch railing (though keeping its shadow), changes the shape and angle of the far hillside, alters the shape of the tree, adds more bushes to the middle distance, loses the back of the bench in shadow, and deemphasizes the linear nature in graduated tones.

AFTERNOON FIRE

Oil on canvas. 43" × 48" (109.2 cm × 121.9 cm). Collection of Mr. and Mrs. John T. Lupton, Chattanooga, Tennessee.

This was the first large painting of the Scoville farm-house, and my interest in glass and its reflective qualities is readily apparent.

I was taken with the sense of atmosphere in this painting: the soft light of an Indian summer day; the warm-cool lavender gray bark of backlit trees juxtaposed with the translucent acid green charged by light from a low sun. A microcosm of that atmosphere affects the house as well: the subtle gradations of light and color on the second story echo those of the sky; the darker recesses of the porch, the windows, and the foundation wear the identical hues of lavenders and grays seen at the wood's edge. (Of course, the reflections also help in this integration of natural and architectural elements.)

When I first approached the windows of the Scoville farm, there was no question in my mind about their importance. At Emily's, the windows involved a long process of discovery; here, the fascination with them was immediate and direct. The influence of glass and its reflections in this composition is obviously great, particularly in the emphasis given to the relationship between the window of the plant room and the glass-enclosed porch. The warm light reflected in the right-hand corner of the porch windows brings the sky into the house and balances the composition by opening up the space on that side of the painting.

A subtle linear motif is also at work here, from the wispy tree branches and picket fence posts to the swaying rhythm of the antenna and clothesline. The fallen clapboard trim and downspout echo the perspective lines of the house, and the linear extensions of clothesline and electric wires restate the horizontal theme of clapboards stretching across the land.

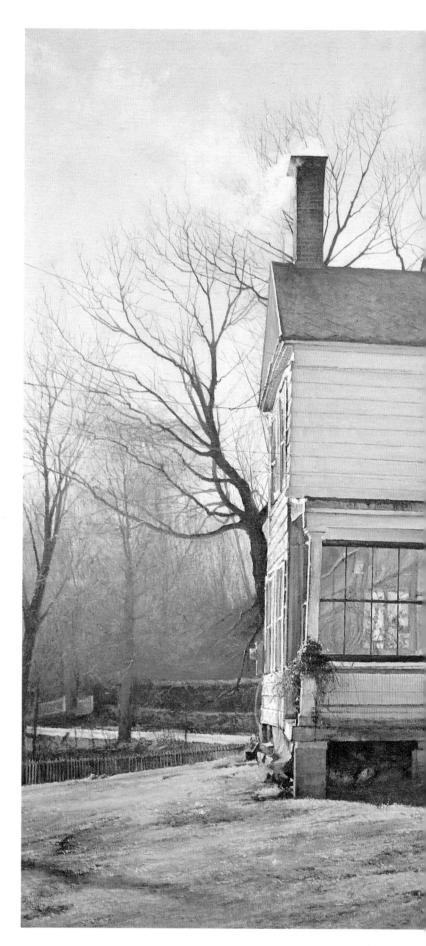

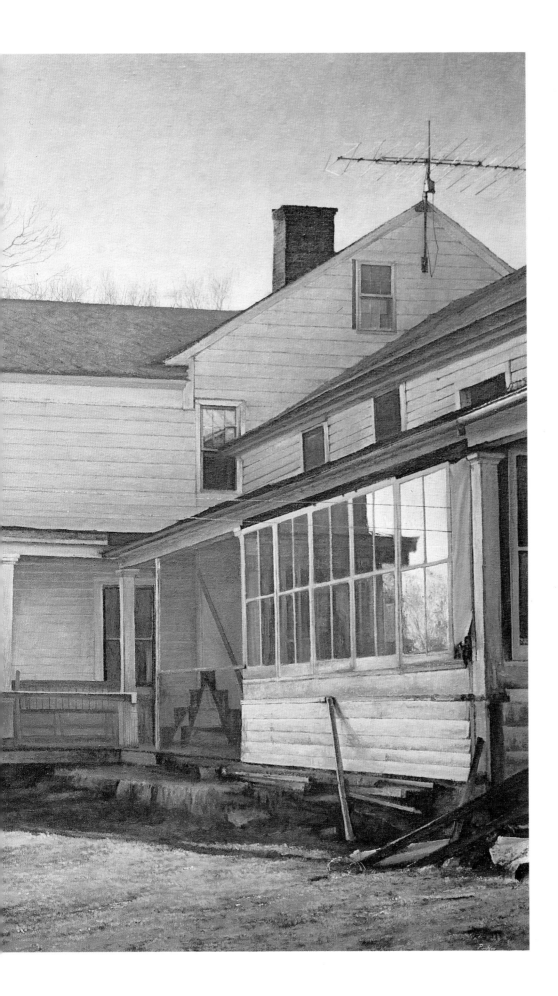

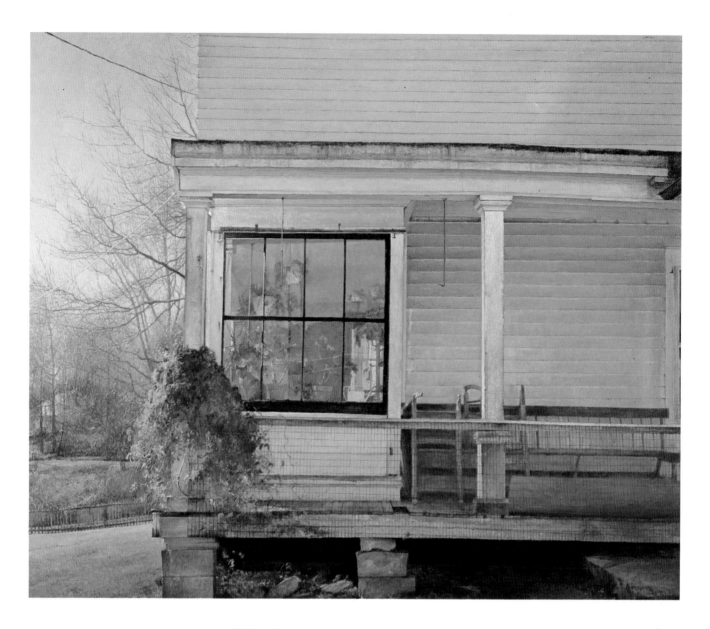

AFTERNOON BEFORE THE FIRST FROST

Oil on canvas. 41" × 48" (104.1 cm × 121.9 cm). Collection of Mr. Scott L. Probasco Jr, Chattanooga, Tennessee.

Afternoon Before the First Frost is a concentrated version of the eastward facing wall and porch found in *Afternoon Fire* (preceding page). It is more expansive in architectural scope than *Reflections, Spring Skies and Siloes* (opposite), but the perspective is less complex. This is a head-on, formal painting; in its essentially flat facade, a sense of depth is only hinted at by the porch's posts, ceiling, and floor. The focus here is on the surface textures, color, and light of the rectangular elements, all caught up in the nuances of the warm reflected light of a mid-afternoon in late October.

As in many of the Scoville paintings, parts of nature are integrated into the architectural. In this case, the blue sky mirrored in the upper part of the windows "pushes" or brings out the sky's cooler influence on the upper story above. Glimpses of direct sunlight can be seen in only a few telling edges, making them all the more dramatic by their spareness: a glistening electric wire; an edge of window mullion; the tips of an overturned rocker; and a vine, still full of life, clinging to the house's

corner post. The vine is the focal point for the most intense sunlight; it becomes the literal tie between the natural and the manmade worlds. Its curving line parallels not only the plants inside but also the shape of the cat in the window.

The focus of this painting is centered on the plant room window; from there it expands and is picked up in various scales and materials, the largest and most important of these being the two spaces created by the porch posts. There are also a number of important vertical linear elements here: the twin porch supports; the vertical posts of the blue rockers; the window mullions; the hanging plant hooks suspended from the porch roof's ceiling; and the cut-off vertical of the frame on the right side of the picture.

A balanced relationship between the busy and the calm presides over this painting: the activities of trees, foliage, and interior intricacies to the left in opposition to the larger expanses of quiet color and the soft transitions of reflected light on the right.

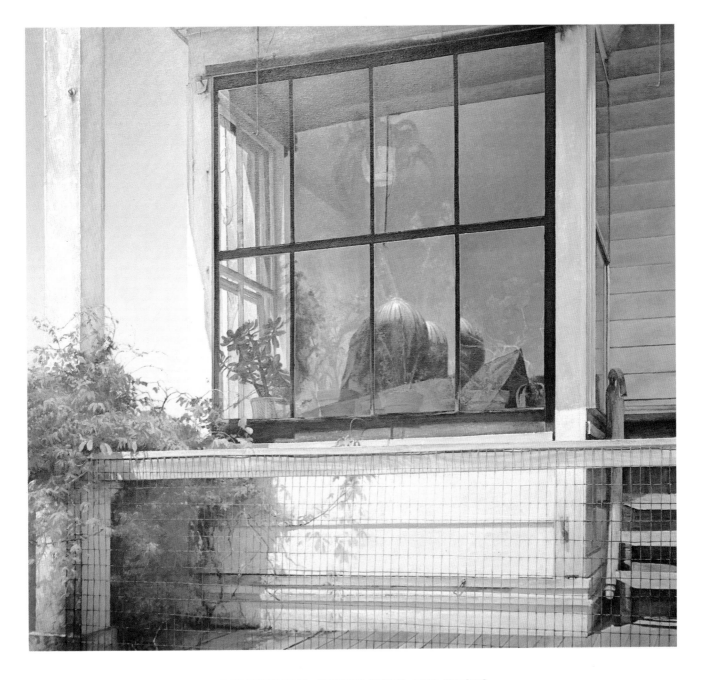

REFLECTIONS, SPRING SKIES AND SILOES

Oil on canvas. 45¾" × 48" (116.2 cm × 121.9 cm). Private collection of Louis F. Polk, Jr.

Of all the paintings done at the Scoville Farm, this one relates the most to the earlier window series at Emily's, primarily because of its singular attention to one window. But in this case, I have also included the dimensional punch of a porch post and a recessed wall to suggest the window's spatial orientation. These additions not only create a more complex formulation of space but also emphasize and define the gradated planes of light that naturally arise in a more intricate composition.

The contrasts and similarities of the negative spaces of real sky caught between post and house with the deeper blues of the sky reflected in the window intrigued me here. The potential for visual complexity in the window is increased by the suggestions of interior images, particularly the diffused but brightly colored suggestion of flowers. Thus the muted tones of interior plant life invite a comparison with outside vegetation, which is seen in the full light of day and in saturated color.

The oblique angle of the picture presented me with some challenging compositional problems. The spatial force of the porch post on the left prompted me to balance it on the right with the inverted rocker, not only to strengthen space on the right side, but also to add color contrast and weight on that side of the picture. Although a small detail, the rusty eyehook on the post is necessary to the structure of the upper part of the painting, as are the two rust-mottled suspended plant hooks. These elements are needed clues to the window's spatial orientation in the upper part of the picture plane.

The time of year and atmospheric qualities are as much the subject of this painting as is the architecture. The wood and glass serve as vehicles for the effects of a very warm, humid, late May morning.

WINTER MORNING, NORTH CORNWALL

*Oil on canvas. 27" × 56" (68.6 cm × 142.2 cm).
Collection of Mr. and Mrs. Dean Phypers.*

Winter Morning, North Cornwall in its lateral expansiveness includes in a single image the subjects of virtually all of my major paintings done at the Scoville Farm. *Maple Sapling* (page 95), the single exception, is of a small connecting shed off to the right of the woodpile.

There were several problems working on such an extended lateral plane, but the primary one was to break the horizontal direction. That is why I didn't include the upper roofline and did cut into the second-story windows so that they would interrupt the flow of the long horizontal of the porch roof. The thrust of the side porch into the picture plane caused a certain spatial weightedness on the left side that was too strong to balance with the extended flat facade alone. The addition of the dark recesses of the woodshed, along with the red accent of the vertical boards, helped but didn't quite accomplish the task. Finally, the placement of the clothesline pole, with its strong vertical presence, stabilized the situation by cutting the horizontal sweep and tying the foreground to the house. The pole also echoes the porch posts and other verticals found throughout the picture.

Toward the completion of *Winter Morning, North Cornwall*, I still felt a need to tie in the jutting perspective of the side porch with the frontal facade; the solution rests in the placement of the black chair, its canted angle paralleling the three-dimensional attitude of the side porch.

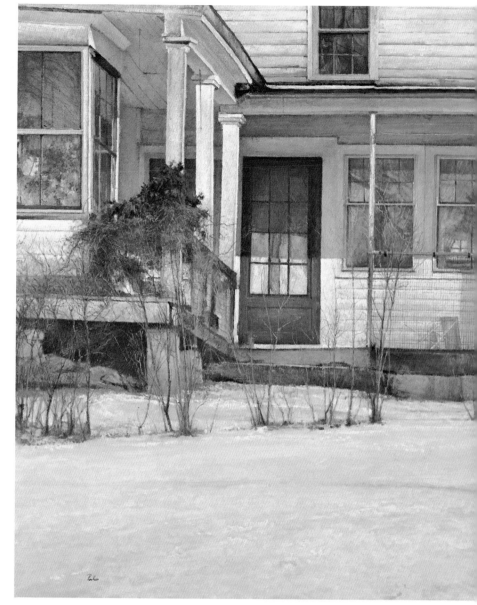

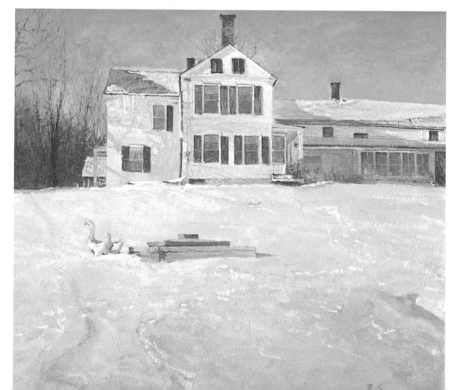

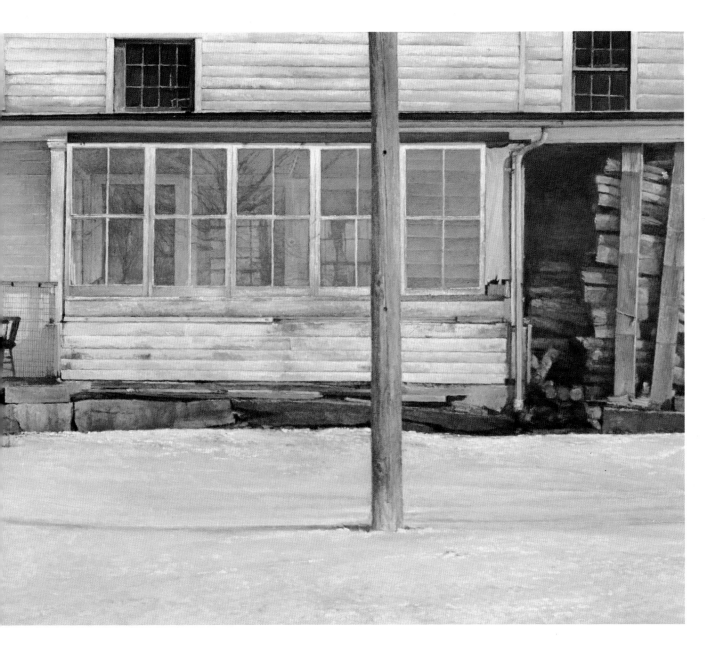

SPRING FED

Oil on canvas. 10" × 11¼" (25.4 cm × 28.6 cm). Collection of Hedda Windisch Von Goeben.

The uphill setting of the Scoville Farm is indicated in this small study. In the Emily paintings, I had used this same compositional device of placing the center of activity near the top of the canvas, but here its application seemed more natural because of the hilly disposition of the land. At the time of this study I was thinking of doing a large, front-on view of the farmhouse, but instead I became more fascinated with the back view. *Winter Morning, North Cornwall* (above) eventually came out of this study, but in another time and in the day's earlier light.

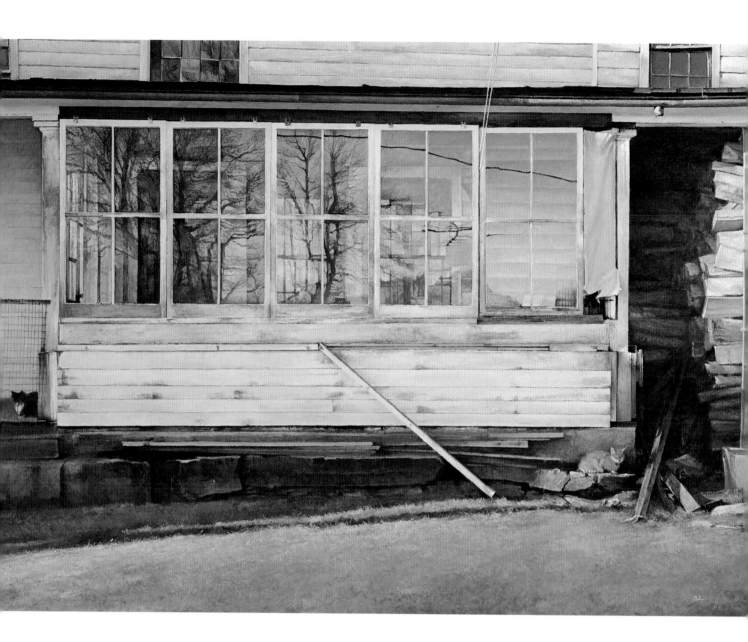

FARM CATS

Oil on canvas. 38¼" × 48" (97.2 cm × 121.9 cm). Private collection.

The full impact of reflected light is explored in *Farm Cats*. The all-important light gradations that I have talked about in preceding works are the key to the success of the space in the frontal planes found here, especially those in the transparent, relfective surfaces of the porch windows. Without this roadmap, the intricacies of overlapping lost-and-found images would be reduced to confusion. Side lighting is also in effect here, reducing and flattening the color of the foreground grass, and giving a warm tone to the reflected light of the house's lower story. This light also provides a temperature contrast with the cooler reflected blues of the sky found in the porch windows.

The success of this painting relies on a few important linear accents: the double strands of clothesline that break the horizontal line of the porch; the rusty sliver of warm color found in the porch rail above the black and white cat, so necessary in defining and clarifying the space of the receding wall behind it; the accent of red silo board that holds the firewood in place; and most important, the two downward-converging elements of

window trim and rusted downspout that frame the tawny colored cat.

Farm Cats is a combination of the subtle space of a facade and reflected images. It's a careful balancing of shapes, colors, and tones. Careful consideration was given to such concerns as how much emphasis should be put on the separate sticks of the woodpile, so that there is a balance between the individual pieces of wood and a group identity; the degree of texture that goes into the grass, so that it doesn't detract from the texture of the twiggy reflections in the glass; or how much peeling paint to include so as not to make the facade a confusion of parts with no sense of the whole.

There is also a particularly important area of the painting that focuses on a primary triad of color: the blue windows, the red silo board, and the yellow cat. This strong color concentration is then balanced by the sheer volume of the facade, with its gathering darkness of reflected trees, heavy foundation stones, and shadowed grass.

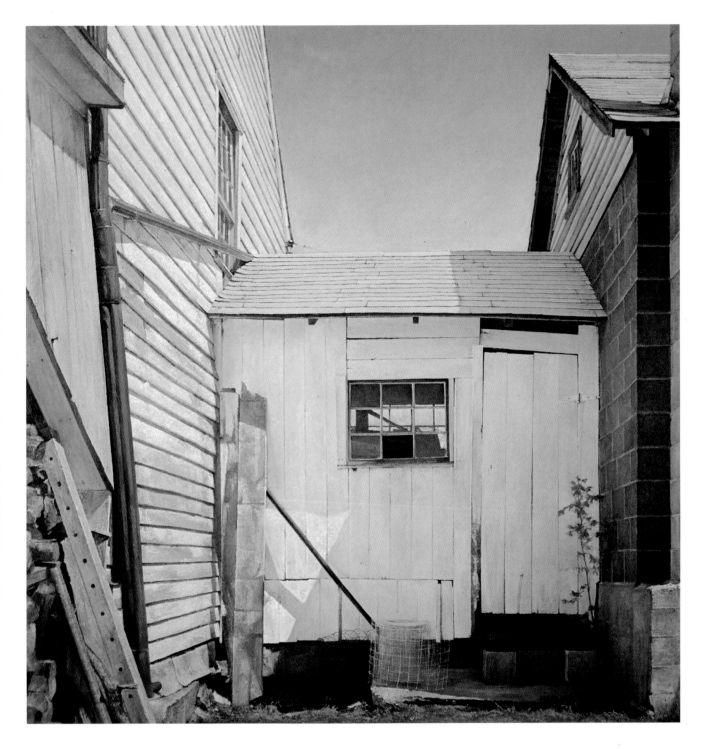

MAPLE SAPLING

Oil on canvas. 48" × 45" (121.9 cm × 114.3 cm). Private collection.

Just to the right of the woodpile in *Farm Cats* (opposite) is this little connecting shed, which leads to the garage. One particularly warm spring day I noticed the wonderful interplay of reflected light on these buildings, especially the shed's cool, inviting shadow. The richness and variety of light, and the geometries of peaks, pipes, blocks, and clapboards, were an irresistible situation.

To my eye, the changes within the shadow's reflected lights were an endless delight. I particularly liked the gradual transition from the house's sunlit influence to the sky's cooler influence. Also, every board's warp and inclination had its own effect on what and how much light was reflected.

For me, this painting is an intriguing meld of textures and surfaces: clapboards, cinderblocks, concrete, rusted iron, glass, and wire, a compression of various substances and forms all brought together into a cohesive whole by the aura of light.

JANUARY THAW

Oil on canvas. 32″ × 54″ (81.2 cm × 137.1 cm). Collection of Mr. and Mrs. P. Dean Phypers.

January Thaw shows a deep spatial orientation. It incorporates more of the architectural forms and includes more of the landscape than do the earlier paintings of this same site. There is also greater variation in and more interesting shapes made of the negative spaces found in the sky.

When working with an oblique angle such as this one, I find that some sort of counterbalance is required. In this case I used the opposing perspective of the adjacent porch's iron railing and post. The horizontal railing intersects the glassed-in porch's movement from left to right, and the vertical post, extending the entire height of the picture plane, acts as a visual stop.

The problem I faced by superimposing the more frontal planes of the iron pipings onto the porch area was the possibility that these forms would overpower the intricacies of the glassed-in porch. If their rusty textures were overly developed or too focused, these strong forms would simply call too much attention to themselves. To counteract their forcefulness, I scraped and repainted until I gained the correct balance of suggested texture and form.

As in previous paintings of this site, the suspended plant hooks are the key to the sense of space in the upper canvas. They not only echo the porch post but also repeat the linear pattern of the trees at the woods' edge. The left hook piercing the sky is particularly forceful in conveying the importance of the vertical theme.

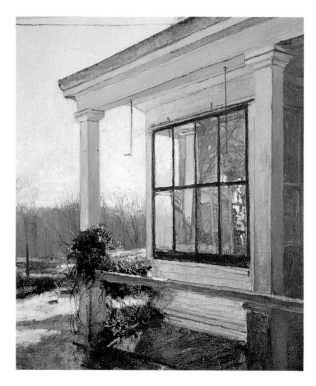

TWILIGHT

Oil on canvas. 10¾″ × 9″ (27.3 cm × 22.9 cm). Private collection.

This study is a transitional painting between the slightly angled space of *Reflections, Spring Skies and Siloes* (page 91) and the much deeper oblique perspective of *January Thaw* (opposite). It was in this painting that I became interested in the angular negative spaces of the sky as they played against the architectural forms.

Because I painted this picture so late in the day, the light is concentrated in the sky and in a few sunlit patches of snow. The sky is the warm foil against which the darker shapes of land and architecture are played. In this case, the spatial thrust of the darkened porch is countered by the saturated, complementary colors of yellow sky and purple woods. To integrate the two areas, patches of white snow bring the color of the house into the landscape.

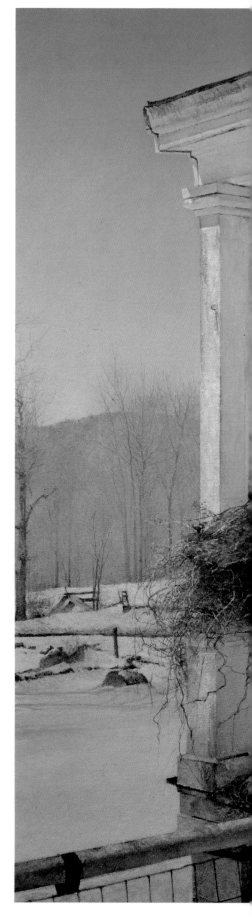

96

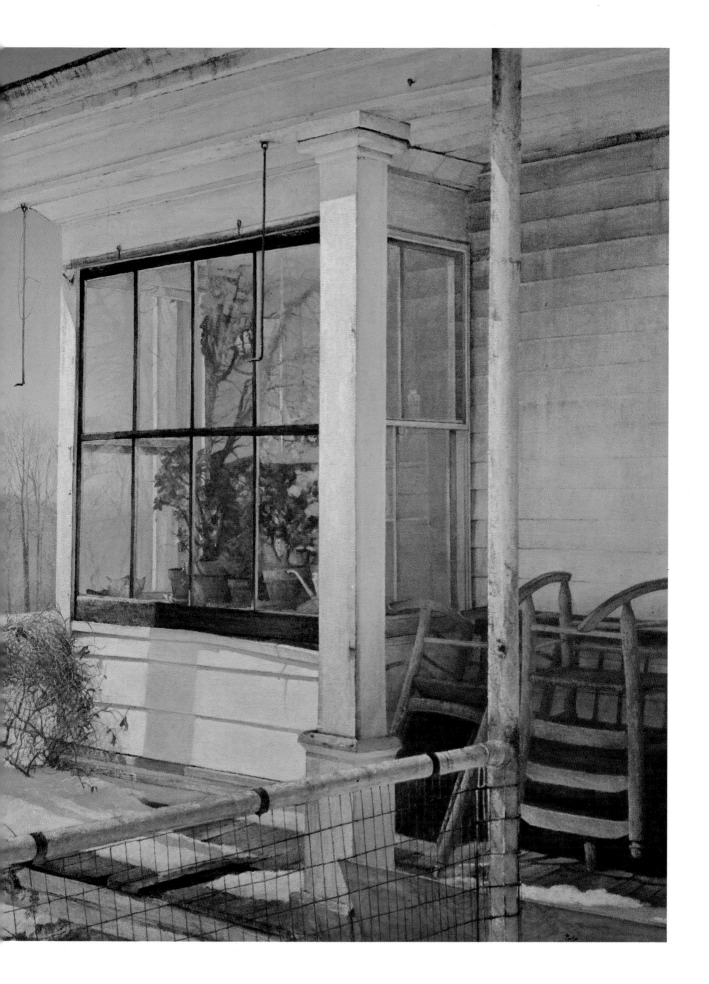

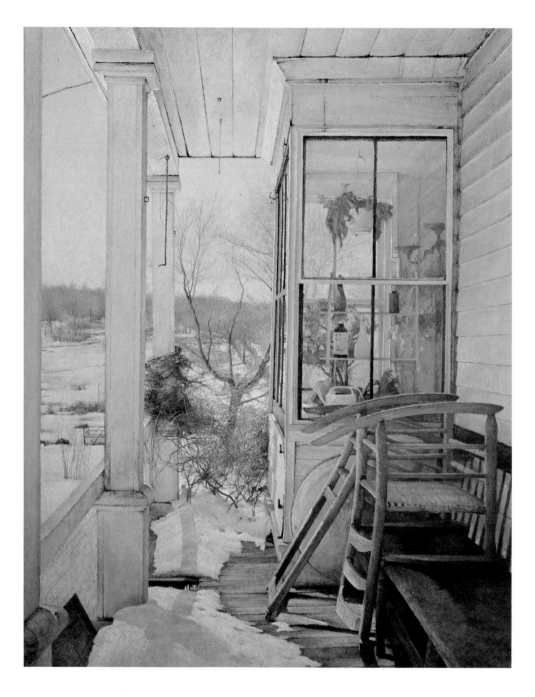

PORCH ROCKERS

Oil on canvas. 52" × 40" (132.1 cm × 101.6 cm). Collection of Mr. & Mrs. Robert C. Jones, III.

I can remember the morning I climbed onto the porch at Scoville and was awestruck by the penetration of winter light. This peculiar combination of cool/warm reflected light bouncing off of white snow pervades and unifies the entire painting. Everything tends to take on a fragile, linear quality; the excitement comes from the intermingling of drawing and painting.

Space is achieved through subtle color-tonal shifts; the lavender yellow of shadowed wood is contrasted against the cooler blue of sky and the colder white of snow. Edges also help define space and form; small recesses, such as the separations between boards and clapboards, indicate where the penetrating light can't enter and is angled into deep shadow.

Small rusted pieces of iron, saturated in color and tone, take on an added significance as they punctuate ghosts of objects absorbed in this engulfing light. The intensity of the light also exaggerates the impact that the dark window frames make on the airy fragility of the objects inside; it makes the faded blue chairs seem fuller and stronger and the beige-ochre of the splint seat more colorful. The chairs were included not only for their much-needed relatively strong color but also for their spatial impact on the composition. Although omitted in both *Spring Plowing* (opposite) and *January Thaw* (page 97), the porch railing appears here because I felt the added spatial orientation was not distracting but necessary in this more subtle and complex view. I also added the third porch post to heighten the sense of space through sequenced repetition of form; I left some negative space showing between the middle and corner posts for the same reason. The plant room objects inside are more substantial than in the other paintings; blooms and bottles accent the spaces as I felt the need for more spots of color.

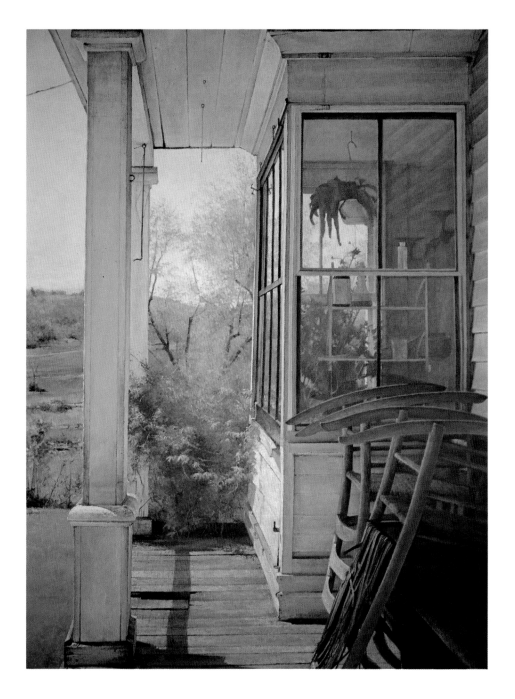

SPRING PLOWING

Oil on canvas. 48″ × 38″ (121.9 cm × 96.4 cm). Private collection.

Warm weather brings a flurry of activity to the farm; with enough dry weather and a diminished chance of frost, the ground can be plowed, tilled, and planted. Overturned porch rockers remain in their winter positions and won't be used for some time yet.

Perspective plays a more important role in this painting than in the more frontally oriented works, such as *Afternoon before the First Frost* (page 90), but the frontal mode is still very strong here. A spatial sense is as much a product of overlapping forms as of truly three-dimensional rendering of individual objects. The correct spatial sequencing of forms on the porch is also a result of color-light gradients: The near post is darker and warmer than the lighter, cooler one behind it; the very subtle gradations of warm yellows shift from far (light) to near (dark) on the porch ceiling; and the color changes determined by

reflected light on the vertical surfaces are warmer on the bottom, cooler on the top.

I integrated and tied the landscape to the architectural form in several ways: The wire across the sky in the upper left parallels the plowed field, which is reflected in the left bank of windows; the exposed tree branches echo the color and thickness of the window mullions; and the rockers' cool copper blues pick up the rhythm and attitude of the plowed strip of land. There is also a similar lateral tie weaving through the lower part of the picture, running from the rocker blades and seats of the blue chairs to the porch's plank floor and out onto the hedgerows and stone walls of the field and hill.

In general, this painting is about looking through a formally organized tunnel of reflected light out onto the direct light of the landscape beyond.

APRIL, CREAM HILL

Oil on canvas. 36½" × 60" (92.7 cm × 152.4 cm).
Collection of Exxon Corporation.

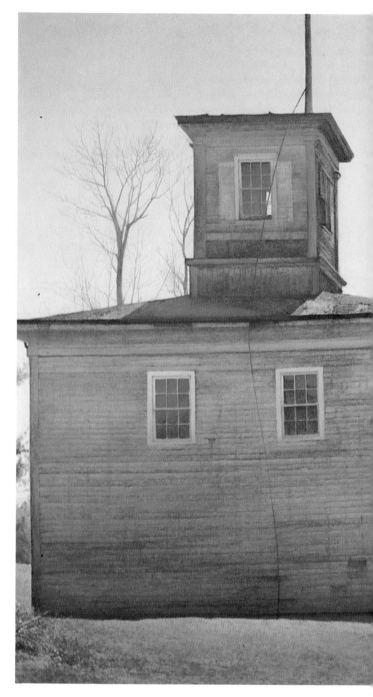

My first impression of Cream Hill was a shocking one, for in my southerly uphill approach the school building was virtually masked by the immaculate white farmhouse. A sudden twist in the road put the ghostly gray building in front of me as if it had been dropped from the sky. The sudden impact of this image has never left me, and no matter how many times I return, there is always a feeling of astonishment in "refinding" it.

As the title implies, it's early spring—one of those warm, semihazy, cloudless days without anything but a few dark branches to cut the impact of sunlight. Here we see the more intimate rear view of the house, backlit with the first of the sun's rays hitting the freshly hung wash. Backlighting has always appealed to me, not only for its effects of intense translucent color, but also for the dramatic effects of sunlit planes placed against massive shadow areas. In this case, because of the high, late morning sun, a strong and wonderful dose of reflected light is brought into play within the shadows. The rear of the white house, which is out of the sun, relies on subtle color and tonal shifts, along with edge contrasts, to help position itself in space. Both sky and white clapboards are keyed very close in tonality. The relative darks of the windows and door punctuate the house and establish its place in the picture plane. By contrast, the gray schoolhouse, with its larger scale, darker tones, and textured surface, establishes itself in space in a more obvious way. However, as in the farmhouse, the windows still contribute to and reinforce the spatial identity of the building.

Compositionally, this is a middle distance painting with an unusually strong reference to the rectilinear. The painting can be broken down into a series of interrelated rectangles, from the largest to the smallest. In this case, not only do the rectangles change size, they change their substance and appear here as brick, wood, glass, cloth, or tin.

Within this essentially rectangular format, there are curvilinear accents to be found, such as the relationship between the vertical sweep of lightning cable draped across the schoolhouse and the graceful lateral arch of the weighted clothesline.

If it seems that I've dwelled too much on the formal, compositional aspects of painting here, it is because these underlying structures and harmonies are so essential to the strength and stability of the final work and these vital elements cannot be overlooked.

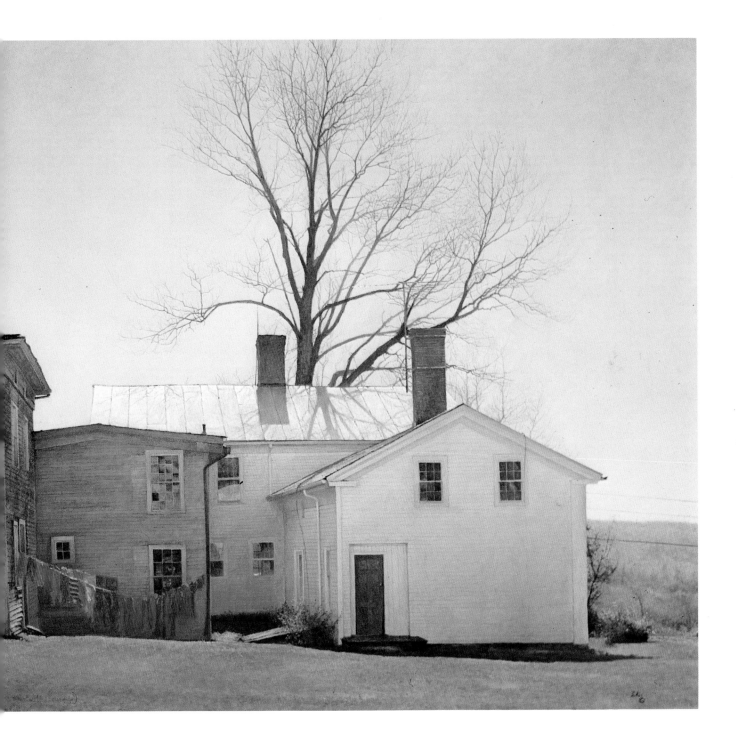

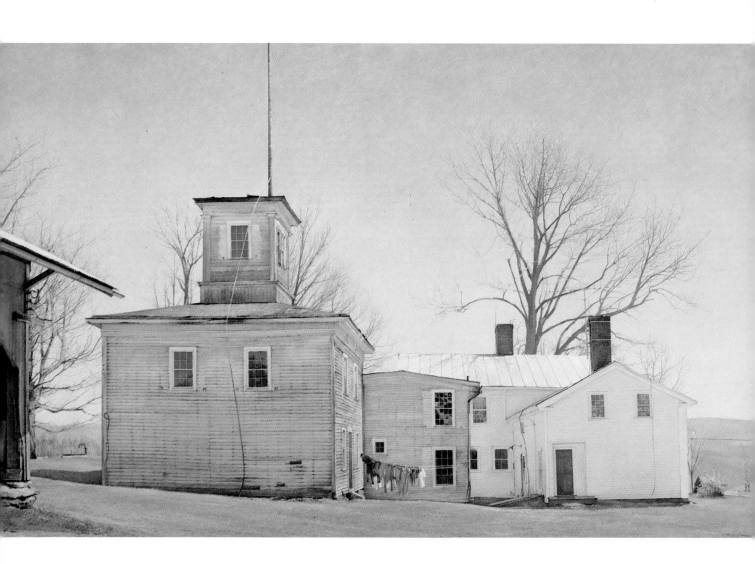

MIDDAY, EARLY SPRING

Oil on canvas. 36½" × 60" (92.7 cm × 152.4 cm). Private collection.

The solidity of form and looming presence of the buildings in *April, Cream Hill* (preceding page) are replaced here by a fragility and assimilation into the landscape. Because I am viewing the same scene from a farther distance and at a later time of day, a higher-keyed, more penetrating light tends to unify the buildings with the sky and far hills. This light particularly affects the gray school building, placing more emphasis on the windows and roof edges because of the loss of contrast between the structure and the sky. The handling of the architecture requires a delicate balance between the subtle tones and color shifts of the larger forms and the dark, linear accents of clapboards and vertical nailing patterns. Too much darkness destroys the subtle light and space; too little and the structure blows away.

Given the elusive nature of the buildings in this painting, I made the edge of the barn on the left the key to the composi-

tional punch that exists here. By placing the barn close to the schoolhouse, I was able to set up a spatial dynamic between the diagonal thrusts of the two roofs. The relationship between these two buildings creates the sky's negative space, an area that is also a reversed reference to the barn's dark opening. Further diagonal references were reinforced by accenting the lightning cable, reversing it from light on dark above the roof line to dark on light below. A jet's vapor trail is another subtle diagonal link going from the barn's rooftop to behind the schoolhouse's widow's walk.

The colorful reds found in the chimneys, drying wash, and barn boards serve as unifying and balancing accents, as do the darker blue and black spots of windows and doors. These areas also function to keep the eye circulating through the composition rather than focusing on one particular thing.

102

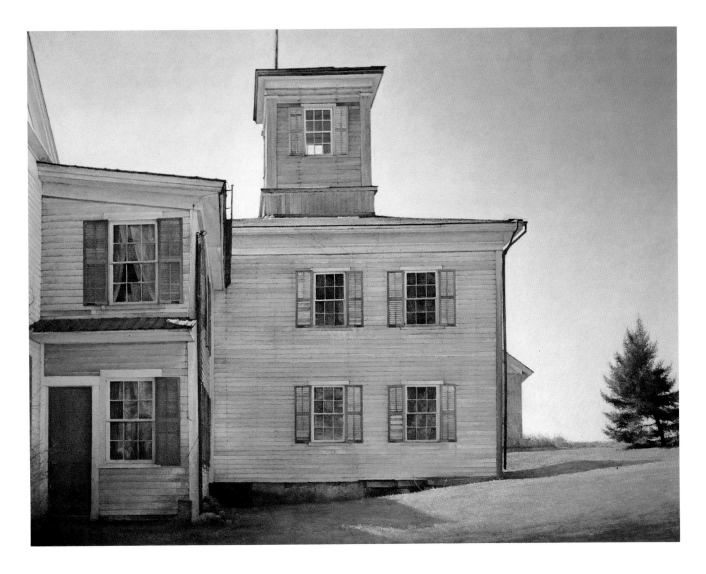

CREAM HILL SCHOOL

Oil on canvas. 44″ × 48″ (111.7 cm × 121.9 cm). Private collection.

This is the Cream Hill agricultural school, seen from the road. On the left side of the canvas is the white farmhouse that masks the school from view as you come up the hill. There is a ghostly feeling about the schoolhouse, as if it's from another time.

I painted this subject late in the afternoon, primarily for the strong backlighting effects and for the pronounced impact of the sky's negative shape. The clear blue of the sky plays against the mass of architecture and echoes the building in reverse. The late day's warm light bounces off the grass onto the lower right side of the building before it gives way to the sky's penetrating blue light. I kept the direct light hitting the architecture to a minimum, limiting it more or less to the shallow rooftop and a few edges of walls and trim, in order to maintain the contrast between shadow and sky.

The windows were painted with a high degree of reflection rather than darkness, because I wanted them keyed to suggest the surface of the plane rather than a sense of depth. The two windows on the left side are bluer and/or darker than the grouping of four; this helps give them a certain spatial dominance on this side of the picture. The patch of blue sky that shows through the widow's walk window is extremely important in linking the sky's negative space with the architectural forms. The little pieces of sky found between the roofs' gutter edges also help with this integration.

Maintaining a compositional balance was a problem. From this particular viewpoint, the edges of the barn and tree are not visible: The barn is behind the school, the tree far off to the right of the picture plane. To balance the massive forms on the left, and for spatial keying, I included the tree's dark shape on the right; to break up the straight vertical wall of the school-house, I "moved" the barn so that its edge appears to the right of the schoolhouse. A glimpse of clothesline was also extracted from the back side, not only as a color accent but also to help define the distance between schoolhouse and barn.

Dawns and Dusk

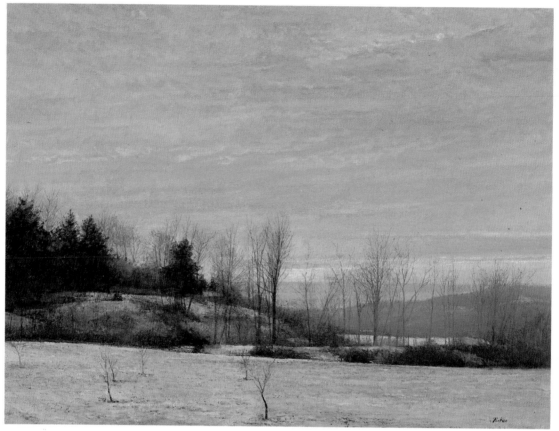

DAWN 1
YOUNG ORCHARD SERIES, *oil on canvas, 18¾" × 24" (47.6 × 60.9 cm).*
Courtesy of Sherry French Gallery.

The integration of land and sky

The most recent developments in Peter's work began with a few small studies he made of the view at dawn from his back porch of a young orchard of apple and pear trees he had planted. These paintings awakened him to new possibilities of color, composition, atmosphere, subject matter, and painting methods that he began to apply in later works.

Up to this point, Peter had been preoccupied with the variety and effect of light as it played upon the textures and angles of architectural planes. Structure, shape, and space had been the major concerns; landscape essentially served as a foil. It was a counterbalance, a framing device, a shape. Color, as well, had come to be employed in a structural fashion to achieve plasticity, perspective, or balance. "I had always thought of sky as negative space in my compositions," Peter explains. In the Dawn and Dusk series, Peter began, in the context of a single pure landscape format, an exploration of the illumination of the sky and of the nature and color of the effects of weather and the atmosphere.

The format is a very simple one: A horizontal landscape strip in the far middle distance divides the canvas into a big sky and a narrow, empty foreground. In the median strip, the low, undulating hills and massed evergreen forms echo the cloud shapes, while the nervous bare branches of the hardwood trees lend a sense of energy as well as texture to the composition.

Almost all the views are in winter, mainly because the frozen or snow-covered land provides a neutral surface that reflects the sky. Furthermore, discrete cloud patterns are rare in the summer, particularly at sunset, since the heat of the day's sun tends to evaporate the clouds. Peter would wait every day for interesting cloud patterns: "Cloud effects were an essential part of these works, giving a variety of pattern and color, as well as spatial references."

Spring Evening (page 107) was one of Peter's few efforts to capture the effects of sunset over the new orchard. The painting is really a dusk scene, since the sun is setting in the opposite direction from this view and is off to the right. Thus, the light on the clouds and distant hills is a sidelight instead of the backlighting Peter usually favors. This type of lighting is subtle and difficult to capture, since each of the four corners of the sky area is a different color and tone, implying a different color perspective at each point. Retaining the dome effect of the light and space envelope of the sky requires the utmost precision in transitional color and value.

The role that weather plays, not only in the cloud patterns but also on the atmosphere and the land, can be seen in *Dawn 5* (page 110), which shows an ice storm clearing; the dense, ragged clouds deaden the sky overhead and the land below. The light of the emerging sun shines through the translucent atmosphere. A few scattered, glistening highlights on the stubble of the field and the bare branches of the trees hint at the coating of ice.

Cloudy Morning (page 109) shows the rolling, cyclonic patterns of an arctic chill, the sub-zero wind thickening the crust of the week-old February snow. While the sun hasn't begun to emerge, the clarity of the light in the sky shows the dryness of the air, and the reflections on the snow indicate the matte texture of the granular surface.

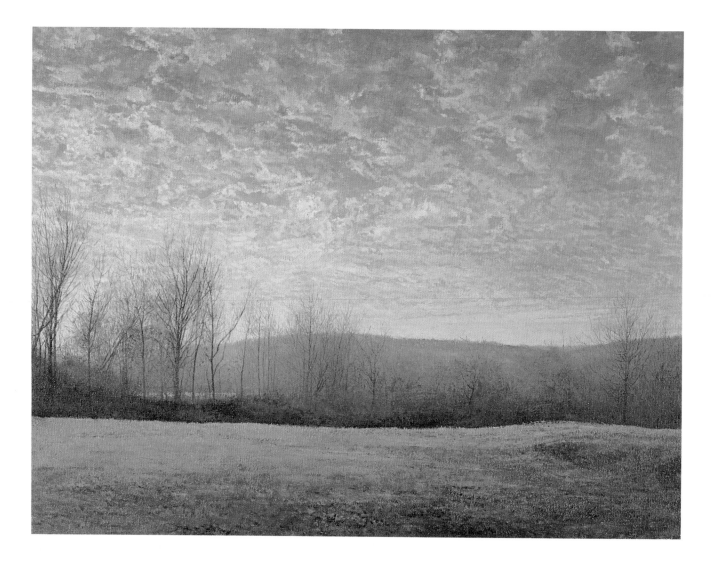

APRIL MORNING, NEW ORCHARD SERIES

Oil on canvas. 18½" × 24" (47.0 cm × 61.0 cm). Courtesy of Sherry French Gallery.

Dawns were painted from my studio window overlooking a small hayfield, where I had planted an orchard of apple, peach, pear, and cherry trees. This proximity allowed for a very convenient day-to-day, even minute-to-minute, observation of my subject in all its dispositions. The closeness and familiarity of the setting freed me to concentrate on subtleties of light, color, tone and their transitions. It had also made me acutely aware of the importance of timing and critical changes in transitional light. When the vocabulary of clouds is understood not only is what's happening at the moment made clear but also there can be some predictability as to what is forthcoming. Many times I would think the show was all over, as I returned by car from a nearby ridge, only to look in the rear-view mirror and glimpse a small part of the drama that I had prematurely discounted. The rush back was never quick enough.

April Morning describes the particular atmosphere of a spring morning in April: extremely moisture-laden and soft. The even textures of the regularly patterned sky and grasses reinforce the softening effects of the atmosphere; because this picture was painted a few hours after dawn, the late morning light tends to subdue texture and form and make the surface appear even more uniform. There is no indication of the young orchard trees so as not to break into the quiet textures. *April Morning* is an interplay between the textures of the sky and the texture of the grasses, separated by the strip of hills.

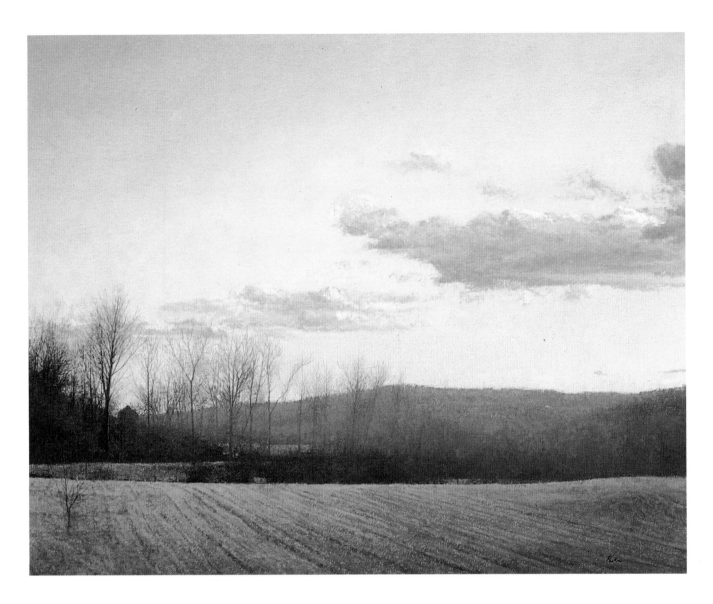

SPRING EVENING, NEW ORCHARD SERIES

Oil on canvas. 19½" × 24" (49.5 cm × 61.0 cm). Collection of Mr. and Mrs. Ted Bellingrath.

It's unusual for me to work on paintings of the young orchard late in the day, because the large hill to the west blocks most of the sun's light long before it sets, eliminating any of its direct influence in the foreground. This particular day, however, the light, color, and cloud patterns were extraordinarily handsome.

There is a separate and specific pattern to the clouds here, as opposed to the uniform texture of *April Morning* (opposite). The clouds, as they step back in space, parallel the receding hayfields in the landscape. A further link with the land is achieved by the shape of the clouds—especially the largest, as it approximates shape and color of the distant hills.

Although *Spring Evening* was painted at the same time of year as *April Morning*, the day's sun has burned off most of the clouds and lessened the moisture content of the air, making sharper and clearer images. The light, now originating from a lower angle, makes the furrows in the hay more prominent, unlike the high sun of early morning that negated the shadow pattern. A young pear tree appears on the left side of the painting; its function is to turn the eye back into the composition and to reverse the direction of the perspective lines found in the hayfield.

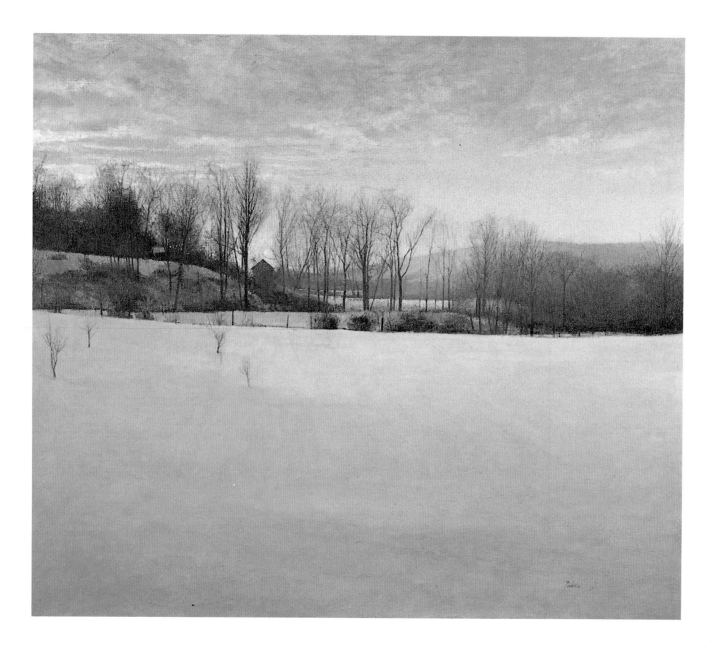

DAWN 3, NEW ORCHARD SERIES

Oil on canvas. 21" × 24" (53.3 cm × 60.0 cm). Collection of Tim and Victoria Maby.

Dawn 3 describes a real dawn, painted very early in the morning, showing the increasing effects of moisture-laden air as it moves deeper into the picture plane. Compared to the far hills in *Spring Evening* (page 107), these hills seem to disappear into the sky, not only because of the misty air, but also because of the muting coat of hoarfrost covering the trees.

Space is achieved through color and light. The cloud patterns here are formed by subtle gradations of soft color rather than by separate, specific shapes, and the hayfield is seen as a flat mass whose sense of perspective is covered with snow. I added more foreground to this painting to make unequal masses of sky and snow, a compositional change that places the band of hills higher on the canvas. The deeper shades of the foreground reflect a part of the sky where there is more of the cloud cover that is only glimpsed in the upper left of the picture. The foreground's cool mass of violet grays is played against the warm colors of the sky near the horizon.

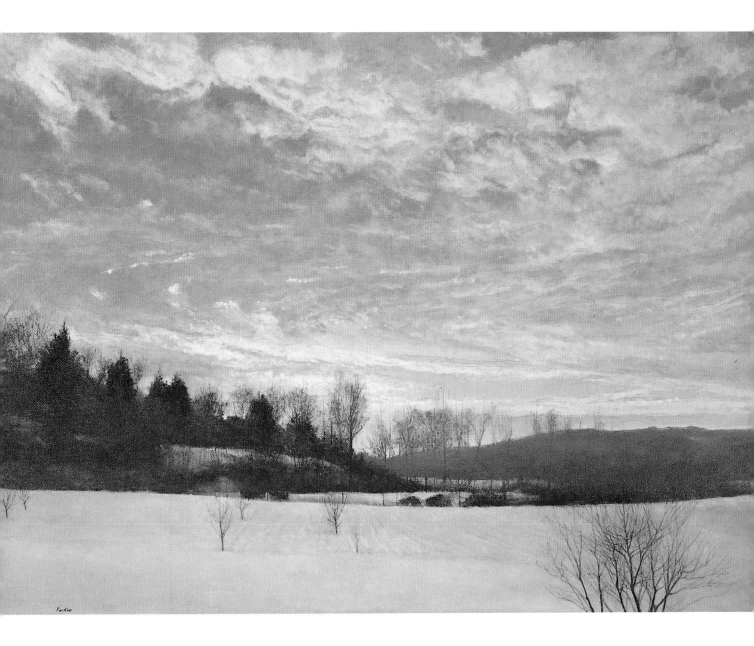

CLOUDY MORNING, NEW ORCHARD SERIES

Oil on canvas. 17¼" × 24" (43.8 cm × 61.0 cm). Private collection.

Cloudy Morning sets a swirling pattern of clouds against the calm of the land below. Variation in the hillsides is kept to a minimum, making a dark shape that separates the two elements of sky and snow. Aerial perspective is also subdued to keep the unity of a dark ribbon stretching across the picture plane. The tree in the right foreground is extremely important here, not only to balance the bulk of concentrated darks on the left side of the canvas, but also to echo the agitation of the cloud pattern.

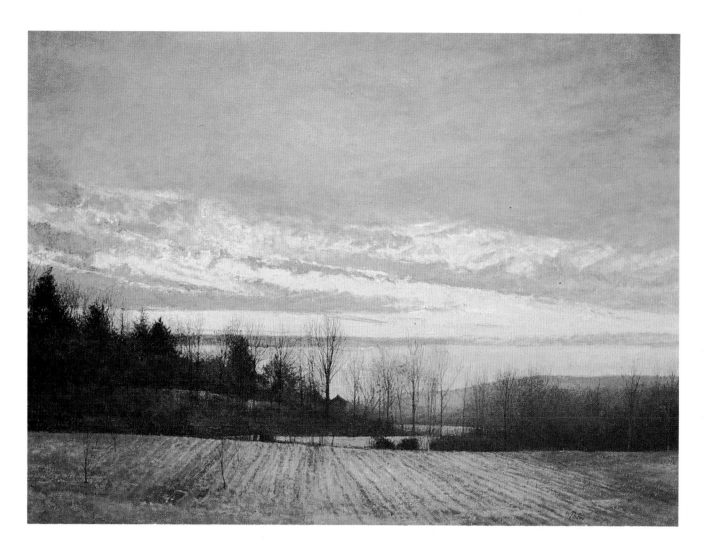

DAWN 5, NEW ORCHARD SERIES

Oil on canvas. 18" × 24" (45.7 cm × 61.0 cm). Collection of Mr. Orton P. Camp, Jr.

Dawn 5 was painted in early winter, with hay stubble still showing through the first shallow coverings of snow. It is mid-December; the clouds thoroughly covering the upper part of the canvas, leave the more dramatic contrasts just above the horizon. A lower band of hills with a shortened foreground plane gives a totally different spatial configuration from that found in *Dawn 3* (page 108). This is true in spite of the fact that the horizontal scope of both paintings is almost identical.

The unity of land and sky in this painting is largely due to the similar coloration of clouds and grasses; both are variations of warm siennas, browns, and grays. Land and sky are further tied together by the linear nature of the rows of grass echoed in the more random patterns of clouds in the lower sky. In other words, what grass is to field, clouds are to sky. *Dawn 5* focuses on the shapes and contrasts found in the lower part of the sky and the horizon, while *Dawn 3* places more emphasis on the total envelope of space as described through color differences and transitions. In *Dawn 5*, the thrust is toward the integration of similarities, resulting in a flattened, more intimate space.

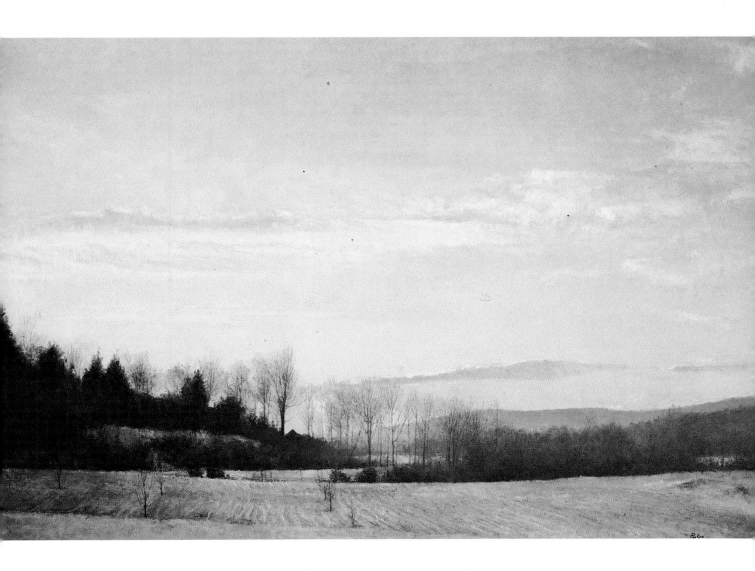

DAWN 6, NEW ORCHARD SERIES

Oil on canvas. 14½″ × 23″ (36.8 cm × 58.4 cm). Collection of Mr. and Mrs. Michael Sermer.

Dawn 6 was done later in the morning than *Dawn 5* (opposite) and illustrates the flattening tendency produced by a higher, cooler, and stronger light. The scope of the view is also broader, which tends to flatten the foreground and reduces the impact of the hill on the left, making for an easier penetration into the far distance.

In this painting, the center of interest is the horizon line on the distant blue hill. The pink cloud above the hill echoes the hill's shape and is also its color complement.

The sky is expansive here; the subtle cloud patterns echo the receding strips of fields. Unlike *Dawn 3* (page 108), where the foreground is a simplified mass, there are textural interests in the foreground as a foil to the simpler sky above. The high-keyed cloud pattern is again picked up by the diagonally shaped snowcover in the immediate foreground area on the lower left.

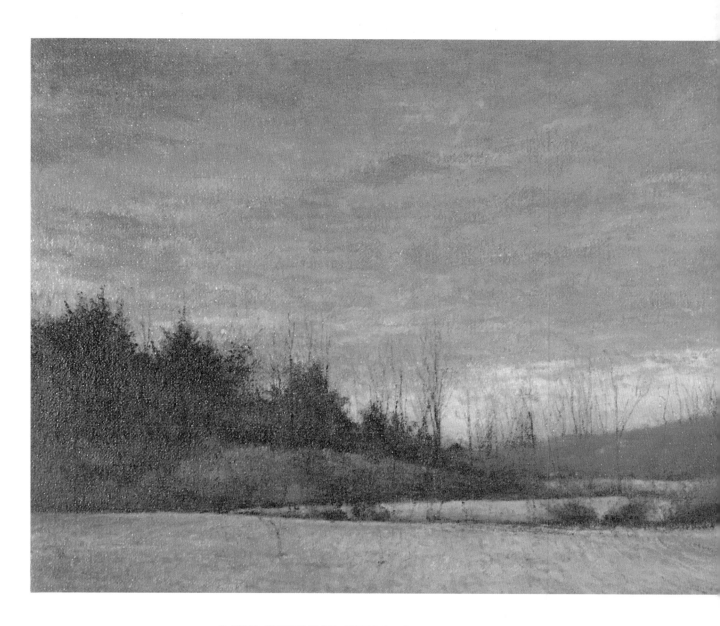

DAWN, DECEMBER, NEW ORCHARD SERIES

Oil on canvas. 10¼" × 18⅜" (26.0 cm × 46.7 cm). Courtesy of Sherry French Gallery.

This is the first small work executed on a colored ground; every other painting of the dawn series was done directly on white canvas. The rich, warm hues of this particular dawn prompted me to try this method. In this case, I worked into the magenta ground immediately, wet into wet, rather than waiting several days for the wash to completely dry before beginning the actual painting, as I usually do with my larger works. The result is a softness and a visual sense of unity compared to the dry edginess of most of the other dawns. This method is more immediate, direct, and painterly, with more fusing and integrating of pieces into the whole. Compared to the earlier orchard paintings, *Dawn, December* has a more painterly and atmospheric effect that all the rubbing, blotting, and modulations of my former, drier approach didn't convey.

The next day, after the paint dried a little, I would go back and very selectively enhance and accent certain edges and forms. I found I was more interested in responding to what was happening in the paint than documenting the specifics of place.

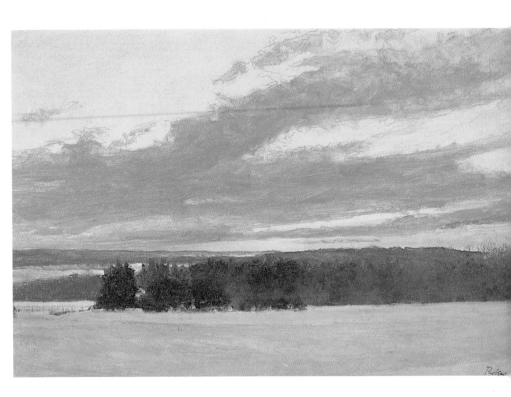

SUNSET, FERENCE FARM

Oil on canvas. 9⅜" × 14" (23.8 cm × 35.6 cm). Private collection.

This is a westward facing view of a farm located on a nearby ridge several miles from my home. As indicated by the more obvious brushstrokes, this study was completed in a single session—alla prima.

Sunset, Ference Farm focuses on the concentration of sharpness and color found at the horizon line just after the sun has set. The cloud, land, and tree masses are secondary to this idea; their suggested textures are left in a relatively unfinished state.

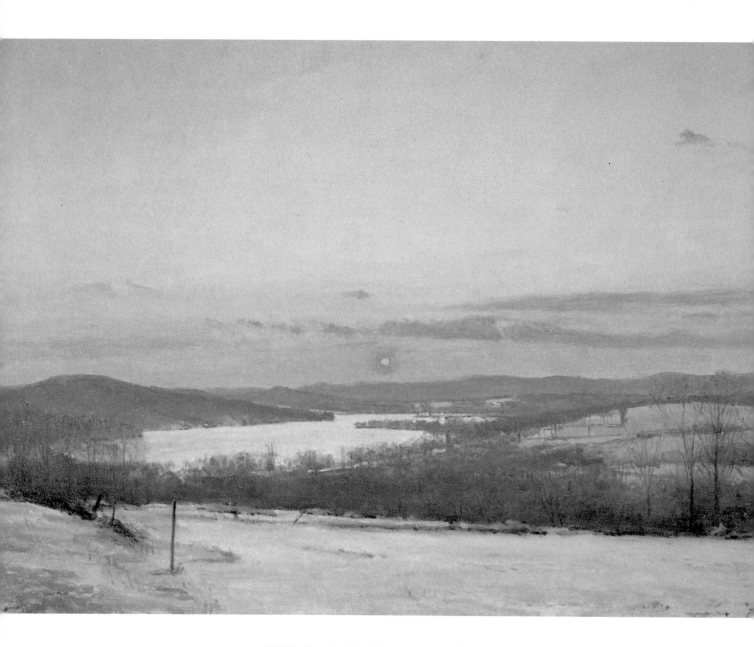

SETTING SUN, LAKE WARAMAUG SERIES

Oil on board. 13⅛″ × 17¾″ (34.0 cm × 45.1 cm). Courtesy of Sherry French Gallery.

A very different light situation and time of year prevail in this painting. Because of the great deal of moisture left behind by a clearing storm, the aerial perspective is more extreme here. So heavy was this effect that it tempted me to include the sun. More detail can be found in this painting than in *Sunset, Lake Waramaug Series* (opposite), partly because *Setting Sun* is larger and partly because the greater contrasts made by the snow-cover require more differentiated edges. The polarity of lights and darks creates a sense of flatness in the land and cloud masses. Space is implied here by detailed edges and overlapping shapes and augmented by the scale changes. Because of this type of handling, this picture has a distinct Japanese feeling.

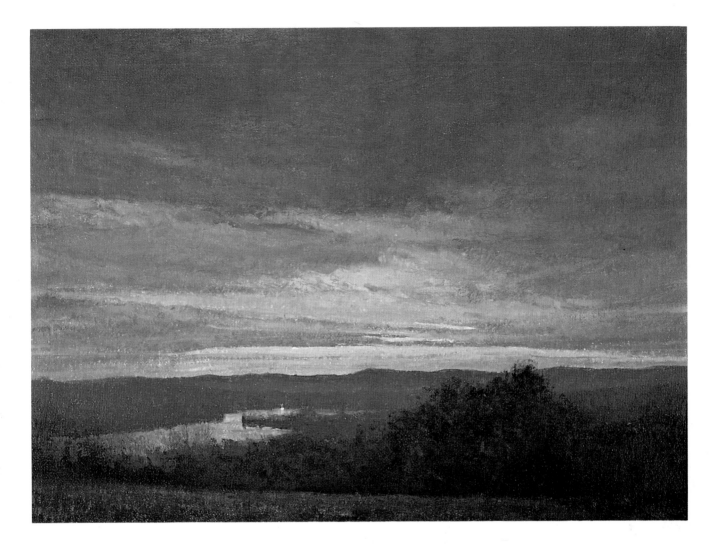

SUNSET, LAKE WARAMAUG SERIES

Oil on canvas. 10" × 14" (25.4 cm × 35.6 cm). Courtesy of Sherry French Gallery.

The hill west of my orchard blocks the light from the sun a full two hours before it actually sets, which limits the strong color effects of the setting sun in the far distances. Because of this, I searched out westward facing ridges within a fifteen- or twenty-minute driving radius, settling on this spot overlooking Lake Waramaug.

The lake was of particular interest to me because of its tendency to inject patterns of light into the darker land masses. This was an important consideration here, because looking directly into a sunset involves backlighting effects, which will group and emphasize the darks even during the daytime, but more so during the subdued light of late day.

This is a small study painted directly on white canvas in a fairly dry manner, as evidenced by the similarity of textures found in the sky and foreground land masses. A larger work would have made more allowances for these differences. The purpose of this study was to capture the light of the moment, so there was little concern for textural detailing.

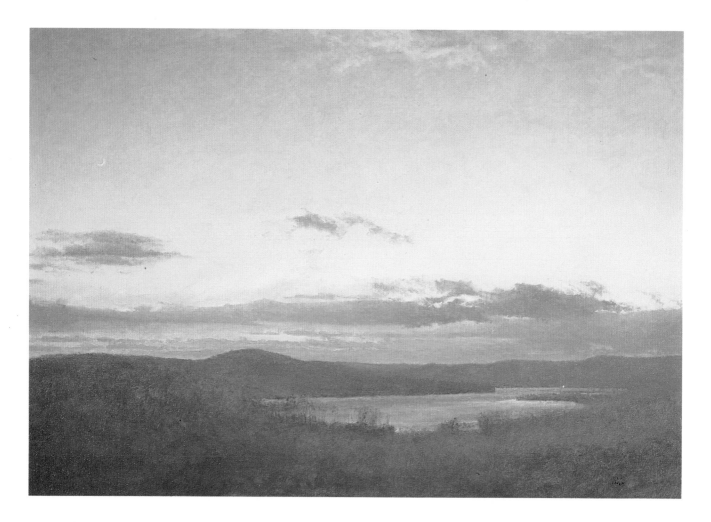

MOONLIGHT-TWILIGHT, LAKE WARAMAUG SERIES

Oil on canvas. 17" × 24" (43.2 cm × 61.0 cm). Courtesy of Sherry French Gallery.

This painting was done in late fall and shows the more drastic clearing provided by an incoming cold front. There is a dramatic concentration of color at the horizon contrasted with the distinctly clear twilight above. An almost burning yellowish white, changing to a colder, darker blue, forms the gradient on which the cloud masses are superimposed. It is very important that these lower clouds are crisp; the emphasis here is on their effect on light and color rather than their feathery forms. This essence of "cloudness" is indicated by the softer, more ethereal forms found in the upper canvas; they also serve as subtle overlapping spatial indicators of the relatively empty space of the higher sky.

The keying of the foreground is intentionally subdued so as not to detract from, but rather to enhance, the drama of the lower sky. Even the ruffled, reflecting waters of the lake have been kept dull to reinforce this contrast. The darkened lake also provides a subtle backdrop for the point of light originating on the lake's far shore, which in turn is echoed in the crescent moon.

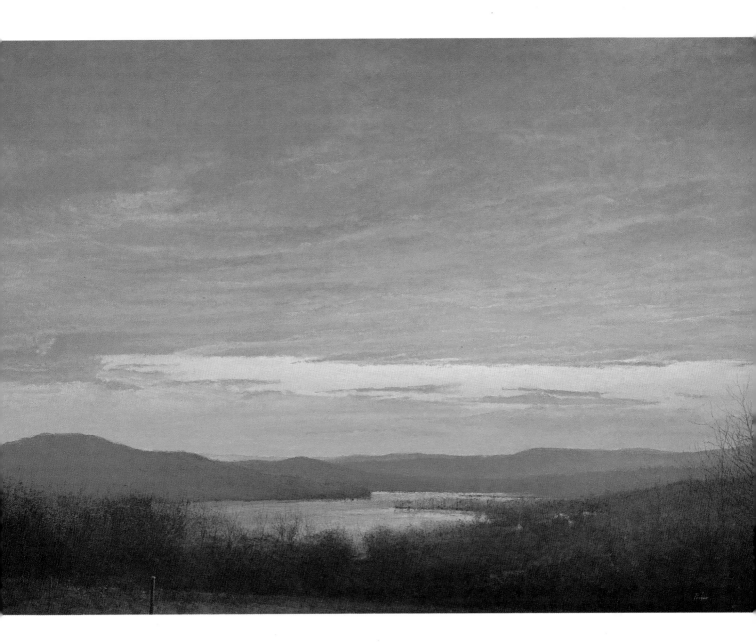

NOVEMBER, LAKE WARAMAUG SERIES

Oil on canvas. 19½" × 27" (49.5 cm × 68.6 cm). Property of The Bank of New York.

This is a painting of a full-blown sunset, as opposed to the more muted tones of twilight found in *Moonlight-Twilight, Lake Waramaug Series* (opposite page). The colors of the lake, influenced by the band of yellow in the lower sky and the violet cloudcover above, are quite warm. In *Moonlight-Twilight,* the relatively cloudless colder blue of the sky also prevails in the water's reflections.

Because this is November and there isn't any snowcover as yet, the landscape has a pervasive darkness that tends to throw emphasis on the lake itself. There is, however, within this darker format, a gradual transition from the cooler blues of the distance, through the purples of the middle ground, forward to the browns of the immediate foreground.

This painting is about, more than anything else, the liquid surface of the lake and the gleam of bright water found near the edges of the land forms. The quiet foreground is matched by the gentle sky above, giving this painting a restful pace compared to the more animated and contrasted surfaces of *December, Lake Waramaug Series* (overleaf).

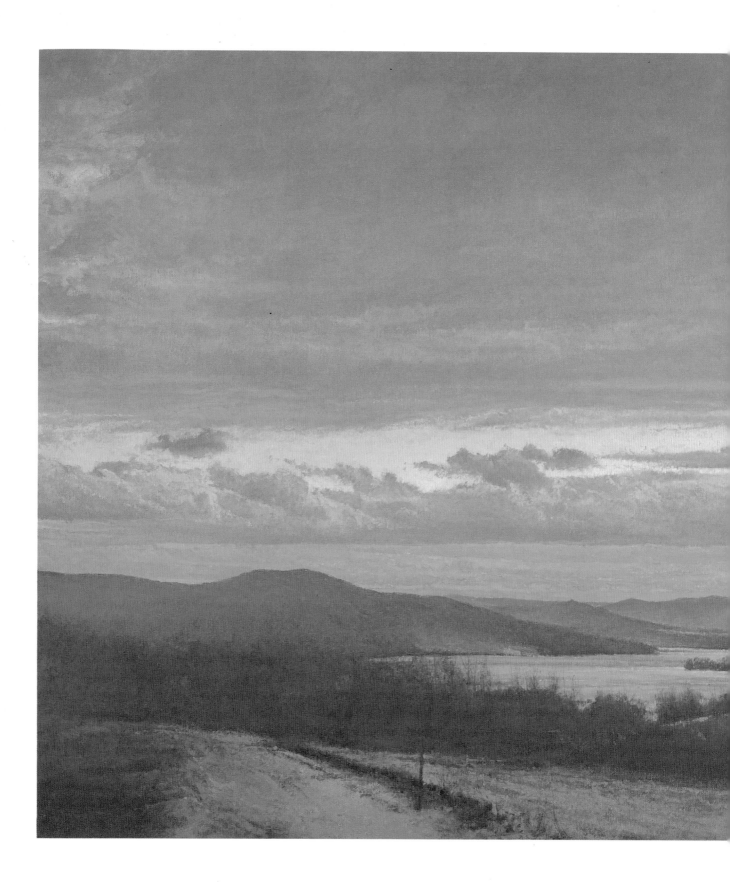

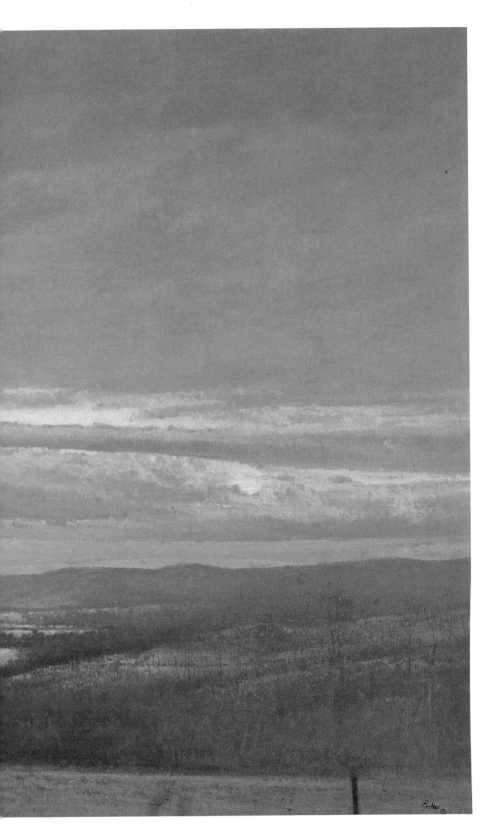

DECEMBER,
LAKE WARAMAUG SERIES

Oil on canvas. 26" × 40" (66 cm × 101.6 cm).
Collection of National Health Insurance Company.

A December storm has left a light covering of snow on the hills, but Lake Waramaug is still liquid at this time of year. The winter wind is riffling the water, breaking up any direct mirror image of the sky into streaks and dots of color. Depending upon the wind's strength and direction, each wave catches color from various parts of the sky. The bands of color are not just yellow, orange, or the color of cloud cover, but a combination of all three.

There is a clarity to the forms here, which is helped not only by the contrast of snow but by the snow's capacity to reflect the warm and cool colors of the sky. In this painting, I love the saturation of warm and cool color found at the horizon line, particularly the intensity of the violet purple snow-covered hills bathed in various degrees of the sky's reflecting warm light. The expression of space is suggested here by two concurrent sweeps of land masses: the darker, tree-studded forms of the middle ground and the lighter, more open snowfields of the foreground. The darker tones form a consistent gradation that ranges from lighter/cooler in the distance to darker/warmer in the foreground, but the lighter snow-covered area is in three bands: slightly darker and warmer in the distance; lighter, cooler in the middle reaches; and once again lighter, warmer in the foreground. This variation is caused by the surface geometry of the landscape and also by what these different planes are reflecting. Because of this painting's more broken and contrasted surface, there is a dynamic interaction between land, sky, and lake. The sky is brought down into the land through the reflecting snow and water; land patterns are brought upward into sky through the contrasting bands of cloud surfaces.

Dawns and dusks became a subject in which I was able to use more and different colors than I had before. Working this way also encouraged a freer interaction of forms, where the interwoven color and light effects of early morning and late day describe the contours and surfaces of the landscape.

Washington
and Woodbury

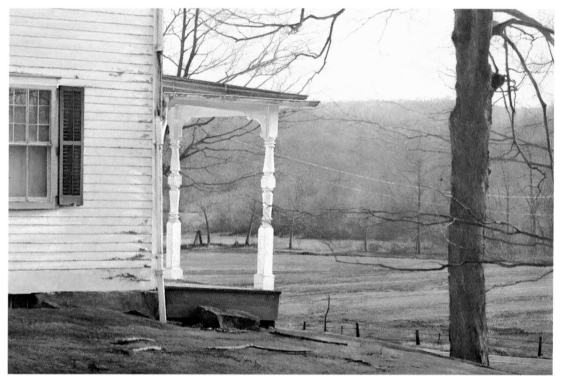

LAST LIGHT—RIVER MEADOWS
oil on canvas, 27" × 40" (68.5 × 101.6 cm). Courtesy of Sherry French Gallery.

*Complexities of light and space
in the frontal plane*

While Peter had driven past the Andrus and Johnson farms many times over the years, and had even stopped to sketch on several occasions, it wasn't until he happened by after a snowfall that he was able to conceive of them as subjects to explore. Although Peter began working on views from the Andrus and Johnson farms concurrently, there is a marked difference in the designs and concerns of these works that illustrates what Peter views as their separate personalities.

To Peter, "the sense of the land, its geography and geology, and the tremendous feeling of weight that you get as that wonderful hill comes down behind the house" was the essence of the Johnson farm. These sensations of gravity, of the weight of the land and its masses and topography, are carried out not only in the distant views of the high hills but in the close-up views as well.

At the Andrus farm, what struck Peter was "the weightless, timeless quality that comes from the immaculate white surfaces and clean lines." Peter's paintings of the Andrus farm all share this sense of pristine presence and clarity of vision. High-keyed and brilliant, they are a series of transpositions of white against white, of weightless forms dissolving and clarifying.

While most of the works at the Andrus farm seem to be extensions of his work in North Cornwall, the works at the Johnson farm precipitated a change in shape and in painting technique.

To convey his feelings about the movement and weight of the land and the long, slow passage of light, Peter began to elongate the shape of his canvas into a panorama that serves to surround and envelop the viewer and diffuse the centrality of the image. To capture the texture and substance of the soil and stubble, Peter continued the experiments with the more direct and painterly application he had begun with his Dawns and Dusks series.

Both of these changes can be seen in *Johnson Farm, Shadow's Edge Into Evening* (pages 128-129), painted on the Johnson farm, in which the eye is led continuously across the canvas instead of remaining fixed on the isolated high-contrast shape of the house. Thicker, more intensely colored blobs of paint now provide more textural interest, particularly in the plowed field and middle-distance trees.

Slow Burn Nooning, Toward Higher Pastures (pages 134-135), another view of the Johnson farm, is concerned with ellipsis, a reversal of the obvious and expected. The center of this panoramic canvas is empty; there is no central focus. This, together with the equality of tone of the foreground and background, encourages us to contemplate the whole of the surface.

The dominant foreground elements of the tree, stone wall, and house are dispersed across the canvas in a slow, geometric relationship. Much of the surface interest of their frontal planes is obscured in the oblique shadow created by the extreme side lighting. We are thus invited to admire the edges of the dominant elements as much as their major planes, and the negative spaces between the elements as much as the elements themselves.

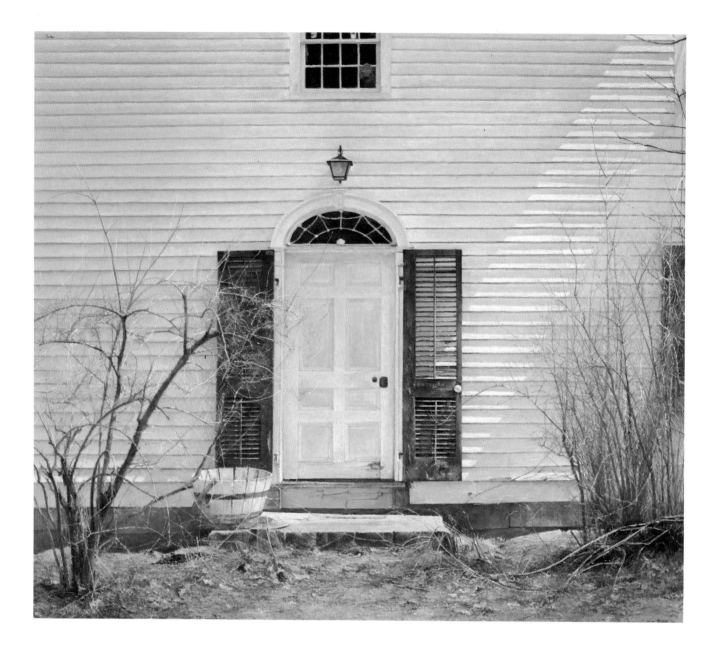

SUNDIAL, ADVANCING SPRING

Oil on canvas. 43" × 47½" (109.2 cm × 120.7 cm). Collection of the artist.

On my treks to Lake Waramaug to observe the sunsets, I would pass by the Dibble farm. The geometry of its clustered barns fascinated me, and eventually I did several small paintings of them from the roadside. As I looked down at the back view of these buildings, I thought about what wonderful, intimate vistas these were. It was here, in the high, raking light of early afternoon, that I discovered this shuttered back door.

The paintings of this house and its doorway marked my return to painting the facade—not to the simple frontal windows of Emily's, nor to the multifaceted porches of the Scoville farm, but to a facade that is punctuated and overlapped by shutters, twigs, and the subtle perspective suggested by the stepping-stone and planter in the shallow foreground.

The shaft of light raking across the facade's left side is important to this picture because it throws off its centeredness and gives texture to the otherwise monotonous clapboard wall. Interest at the peripheral edges of the picture is also of prime importance; the strong clump of branches on the left is balanced by the more delicate twigs on the right, reinforced by the green edge of a partially seen shutter and the fragile branches of a nearby tree in the upper right.

To retain the sense of a flattened facade in this picture, the foreground's unified plane of brown leaves is broken up by the addition of soft green grasses.

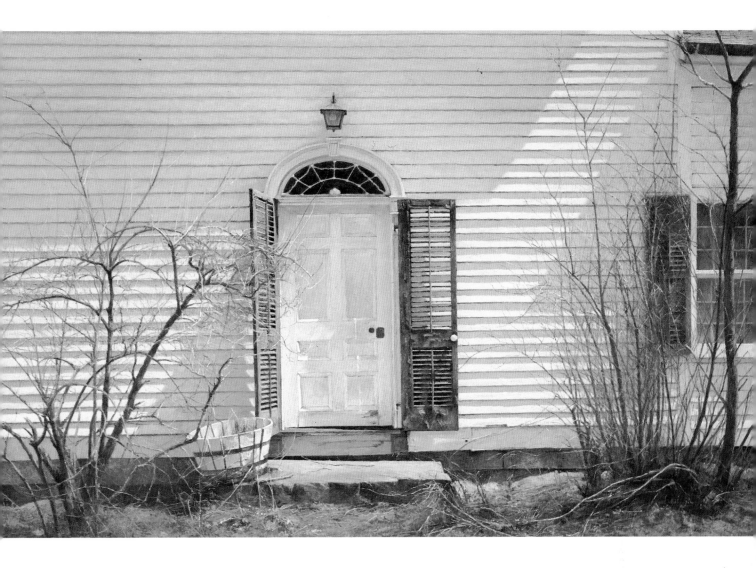

APPROACHING FULL SUN, DIBBLE FARM

Oil on canvas. 34" × 54" (86.4 cm × 137.2 cm). Courtesy of Sherry French Gallery.

The sun had rounded the house's southern gable end and produced a more diffused pattern of light to the facade than that found in the narrow shaft of *Sundial, Advancing Spring* (opposite). Diagonally shaped shadows are cast by the roof and by the shutters and form a repeated slanting pattern extending across the facade. The sense of space here is deeper than in *Sundial, Advancing Spring*, even though the foreground is shallower. This is true because the picture has been opened up horizontally, which in itself implies more depth. The stronger spatial emphasis of broken light patterns and the unified plane of brown leaves in the foreground also increase the feeling of depth in this painting.

I did not include the small upper window over the doorway, as I did in *Sundial, Advancing Spring*, because it draws too much attention to the center of the painting. Thus, the relatively unbroken top plane shifts much more of this central emphasis to the sides of the painting, where a double framework of dark branches acts as clues to space.

There is more happening at the picture's edges here: The sliver of green shutter broken by sunlight on the left plays off the window and shutter on the right, and both read as part of the facade. Additional spatial accents are provided by the dark, warm-colored pipes, the tangle of branches on the left, and the dark vertical of the tree that bisects the window on the right.

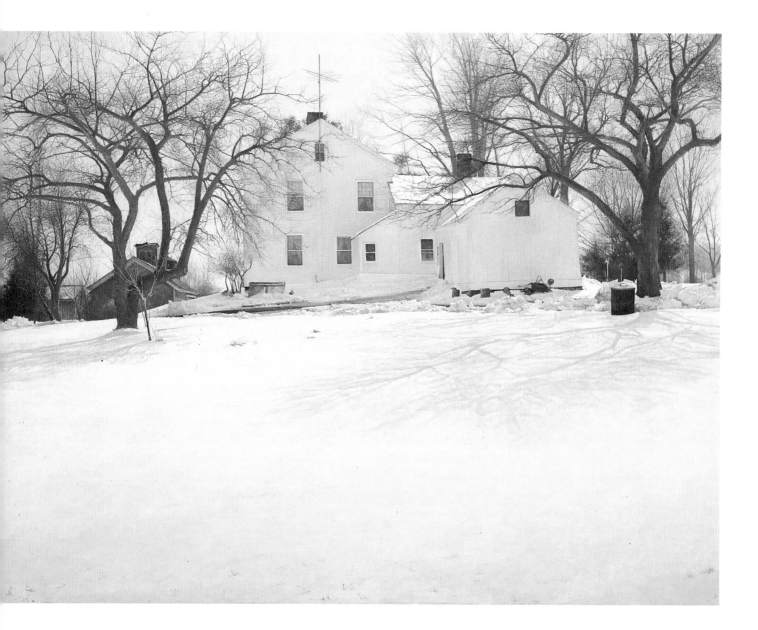

APPLES, LILACS, PASSAGE JANUARY INTO FEBRUARY

Oil on canvas. 40" × 52" (101.6 cm × 132.1 cm). Courtesy of Sherry French Gallery.

The Andrus farm overlooks the Shepaug River Valley. It is meticulously maintained, reflecting a love of land and place. This is truly an enchanted place, an oasis of white surrounded by shade trees, all the stuff that eternal Sunday mornings are made of.

In this painting, the back side of the Andrus House is seen in the high-keyed light of early afternoon. Although the day is somewhat hazy, there is also an interesting glare effect that is created by the thin, icy crusts that form on the snow once it has melted and refrozen.

The values of sky, house, and snow are very similar, with minor spatial clues and subtle differences: The sky hints at blue; the house is slightly darker and more lavender than the sky, gradually becoming warmer as it comes forward through a succession of additions; the foreground's high-keyed whites are lightly tinged with yellow. This envelope of bright light makes the house ghostlike, its identity conveyed by a peppering of dark windows and chimneys. No trees are solidly massed behind the house, as they are in *Passage February into March, Afternoon into Evening* (opposite). The hardwoods in the background commingle with the apple trees, diminishing their spatial impact and letting the form of the architecture dominate.

The house is placed high in the picture plane to focus on the concentrated activity of the flanking trees. The mass and spareness of the foreground are tied to the tree textures above by the lavender shadow's intricate tracing of branches.

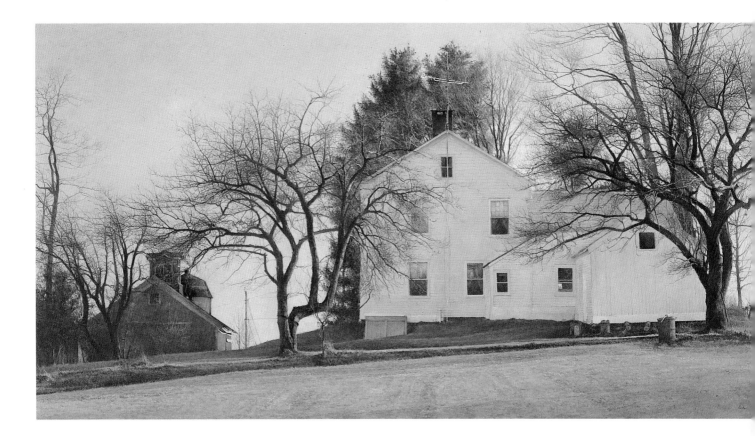

PASSAGE FEBRUARY INTO MARCH, AFTERNOON INTO EVENING

Oil on canvas. 30" × 56" (76.2 cm × 142.2 cm). Collection of Clara F. Lane.

In this composition I wanted a more strung out lateral feeling reinforced by the shape of the grass field and its long shadows, together with the spreading architecture encompassed in a long horizontal picture plane.

Although the house in this painting retains some of the ghost-like appearance found in *Apples, Lilacs, Passage January into February* (opposite), its forms are more defined by the two contrasting evergreens behind it. By increasing the distance between the barn and the house, the sense of the house as a solid object in space is reinforced. The two apple trees are placed closer to the house here, which links them to the house's frontal plane. The deeper recesses of the barns and more distant trees create a spatial tension with the house and its flanking trees. The negative channel of space formed between the barn and the apple tree to the left of the house is extremely important in this regard.

The late day's low light gives more definition to the roundness of form in both the barns and the trees. In this type of sidelighting, some of the branches are described by light on dark effects, which are different from the dominant dark-on-light found in the strongly backlit *Apples, Lilacs, Passage January into February*. This relative fullness of light range also adds to the dimensionality of the tree forms. Here they are not just silhouettes.

A very important consideration in this painting was how much texture should prevail in the grassy foreground, so that it is sufficiently rendered to distinguish its surface from those of the house and sky, but not so much that it overpowers those elements that exist deeper in the picture plane. The foreground area also had to incorporate a gradient of light to reinforce the sense of its receding space.

LOCUST AND APPLE

Oil on canvas. 10" × 13¾" (25.4 cm × 34.3 cm).
Collection of Lawrence H. Pratt.

Locust and Apple was painted directly on white canvas (alla prima); the pores of the fabric can be seen in the patches of grass in the foreground. It was one of the studies I used to resolve the composition for *Passage February into March, Afternoon into Evening* (above) and was done in early February, when patches of grass had just begun to appear in earnest. The viewpoint here originates much farther to the right and shows the back view of the house that is catching the direct sunlight. The barn on the left is overlapped by the house, preventing the sun from reaching it.

TWILIGHT, ANDRUS FARM

Oil on canvas. 45" × 58" (114.3 cm × 147.3 cm). Private collection.

Because of my preference for strong light effects, I typically paint facing into the sun, so it is unusual that my first large painting of the Andrus farm shows it facing away from the sun during a time of day when sunlight is giving way to twilight. The subtle, moisture-laden atmosphere of late day produces here a uniformity of textures and a quietness of form. The rocky outcroppings, near dark trees, and recesses of the house are all intentionally hushed. The pink-tinged walls of the house are a subdued mirror of the western sky; its rooftops hint at the muted blue to be found in parts of the overhead sky hidden from view. In essence, the house's form is lost to subtle gradations of color and light; it almost becomes one with the snowfields, distinct against the landscape only where its highest roof plane pushes into the mass of the hillside. This intrusion of house into hill makes a more obvious connection between the color and the volume of the hill's snow-covered outcropping with the colors and form of the house itself.

At first glance, this painting looks like an atmospheric arrangement of three subtle but distinctive bands of color, but there are slight shifts in the hues of the middleground snowy planes, the warm inflections of the far fields, and in the cool blues of the foreground that suggest a subtle evocation of deep space.

RIVER MIST

Oil on canvas mounted on board. 12⅝" × 15½" (32.1 cm × 39.4 cm).
Collection of Dr. J.H. Sherman.

This is a very similar viewpoint to the one seen in *Twilight, Andrus Farm* (opposite), but the obvious difference is seasonal; *River Mist* was painted in earliest May and is characteristic of a warm spring morning. At this time of year, the aerial perspective is pronounced because of the warm, moisture-laden air compounded by the mist still hanging in the river valley beyond the far field.

This painting is a seasonal variation on the four-tiered space found in *Twilight, Andrus Farm*, from sky to far hill to far and near field. In this case, the blue of the hill is brought into the nearer plane by the reflected color of the rooftops, and the sky color is echoed in the walls of the house. To keep the mist and paling effect of the morning dew from dominating this painting, I used the backlit shapes of the newly leafed apple trees to give this picture some additional contrast and spatial punch.

126

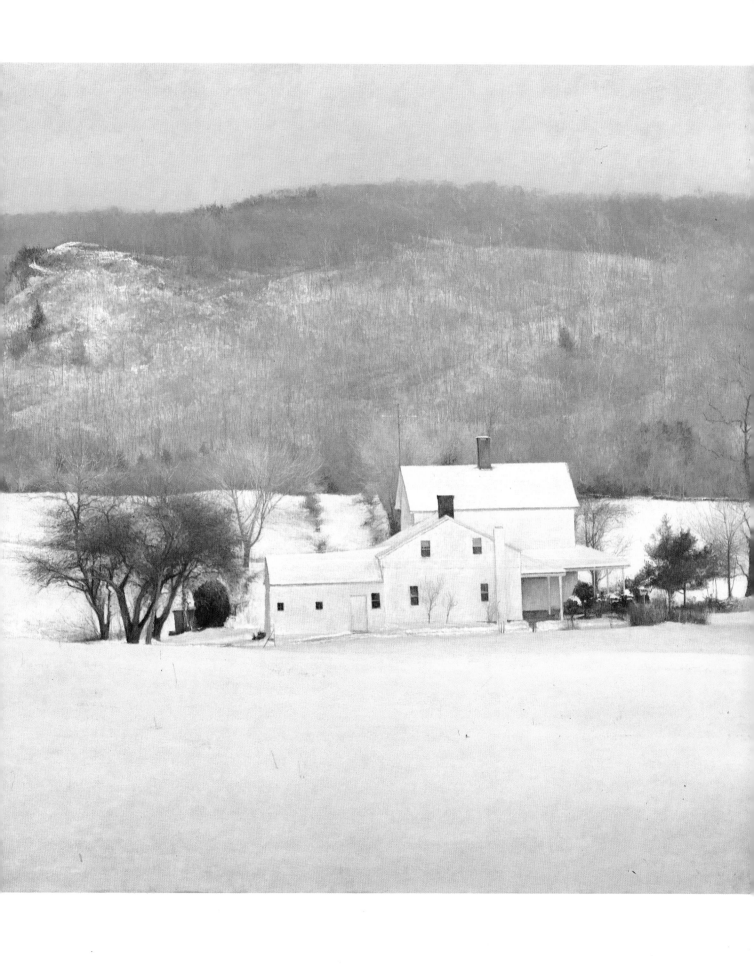

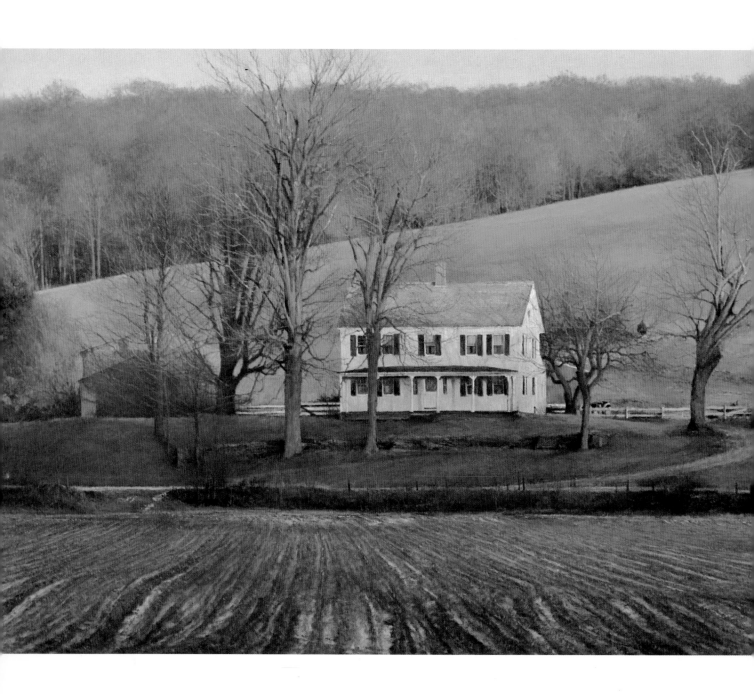

JOHNSON FARM, SHADOW'S EDGE INTO EVENING

Oil on canvas. 29" × 60" (73.4 cm × 152.4 cm). Courtesy of Sherry French Gallery.

I painted this picture from the far hayfield's little knoll that looks across the cornfields and onto the Johnson farm. The new spring greens are just hinted at in the cornfield's edge and in parts of the lower pasture. Remnants of snow and ice still cling to the furrows of the near field.

The geography of the Johnson farm, with its beautiful, weighty sweep of diagonal hill coming down to the farm buildings, is impressive. I would come to this field almost every day to watch the shadow of the western hills envelop the valley but leave the hill's tawny covering of haystubble golden in the last of the day's light. The relative whiteness of the house seems almost foreign here and perhaps it would be if not for the overlapping trees that help integrate the architecture into the landscape. The cool, narrow strip of sky above provides temperature contrast to the warmth of the woodlot and rising hill. The relatively textured foreground, composed of icy patches and cut cornstalks, is contrasted against the smoothness of the upper field.

The series of lateral shapes stretched across the middle distance (house, stone wall, fence, roadway) provide a necessary break between the hill behind and flat field in front. Interwoven with the verticals of the trees, these lateral shapes create a sense of spatial stability and act as a foil to the diagonal thrust of the hill.

A necessary counterpoint to the incline of the hill is the hedgerow on the upper right; it stops the eye from going out of the picture and takes it back down into the lower parts of the composition.

Some very important color accents are found in the middle distance: The orange of the house's chimney echoes the unpainted new wood on the barn's gable end; the three spots of barn red, especially the vertical rectangle of sunlit red on the left, pick up the shape of the chimney and its small shadow. These reds also repeat the colors of the woodlot. The barberry red found in the hedgerow is a more direct echo of the barns' reds; their color and contrast hold the lightly weighted upper-right corner of the painting together.

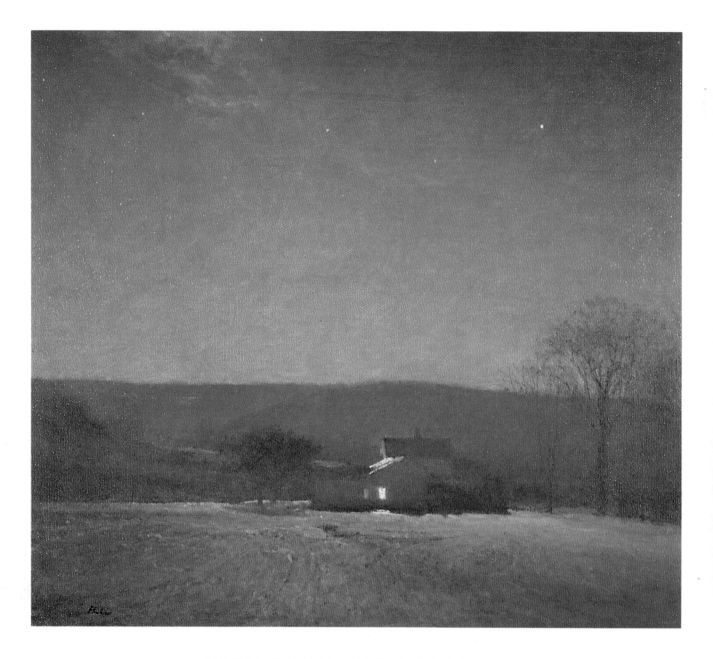

MOONLIGHT, HIGH MEADOWS, ANDRUS FARM

Oil on canvas. 13¼" × 14¼" (33.7 cm × 36.2 cm). Courtesy of Sherry French Gallery.

This painting faces the moonlight, creating the effect of nocturnal backlighting. The house, which is defined by a slight gradient of light reflecting off the snow, seems to grow out of its own shadow. The forms of the house are suggested by the glint of moonlight on its tin roof and the muted light reflected on its gable side. I was intrigued by the relative strength and warm glow of the bright kitchen window compared with the diminished light of the adjacent woodshed window.

A nighttime scene has its own manifestation of aerial perspective. Although the tonal range is kept in the lower key, there are obvious gradations of color and light; in this case, they range from the warmer light blue of the foreground, to darker blue gray, with purple overtones, of the middleground, to the bright coolness of the night sky. Additional tension is created by in-

creasing the light around the band of far hills and fields; the foreground is illuminated more sharply at the shadowed edge of the house, while the sky grows lighter at the horizon.

To counter the weight of the house and trees on the right side, I included the thin film of cloud cover in the upper left. The relative intensity of the stars also balances the picture and is an important indicator of space in the sky.

Because I was familiar with this particular site, I was able to interpret select areas of the landscape. In this case, I was well aware of the uncut meadow's coloration on the left side of the distant field. Although I couldn't see its color in moonlight, I painted in its influence from knowledge if not vision; its warm russet tones help project the sense of space in the hills' dark bands.

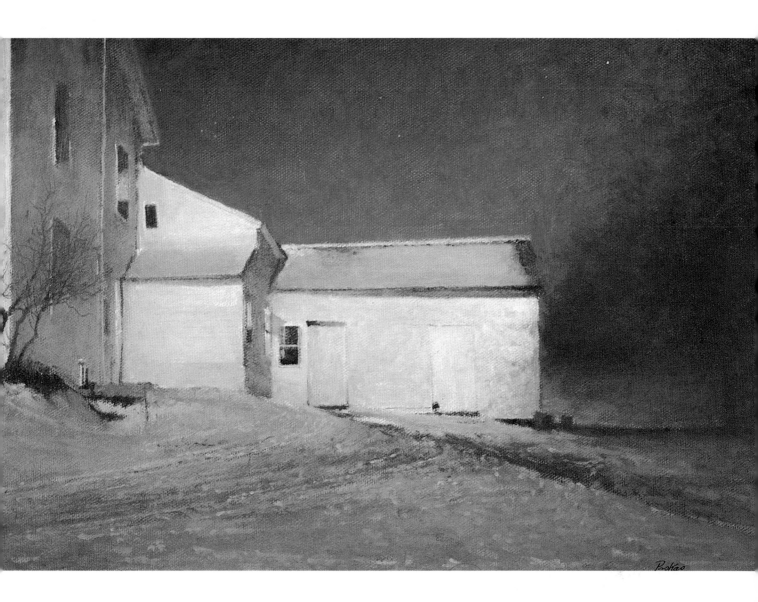

ANDRUS FARM, EAST SIDE MOONLIGHT

Oil on canvas. 9" × 14" (22.9 cm × 35.6 cm). Private collection.

I had been observing the effects of moonlight at the Andrus Farm for a number of years; the house has a well-maintained tin roof that reflects the light well. The additional brightness of snow-covered fields in winter made the night landscape work for me.

The sky blending into the dark trees on the right is the major dark shape in this painting. Light, in the form of moonlight, is concentrated on the white architectural form; blending into darkness, this focus of light on the house creates a solidity and a monumentality of form very different from the ghostlike appearance of a white house against a light sky in the daytime.

This more fixed contrast evokes a feeling of stillness.

Gradations of light are important for defining form and space in this picture. Even in darkness, there are still subtle transitions in the night sky, just as there are varying intensities found in the stars. The star on the right assumes a larger size and a higher intensity in order to offset the weight of light and form on the picture's left side. By intensifying the yellow warmth of interior light, I made the moonlight on the woodshed seem cooler by comparison. With the same idea in mind, I made the masses of snow a warm brownish lavender to intensify the cold blueness of the sky.

131

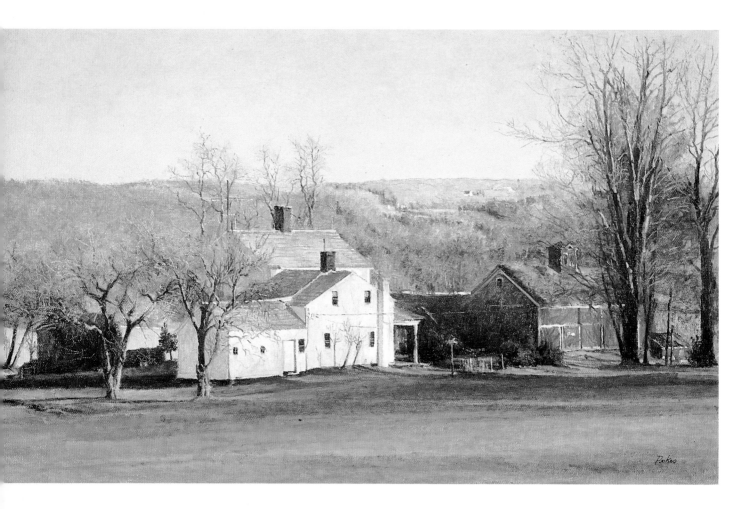

MARCH, ANDRUS FARM

Oil on canvas. 11¼" × 19½" (29.9 cm × 49.5 cm). Private collection.

Almost all the outbuildings of the Andrus Farm can be seen in this view, which faces southeast from the upper hayfields. It is almost April, and there are only a few signs of snow left near the edges of the far fields.

This picture is certainly unlike my many frontal themes, but I was attracted to this viewpoint because of the strung-out relationship between the various buildings. The architecture serves as a kind of interlocking jigsaw puzzle of perspectives; the light and dark sides repeat the more natural facets of the hillsides above.

The keying of lights relative to darks is very important in this painting. The placement of sheds, trees, and shadows on the left side of the canvas is essential for bringing out the solidity and light values of the house, as are the dark shadowed ells of the barns on the right. The front of the barn relies on the overlapping dark tree shapes to bring out its reds. I also solidified and

darkened the shadows of the foreground to strengthen the impact of light on the buildings.

The trees in this painting are not only necessary to the composition and balance of the picture, they also provide very important spatial clues: The two large maples that extend to the top of the picture reinforce the deep space of the sky and distant landscape; the tall group of locusts above the house push the far hills further back, but the locusts also help position the house and the apple trees in space.

In this painting, I am beginning to sense the need for larger, more complete studies to further anticipate complex light effects and compositional needs in the larger works. These studies should also help to document smaller details, such as the whirligig sitting on its pole in front of the barn's shadowed ell. In addition, they will allow me to work out more intricate light patterns on small surfaces.

LILACS, EARLY APRIL

Oil on canvas. 11⅜" × 15⅜" (28.9 cm × 39.1 cm). Courtesy of Sherry French Gallery.

This is really a picture about shapes and light. It involves the interplay of the shape of the sky, shapes of roofs, shapes of shadows and light, and shapes of snowpaths and grass. The painting is still involved with the ghost of a structure, a white house in high country set against the sky. Although this seems an obvious contradiction, I love the strength of its subtleties: the quiet power of white seen as an almost negative intensity. There is also a duality of texture and light at work here: the lateral rhythm of clapboards and their shadows suggesting a gigantic bird's wing found on the wall of the woodshed, along with the wavelike cadences of the tin roof and the ladder of clapboard rungs going up the house's edge on the left.

Reversed shapes and images weave their way through this painting: The darkened windows of the shed are seen as reflected skies of glass in the left-hand upper story; the two mute white doors, one recessed, the other flush, are subtle variations of the rectangle theme; patches of snow carry the color of painted wood into the landscape.

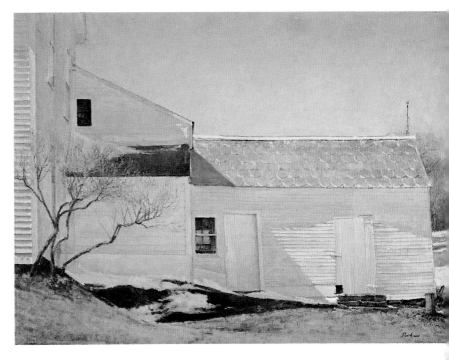

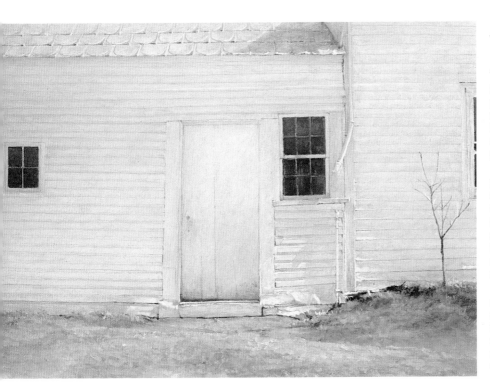

WOODSHED, ANDRUS FARM

Oil on canvas. 13¼" × 19" (33.7 cm × 48.3 cm). Courtesy of Sherry French Gallery.

This is the opposite side of the woodshed found in *Lilacs Early April* (above). It was painted in March, in early afternoon, just as the sun rounded the south side of the house. Because of the sun's high angle, only the clapboards near the bottom of the house are catching light.

There is a very abstract sense to this painting; it is intentionally empty and is critical in its balance; it focuses on a few dark shapes, textures, and subtle color. If any one element or detail were eliminated here, such as the sharp darkness of the little window on the left, the textured tin roof, or the sliver of a window on the right, the painting would fall apart.

I can remember spending hours figuring out the exact proportions of each shape in the composition along with all the considerations needed to determine the light gradients, textures, and colors, to make these often very separate parts work as a whole.

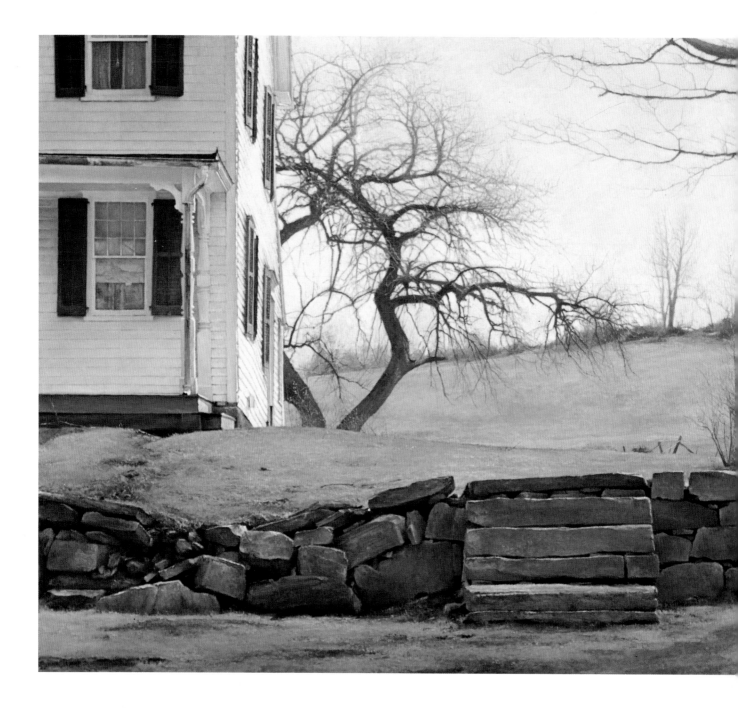

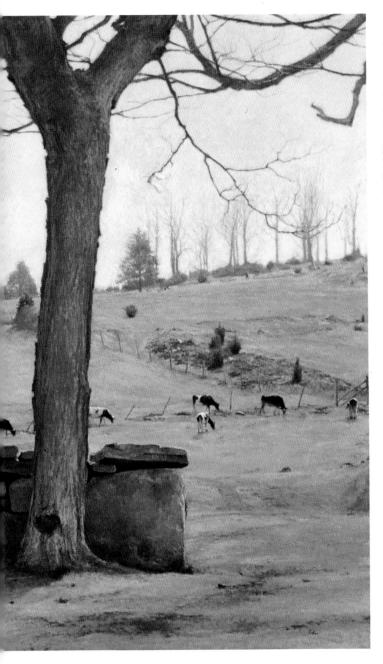

SLOW BURN, NOONING, TOWARD HIGHER PASTURES

Oil on canvas. 31" × 54" (78.7 cm × 137.2 cm). Collection of Mr. Orton P. Camp, Jr.

This is the front of the Johnson farm seen from the road's edge. The sun is starting to burn off the valley's heavy mist in earnest as cows meander toward the upper pastures. It is around eleven o'clock in the morning.

Although this painting doesn't describe the dynamics of the frontal plane as does *Petal Fall: Portals of Early Spring* (pages 138–39), it is similarly concerned with the peripheral and with the relative emptiness at the center of the canvas. In both paintings, the entire surface of the picture plane is important.

The role that a true sense of perspective plays here is minimal; the farmhouse extends out of the picture plane before the complexities of its three-dimensional form are fully realized. In this case, the house's overlapping relationship with the apple tree behind defines its location in the picture plane more than the illusion of form. The frontal attitudes of objects and their strong vertical-horizontal axis make this a very formal and stable composition. This formality is reinforced by downplaying the dimensional aspects of the stone wall; its thickness is only hinted at by the darkness of its recesses and a few edges of direct light.

Aerial perspective bears the burden of defining space in this painting. It is used in an overlapping manner above the stone wall and as a gradient going from the foreground through to the upper pastures.

The cows not only serve as a rhythm of shapes in the painting but also carry the high-keyed white of the house into the right side of the picture. Because I felt it important to position one cow to the left of the foreground tree and to have other cows balance the right side, I found myself playing with their actual arrangement in the field. It is also important how the cows parallel the diagonal pattern of rock where the downspout's flow has undermined the wall.

Instead of the single tall tree you see here, I had originally placed two trees parallel to each other on the right side of the composition, thinking that their echo of the house's twin shutters would be effective; however, the second tree polarized the composition much too rigidly into right- and left-hand sides. The single tree's contribution, by contrast, is more asymmetrical and subtle and allows the eye to move more easily through the composition.

Slow Burn is essentially about gradations of light, color, and atmosphere that are both accented and flattened by their arrangement as overlapping forms.

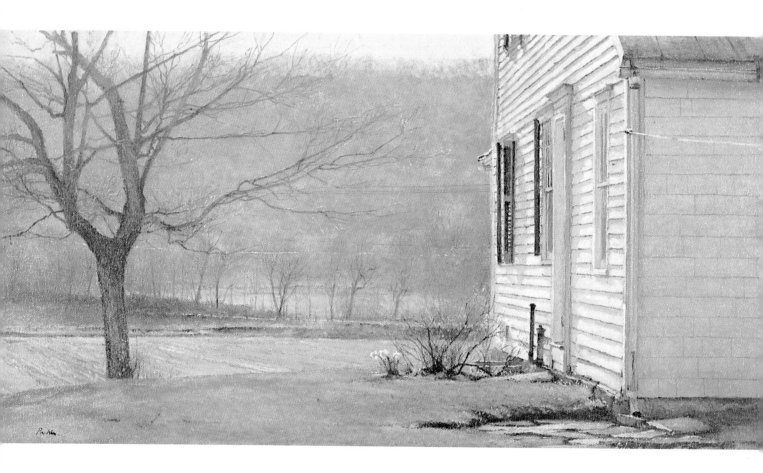

EARLY SPRING, ABOVE RIVER MEADOWS

Oil on canvas. 11" × 21½" (27.9 cm × 54.6 cm). Private collection.

I became intrigued with the possibilities of stretching the lateral plane in *Slow Burn, Nooning, Toward Higher Pastures* (preceding page) and decided to continue with that theme here. In this painting I explored this idea by placing an architectural form on one side of the picture and balancing it with organic forms on the other side.

Because the view we have here is of the house's shadow side, whose tonal values are close to the far hill in the background, the architectural element doesn't have much punch; instead it serves to accent the dark verticals of the shutters, stand pipes, shrubbery, and dark shapes of the stonework. The combined impact of these objects is then balanced and echoed by the size and relative complexity of the tree in the near foreground.

Space is primarily indicated here by overlapping forms; the house's perspective is cut off by the top of the picture plane. There is, however, an interesting spatial effect that occurs in the receding field's bands of green, where the grass of the foreground and that of the far field are similar in warmth and tone but are separated by an intervening band of cooler, lighter green. Though, to some extent, this interruption does not adhere to the tenets of true aerial perspective, the space still works in this painting. This is true because there are many ways to approach the handling of space, some of them seemingly contradictory; but by using combinations of varied spatial clues, aerial perspective, color, tone, scale, and overlapping forms, a sense of depth can be made, accented, denied—or anything in between.

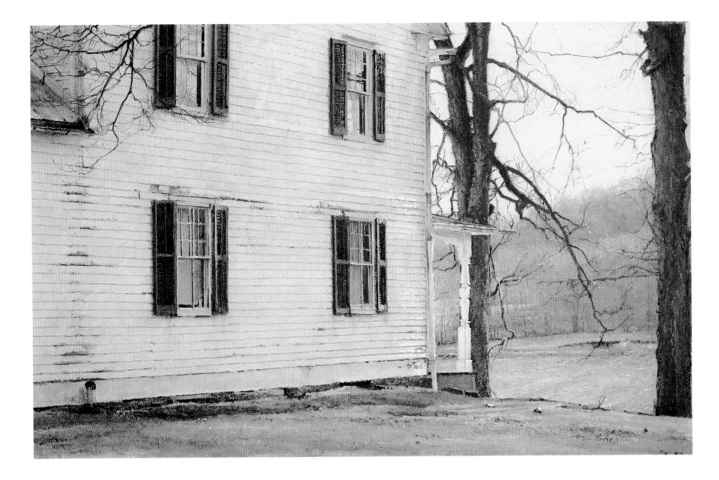

APRIL DESCENDING, PASSAGE INTO LATE AFTERNOON

Oil on canvas. 13" × 19½ (33.0 cm × 49.5 cm). Collection of Dorothy R. and Paul N. Cohen.

This is the north side of the Johnson farmhouse. Its large, rather empty surface is a foil for the details of its structure—their inherent beauty, geometry, and relation to each other.

The framing of negative spaces and the repetition of twin elements are what this painting is all about. The two trees are to the landscape what the twin shutters are to the windows. Contained miniature skyscapes are found reflected and framed in the upper stories of the house, echoed by the small slice of land caught between downspout and porch post. A corner of the roof on the left combines with a section of back wall to make another rectangular shape, which also helps to balance the composition. I introduced the branches in that area to bring texture and added spatial punch to the left side of the canvas.

The keying of light in this painting is quite high, especially in the large areas of the house and the sky. These areas were kept quite similar in tone to emphasize the dark verticals found throughout the painting.

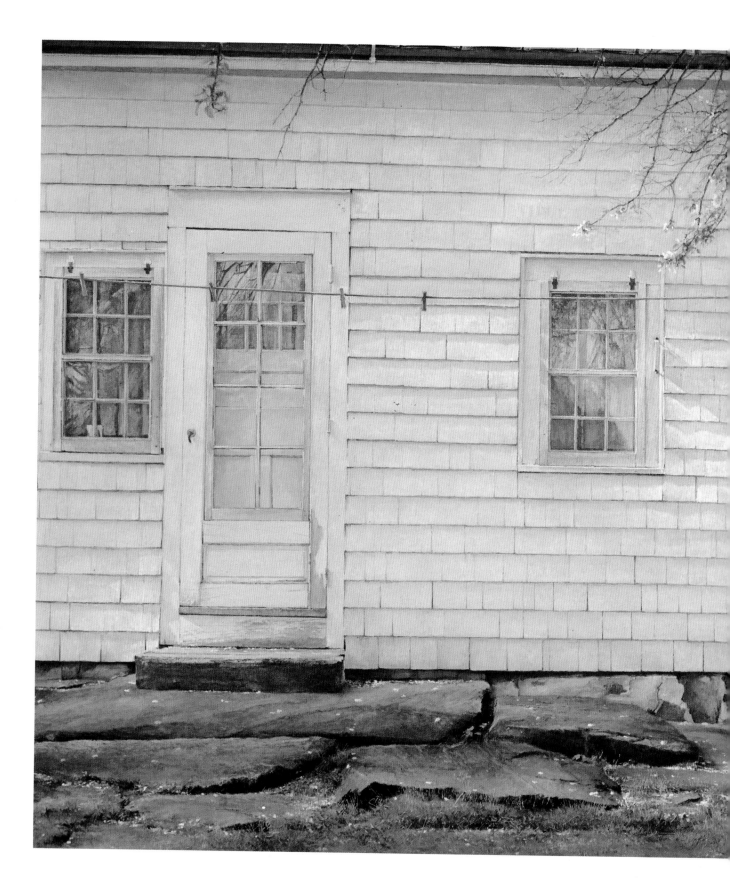

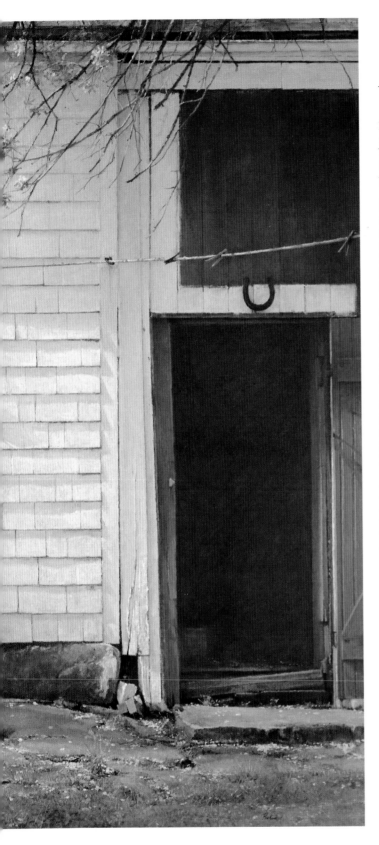

PETAL FALL, PORTALS OF SPRING

Oil on canvas. 38" × 52" (96.5 cm × 132.1 cm).
Courtesy of Sherry French Gallery.

Early spring, its warmer days full of moist atmosphere and softness, is my time of year to be out in the field gathering material. While the increased aerial perspective is intriguing, a more immediate appeal lies in its strong reflected light that has not as yet been absorbed by the coming full foliage.

This painting is about the complexities of spring's reflected light on a chameleon surface of white. The house contains a microcosm of spring on its surface and in its reflecting windows. In particular, I was drawn to the soft hues of the late-afternoon sun disappearing from the kitchen's exterior wall. This shell pink color found on the shadowed white shingles of the house is repeated throughout the picture on scattered, fallen petals and on the few apple blossoms still left on the tree.

The subtle gradations of light within the shadow of the facade are so important, ranging from cool lavender grays to the warm yellows directly below the roof's edge, along with a complementary gradient of light and color found on the dark edges of the shingles. I also found that the softened sky and tree images contained by the windows and storm windows were especially effective for conveying the misty qualities of early spring air.

Compositionally, I was concerned with an asymmetrical assemblage of rectangles; with light balancing dark; and with strong color versus subtle color. Like *Slow Burn, Nooning, Toward Higher Pastures* (pages 134–35), the center of the composition is intentionally spare; the action is spread around the periphery.

This painting is of a rather simple facade, punctuated by the more intricate and colorful apple branches extending downward into the picture. In this case, what is important is not just the overlapping position of the branches, but also their warm brown color in relation to the cooler tones of the shadows behind. In reality, the branches were almost completely covered with leaves, making for a much too solid and obtrusive green. I adjusted and pruned them to suit my purposes. The clothesline is another important overlapping spatial clue that undergoes a dark-light, figure-ground reversal on its extension across the picture plane. The clothespins dancing on the clothesline are necessary little accent notes, as are the similar-sized rusted hinges above the storm windows.

The stonework's dark lateral rectangles provide contrast with the delicacy of light found on the house. To integrate these two areas, however, careful consideration was given to the dispersion of white petals on the stones. The blossoms had to sit comfortably on the stone surfaces, as any wrong placement would negate the spatial clarity of the painting.

The Painting in Progress

The following demonstration shows the process I go through when painting a small, intimate-sized work. As opposed to the large scale paintings, where I work from studies inside the studio, I begin the small paintings on-site, using a random-sized piece of canvas tacked to a drawing board. This method eliminates the need for an easel and allows me to rest the board on my lap, as I used to do when I worked with watercolors. In this case, I had done a preliminary drawing during the day to locate major objects and land masses in the composition. Most attention is given to the trees and house in the middle distance. I find that too much drawing information in the background and foreground isn't necessary because the more general textures of these areas are better determined by the brush.

A ground color of burnt sienna, thinned with turpentine (to a density that feels right), is put on the surface with a soft two-inch house-trim brush. When the board is propped upright, gravity pulls down the succeeding horizontal washes into a relatively smooth tone. I usually allow about five or ten minutes for this to happen; then I brush away any excess color from the edges of the canvas.

For the block-in, I tend to focus on and paint areas that are in the same spatial plane, proceeding from back to front. In the background, I begin with the sky followed by the wooded far hill and then descend down into the middle-ground area at the left. Before going on to the foreground fields, while I still have the uncovered drawing to refer to, I paint in the shapes of any major overlapping objects—in this case, the large tree forms on the left. As you can see here, I do much of the drawing with a brush, because the pencil work has been pretty well covered by the block-in. At this point, the drawing beneath the ground color serves as a locator that allows me to focus on tone and color in the changing light conditions. In some areas, such as the lower edge of the trees on the left, I paint certain elements in quite lightly, leaving the ground color to interact with subsequent applications of paint. How much of the ground color I allow to come through is a judgment call; to cover this ground completely defeats its purpose, to let it show its influence everywhere would prove too monochromatic.

The heavier, more opaque colors of the snowfields are now put in, then the details of the buildings, trees, and landscape in their proper spatial sequence—once again working from back to front. In doing this I painted around and between the house and barns leaving the transparent ground on which to paint the buildings in order to heep intensity in their color; to overpaint the snow color would negate this transparent glow. In order to locate ground-covered lower portions of the middle-distant trees, I paint these areas in, allowing their top halves to overlap into the far hill. Sometimes I expose the drawing beneath by wiping away the layer of ground color with the stubble of a worn-out brush. But at this stage, the detailing of objects is just cursory.

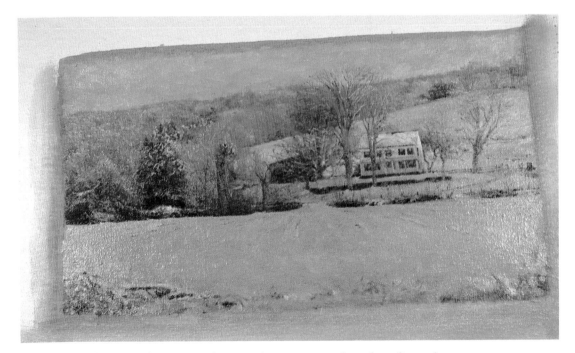

The foreground is painted in now; in this case, there is a particular soft quality to the lower edge of the picture; so that the middle distance retains its importance. There are indications of furrows beneath the snow, their snow-covered forms subtly catching the reflection from various parts of the sky. (The wet surface of the painting at this stage is responsible for the glare you see here.)

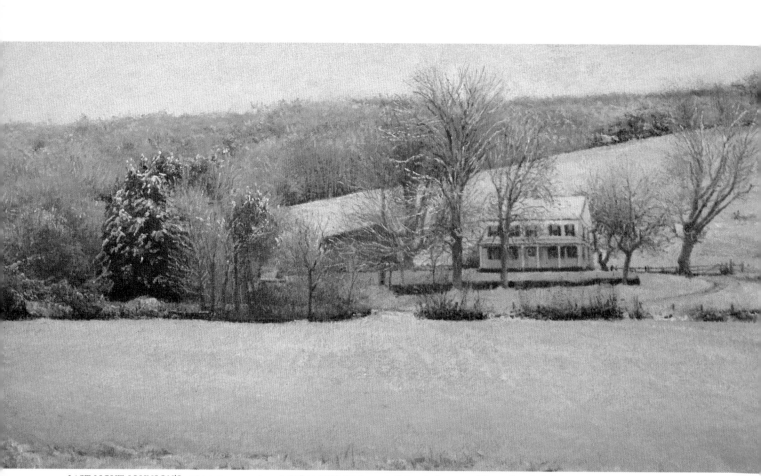

LAST LIGHT, JOHNSON'S, *oil on canvas on board, 9¼" × 16½" (23.5 cm × 41.9 cm). Courtesy of Sherry French Gallery.*

Once the ground-influenced block-ins are completed, I begin to think about color changes that will enhance space and form. The sky is pushed toward yellow and aqua; the foreground snowfield moves toward blue and violet; the slanting field behind the house shifts from cooler tones on the left to warmer tones on the right. Cool colors are also worked on top of the woodlot's warm underpainting, and the snow cover on tree branches is modified with transitions of warm and cool color. The red barn is made cooler and darker to set it back in space and bring the house forward.

In the end, refinement is more a function of shifting colors and tones in order to clarify space, light, and form rather than building detail in the linear sense. For example, I decided that the brambles in the lower foreground were too distracting, and I reduced them into a contained horizontal band that relates to the shrubbery at the far edge of the field. Feeling that the middle distance needed more tension, I also darkened the shrubbery in that area. This seemed to crystallize the space and accented the atmosphere.

Index